# FINDING
# T·H·E·I·R
# V·O·I·C·E

# FINDING
# T·H·E·I·R
# V·O·I·C·E

*Peruvian Women's Testimonies
of War*

## KRISTIN HERZOG

TRINITY PRESS INTERNATIONAL
Valley Forge, Pennsylvania

Trinity Press International, P.O. Box 851, Valley Forge, PA 19482–0851

Printed in the United States of America

**Library of Congress Cataloging-in-Publication Data**

Herzog, Kristin, 1929–
    Finding their voice : Peruvian women's testimonies of war /
Kristin Herzog.
        p. cm.
    Includes bibliographical references and index.
    ISBN 1-56338-075-7
    1. Violence—Peru. 2. Women—Peru—Social conditions.
3. Peruvian literature—Women authors. 4. Reportage literature,
Peruvian—History and criticism. I. Title.
HN350.Z9V54 1993
305.42'0985—dc20                          93-33247
                                          CIP

*To the memory of*
*María Elena Moyano*

In the act of "writing culture," what emerges is always a highly subjective, partial, and fragmentary — but also deeply felt and personal — record of human lives based on eyewitness and testimony. The act of witnessing is what lends our work its moral (at times its almost theological) character. So-called participant observation has a way of drawing the ethnographer into spaces of human life where she or he might really prefer not to go at all and once there doesn't know how to go about getting out except through writing, which draws others there as well, making them party to the act of witnessing.

<div align="right">

Nancy Scheper-Hughes,
from the "Prologue" of *Death without Weeping:
The Violence of Everyday Life in Brazil*

</div>

# CONTENTS

## Part One
## PERUVIAN WOMEN'S TESTIMONIES
## ABOUT WAR

*Chapter 3:*

*Chapter 4:*

## Part Two
## THE WOMEN'S MOVEMENT OF PERU
## AND THE THEOLOGY OF THE FIRST WORLD

*Chapter 5:*

*Chapter 6:*

*Chapter 7:*

*Chapter 8:*

## Part Three
## WOMEN'S VOICES FROM THE THIRD WORLD:
## LITERARY AND THEOLOGICAL DEBATES

# LIST OF ILLUSTRATIONS

# PREFACE

Relating testimonies of war by Peruvian women has meant for
me struggling to find my own voice in matters of war and peace.
It turned out, however, to be not just my individual voice, but —
to use a title of Susan Griffin's — "A Chorus of Stones" singing
"the Private Life of War." Countless people, events, books, and
everyday experiences have contributed to my conviction that
there is a "chorus of stones" affirming life and refusing to kill in
war — whether for God, land, honor, "manhood," world revolu-
tion, or even survival. This common voice reaches beyond any
national, ethnic, or religious identification. While the refusal to
kill has often been relegated to a "world to come," many people
of faith have seen it being realized in this world, here and now.

Concerning the presence of God's reign on earth, Jesus of
Nazareth claimed that "the very stones would cry out" if his
disciples remained silent (Luke 19:40). Much earlier the Hebrew
prophet Habakkuk foresaw that "the stones will cry out from
the wall" against those who plunder nations, spill the blood of
human beings, and do "violence to the earth" (Habakkuk 2:11).
I take both sayings to mean that there is a "common sense"
working in the conscience of humankind witnessing to life and
justice. The sufferings of Peru would be overwhelming to me if
I were not convinced that, together with the voices of women
and men, "the very stones" are crying out for a just peace. How-
ever, my sojourns in Peru have also taught me that I have no
right to proclaim some "universal truth" about nonviolence in
the midst of people who have suffered violence all their lives
and for generations. I cannot turn the "chorus of stones" into a
moral prescription. All I can do is to voice my own witness and
acknowledge some people who have been part of my "chorus of
stones" or my "cloud of witnesses."

Since I never would have gone to Peru without the initiative of my husband, Frederick Herzog, and since I cannot always separate my work from his, I have to talk of many of these people as influences on us both. Rosanna Panizo, director of the Comunidad Bíblico Teológica in Lima, has impressed me with her theological perspicuity, her endurance under most difficult circumstances, and her critical reading of my manuscript. The generosity and kindness with which Aída Balta, Carmen Luz Gorriti, and Mariella Balbi shared with me their insights and materials will be evident from the chapters describing their work. Carolina Carlessi has proved to be a constant and invaluable source of information. The Andrade family repeatedly provided a home at times when Lima was in turmoil. Teresa Araneta offered hospitality when we needed it badly. Fernando and Teresa Santillana were among the first to welcome us to Peru and to give us a sense of the celebration of life amid the country's crises. Fathers Thomas Burns and William McCarthy early on introduced us to the migrant settlements in the stony desert around Lima. The wisdom and courage of these two will not be forgotten.

Gustavo Gutiérrez in friendship shared his vast knowledge and experience whenever we visited with him, and researchers at his Instituto Bartolomé de las Casas, Catalina Romero, Carmen Lora, Irene Pujazón, and Fryné Santisteban, provided me with important thoughts and materials. Eric Torres Montes patiently offered his time as well as his legal, political, and spiritual understanding. Liselotte Schrader and her family will be acknowledged in my last chapter. The people of the Flora Tristán and Manuela Ramos women's centers gave me a wealth of materials and information, and I owe a special debt to Helen Orvig of the excellent documentation center CENDOC-Mujer. Ana María Portugal was the first to lead me to Peruvian women's literature. Gertrudis Braunsberger de Solari shared her unusual knowledge of Ayacucho and its artists. I have never met Giovanna Pollarolo, but her writings and phone conversations significantly contributed to my work. There are also the wonderful people in the Methodist congregations of Lima and Cusco whom we will always remember for the tenacity with which they held on to life and for a faith that keeps "singing in the midst of chaos."

Luis and Catty Reinoso have proved to be true friends in Peru as well as in the U.S., and their knowledge of all things Peruvian

has continuously seeped into these pages. Also spanning North and South America were Leif and Rivkah Vaage, who kindly read the first draft of this book and helped me with their excellent comments as well as their commitment to Peru.

In terms of theological critique, I owe special thanks to Susan Thistlethwaite, who took the time to read the manuscript and to make valuable suggestions for its final form. Another person who worked through these pages with patience and sharp wit is Kitty Dixon, a wise and wonderful friend.

Close by in Durham, Robin Kirk has been immensely helpful through her journalistic work on Peruvian women and through conversations and lectures. The Duke/UNC Center for Latin American Studies, through its coordinators Natalie Hartman and Sharon Mujica, has been an important resource, especially the superb working group discussing "Power and Gender in Latin America." I continue to cherish my colleagues in the Independent Scholars' Association of the North Carolina Triangle and the National Coalition of Independent Scholars.

There are also people in Germany without whom parts of this book could not have been written, especially Ingrid Bettin and Gaby Franger. Elisabeth Moltmann-Wendel gave me courage to publish a book on Peruvian women when she asked me to write a German article for the journal *Evangelische Theologie* out of which grew Part Two of this book. I am grateful for the hard-nosed theological give-and-take with her that has always been creative. Gisela Ecker taught me much about feminist theory. My sister, Ruth Karwehl, and my brother and sister-in-law, Hans-Martin and Brigitte Karwehl, kept me up to date about German scholarship on Peru.

I am happy to have found Harold Rast to be a gracious and efficient publisher and John Eagleson an excellent copy editor.

There are ties of heart and mind that are difficult to put into words. Our daughter, Dagmar Herzog, and her husband, Michael Staub, have for years sharpened my understanding concerning issues of gender, race, and ethnicity. Finally, my work has been continuously sustained by the theological acuity and human caring of Frederick Herzog.

*Durham, North Carolina*
*September 1993*

# BASIC FACTS ON PERU

**Area:** 495,733 square miles, larger than the states of California, Oregon, Washington, and Nevada combined.

**Population:** 21.8 million in 1989. Population growth rate was 2.5 percent in 1989. 69 percent are urban, 31 percent rural. 60 percent of the population is fifteen years old or under.

**Ethnic Groups:** 45 percent are Indian: Quechua and Aymara Indians in the highlands (and, after the massive migration of the last decades, in the coastal cities) and numerous native groups in the jungle. 37 percent are mestizo, meaning of mixed Indian and European descent. 12 percent are of European descent and are called *criollo*. 5 percent are of African descent. The remaining 1 percent include Chinese, Japanese, and other immigrant groups.

**Geography:** The pacific coast is home to 52 percent of the country's population. The capital, Lima, with about 8 million inhabitants, is bordered by the ocean on one side and by a ring of migrant settlements on all other sides. The coastal area is mostly arid desert, with fertile areas around the rivers coming down from the mountains. The Andes mountains are home to 37 percent of the population and the eastern jungle (comprising 62 percent of the land area) to 11 percent.

**Language:** Spanish and Quechua are the official languages, and Aymara is the second most important indigenous language, but all official transactions are in Spanish, resulting in difficulties for monolingual Quechua and Aymara speakers and for the tribal Indians in the jungle who belong to more than twenty linguistic groups with over fifty-nine distinct dialects.

---

Where not otherwise noted, the information is excerpted from: Jo-Marie Burt and Aldo Panfichi, *Peru: Caught in the Crossfire* (Jefferson City, Mo.: Peru Peace Network, 1992), 3f.

**Religion:** According to a census of 1981, 89.1 percent were Roman Catholic and 4.7 percent of "other religion," including groups like Lutherans, Methodists, Presbyterians, Baptists, Anglicans, Jehovah's Witnesses, Adventists, and various Pentecostal groups. During the last decade, the more "evangelical" Protestant churches have grown rapidly.[1]

**Economy:** The top 5 percent income earners receive 24.28 percent of the national income; the lowest 60 percent receive almost the same proportion, 24.93 percent. Only 15 percent of the population live above the poverty line, whereas in the U.S. only 15 percent live below the poverty line. According to the World Bank, Peru's external debt is 22 billion dollars. By 1989 cumulative inflation had reached 2,772 percent. Since President Alberto Fujimori's "shock" program, inflation has been curbed, but government programs have been cut to the extent that now an estimated 13 million people, over half the population, live in abject poverty.[2]

**Employment:** By mid-1991, only 5 percent of the economically active population was fully employed. Unemployment in 1992 was 8.6 percent, and 86.4 percent were underemployed.

**Social Conditions:** The infant mortality rate in 1990 was 81 deaths per 1,000 live births, the third highest infant mortality rate in the hemisphere after Bolivia and Haiti. Adult illiteracy stood at 15 percent nationally in 1985, but was 22 percent for women. Malnutrition affects 65 percent of all children in Peru. A recent UNICEF report describes one million Peruvian children under five years old as chronically malnourished.[3]

**Violence:** An estimated 27,000 people have been killed by guerillas, the military, and paramilitary groups since the Shining Path (Sendero Luminoso) began its armed offensive in 1980. The material destruction caused by this war amounts to billions of dollars.[4]

---

1. Statistics are from Jeffrey Klaiber, S.J., *La iglesia en el Perú* (Lima: Pontificia Universidad Católica del Perú, 1988), 478.
2. See information sheet from Center of Concern, 3700 13th Street N.E., Washington, DC 20017, Summer 1993.
3. Ibid.
4. See Deborah Poole and Gerardo Rénique, *Peru: Time of Fear* (London: Latin American Bureau, 1992), viii, xi.

# FINDING
## T·H·E·I·R
## V·O·I·C·E

# Introduction

# WITNESSING WAR
# AS A *GRINGA* IN PERU

It was a normal evening in Lima, July 16, 1992. Around eight o'clock in Miraflores, the most prestigious district in this city of about eight million people, the last street vendors began to pack up their carts and leave the narrow Tarata Street. Foreigners still enjoyed their cups of coffee in cafés while local citizens rushed to the large department stores to make their last purchases before the government-ordered curfew for all motor vehicles would take effect at ten o'clock. A watchman at one of the banks in the area examined the license plate of an incorrectly parked car. Seconds later the man was engulfed by an explosion, and stores, hotels, offices, and apartments were blown to pieces. When morning dawned onto the inferno of the night, twenty-two people had died, and hundreds were wounded, mutilated, or homeless. A car bomb of six-hundred-kilo dynamite seemed to have signified the beginning of the "total war" that the guerilla movement, Sendero Luminoso (the "Shining Path"), had proclaimed earlier.[1]

Two months later, on September 12, the citizens of Lima were startled by another event. As they watched the evening news, expecting the usual reports on the day's bloody events in some part of the country or city, President Alberto Fujimori announced that Abimael Guzmán, the scholarly leader of Sendero Luminoso, had been captured in a suburban home together with a group of his followers. Most Peruvians felt immensely relieved, and Fujimori in the following weeks bragged about the achievement of his government, displayed Guzmán in a cage like an animal in a zoo, and stated that only by his suspending the corrupt Congress more than three months earlier was this success made possible. His increasingly authoritarian actions and his nonchalant rejec-

tion of reports on his military's abysmal human rights record were for a while ignored. He was a winner.

I witnessed these events during my fifth and sixth visits to Peru, which were connected by a six-week stay in neighboring Bolivia, where the fear of an influx of "Senderistas" was as strong as the distaste for U.S. intervention in the Andean "drug war." I had gone to Peru for the first time in 1987, but it was during a five-month stay in 1989 that I started my research into Peruvian women's response to the violence that has engulfed their country since 1980. For several years I had been exploring the work of women authors of the United States who in the nineteenth and twentieth centuries wrote novels or poetry to describe situations of war. Since I had the opportunity to be in Peru repeatedly, I wanted to expand my research to include women's responses to guerilla warfare in a Third World country.[2]

What began as a sideline, however, turned into a major preoccupation. What I had witnessed in Peru no longer fit into the framework of a manuscript on U.S. women writers; so the latter was put aside half-finished in order that I could give undivided attention to my new field of inquiry. Academic curiosity turned into the strong desire to study the innumerable aspects of Peruvian women's articulation of war experiences in order to clarify my own witness about war and peace and women's role in it. This was not a war like any other; it was war as a way of life, the fear of terror at your office or grocery store or the next street corner — and all this without any battlefront or governmental declaration of war. I asked myself whether this might be the war of the future since it is already prefigured in some inner-city districts of the First World, is acted out in the bloody turmoil of the former Yugoslavia, and finds countless parallels in the southern part of the globe. The bombing of the World Trade Center has caused U.S. citizens to fear more "terrorism at home."

During the past five years the sights, sounds, and smells of Peru have stayed with me whenever I have reentered the United States or Europe. There lingers, for example, the delicious smell of fresh bread in the little store that was bombed but courageously reopened two days later without doors. There is the abysmal smell of burned garbage along the road in one of the districts that cannot afford the price of city garbage pickup. As I settled into my seat on the flight back from Lima to Miami in

October 1992, I skimmed through the pages of *Harper's Bazaar* thoughtfully provided in the seat pocket in front of me. In an article on the perfume industry I read the following:

> To launch a [new] scent requires a minimum of $7 million to $10 million in advertising and promotion expenses; spending $40 million–$50 million is not unheard of, particularly among American fragrance houses. Some 56 new scents were launched in 1992, a record for fragrance introductions.[3]

I ask myself how many minimum-standard houses could be built or how many settlements could be rid of the stench of garbage in Peru or any other hurting country if one of the "fragrance houses" would give up one "new scent." I wonder how much deeper the gap between First World and Third World can become in the future. Do we need more eyewitnesses who go back and forth between these two worlds and witness to a truth that knows no borders? What can testimonies accomplish anyway?

An article by Paul Ricoeur, "The Hermeneutics of Testimony," clarifies the various aspects of the term "testimony" and can also serve to define my larger use of the term "witness."[4] "Testimony" refers to a primary affirmation of events as well as to their interpretation. The eyewitness in testifying transfers things seen to things said so that others can *hear*. Since testimony contains not only an element of perceiving, but also of judging, it is used in trials and is sometimes ritualized by "swearing in" a witness and by formally bringing proofs for or against an accused. This aspect of testimony is certainly familiar to Peruvians because countless citizens have been put on trials as suspected or real subversives, and countless others have experienced hastily assembled "people's courts" that "proved" the guilt of a victim before an execution. Testimony always anticipates the reactions of an audience and therefore implies passions of persuasion or of praise and blame; it is not neutral and "objective," and it is often difficult to distinguish the true from the false witness. It is especially compelling when the test of a witness's conviction becomes the price of life: The "martyr" is literally in the Greek root of the word a witness. As I will show in the example of María Elena Moyano, there are many such martyrs in Peru. Their testimony has moved from speech to action, and their whole life has be-

come a witness. They testified not to an isolated event, but "about the radical, global meaning of human experience."[5] Their witness therefore has a prophetic aspect even in a secular context. It often also has a confessional character.

In this book, then, I will use the terms "testimony" and "witness" interchangeably, in the sense of immediate perception and critical interpretation as well as referring to manifestations in the form of actions and whole lives. "Witness" as a noun has fifteen meanings, according to the *Oxford English Dictionary*. They range from the obsolete connotation of "knowledge, understanding, wisdom" or the objective statement of "one who is...able to testify from personal observation" to "one who testifies for Christ, especially by death."[6] The entry also makes the point that the passage in meaning from abstract to concrete is the same in "witness" as in the Latin *testimonium*, leading to English "testimony." The point of my use of the terms "testimony" and "witness" is exactly this: They range from the more abstract factual evidence available through women's firsthand observation to praxis issues of women's risking their lives in witnessing against violence and finally to seeing some women's whole lives as a witness to peace and justice. All of these meanings can pertain to the secular as well as to the religious aspects of the terms, and often the two are inseparable.

I am not an oral historian, and I did not work with a tape recorder specifically to elicit stories to be transcribed as *testimonios*, although I will deal with this literary genre in the last part of the book. I have simply woven together my readings and listenings, research and private talks, interviews and observations in order to shape my own witness out of other witnesses. I have not limited myself to women of any one social class or ethnic group. The light-skinned *criollo* elite[7] has a tremendous influence in the country, and those that have not left Peru — as did thousands of others — feel a responsibility to help solve its problems. As a white middle-class foreigner I have no reason to romanticize the suffering of poor indigenous women and to ignore the attempts of "privileged" Peruvians to use their education as best they can toward ending the civil war. Especially in view of the fact that the country's most violent group, Sendero Luminoso, is being led by highly educated people, it would be a mistake to think that violence can be overcome without other "brainpower." As Gustavo

Gutiérrez has rightly emphasized, God is on the side of the poor not because the poor are good, but because God is good. While it is our task to listen to the voices of the poor, it is helpful to view a wide spectrum of a society since nobody owns the whole "turf" or the whole truth.

Why concentrate on the witness *of women?* I have never subscribed to the notion that women are naturally more peaceful than men. Anybody still tempted to think that way should take into account, for example, the women of Sendero Luminoso who efficiently coordinate assassination squads and give a victim the final *coup de grâce* because he or she has been a tireless community organizer opposing the violence of Sendero. The voices, initiatives, and movements of women described here have countless parallels involving Peruvian men. I chose to write about women, however, because women in Latin America, even more than in North America or Europe, have been ignored or silenced. Under the most adverse circumstances of poverty, abandonment, legal inequality, the pressure to bear too many children, rape, death and disappearance of their men, and lack of education, Peruvian women have risen to the challenge of proving their strength and creativity. Witnessing firsthand a "low-intensity" war that makes daily life a most intense strategy for survival, they have found their voice, naming and shaming injustice and terror whether perpetrated by corrupt government officials or ruthless guerillas. Not all of these voices are voices of peace; some are proclaiming war as the only way to peace. While I disagree with them, I have no right to suppress their voices. As a *gringa*, a woman from *el Norte*, I have no business telling Peruvian women how to solve their problems nonviolently. I can only relay their different witnesses in order to intensify the bonds between the continents and to encourage others to shape their own witness. I am dealing, therefore, with women who are peaceful and articulate as well as with those who are shouting and shooting. Some are still unable to become visible and audible and keep suffering in silence. The fight for survival, peace, and justice, however, has steeled the hearts and minds of masses of Peruvian women and has loosened their tongues.

There is another reason to concentrate on women: In their bodies they are affected by war in ways different from men. In a recent report from Americas Watch, Robin Kirk writes:

An examination of what has been written about human rights abuses in Peru reveals a glaring omission. Abuses against women figure only briefly in most reports, including those published by Americas Watch. In particular, rape by the security forces has been at best overlooked, at worst virtually ignored.... In a similar manner, although Shining Path attacks on women have drawn the attention of the national and international press, the underlying motivation for such violence — to suffocate dissent and force collaboration — remains little examined, or condemned.[8]

Peruvian women who give testimony about being raped need a special kind of courage since frequently they become social outcasts in their communities or are rejected by their husbands. It is only by making these testimonies known to the world at large that the legal and social climate can change. There are, of course, numerous other examples of women being affected by war in special ways, for example, as heads of households responsible for feeding and nurturing a family while being unemployed refugees.

Peru is a quintessential country of the Third World, which is very much neglected in the media of what is considered the First World. Only when Peru is listed for several years as the country with the most "disappeared" persons, or when a Peruvian president dissolves the Peruvian Congress and even risks his chances of getting U.S. money related to the so-called drug war does the U.S. press take a more than casual interest in such a country. The daily war of women's lives, however, finds even less media interest, and that is another reason for listening to firsthand witnesses.

How does the articulation of war and peace relate to theology or even to the pale notion of "religion" in a secular world? In some languages of North American Indian tribes, the word for "peace" is identical with that for "law," and the same root is also used for the word "Lord" in their Bible translations.[9] Besides, none of the American Indian languages has a word equivalent to our "religion." "Rather, religion is pervasively present and is in complex interrelationships with all aspects of the people's life-ways."[10] Unless we learn that "religion" is all about "law" (justice), the "Lord" (divine rule), and peace (what the Hebrews

call *shalom*), and that it is intimately connected with all our life-ways, we are stuck with a very diminished view of religion. Unless theology is working for "peace, justice, and the integrity of creation" not only at world conferences, but at the grassroots level of local communities and churches and at the center of its teaching, it will remain sterile. Unless we postmodern people in the industrialized countries acknowledge the mystery at the center of all life — and thereby the origin of all religion — our ethics and our peace efforts will remain moralistic and oppressive. It is from the daily witness of women that theology can draw life-blood after it has centered too long on the theories of men, and it is the issue of *shalom* that has to be one of the primary theological concerns today.

When I talk about theology I am referring mainly to the Christian tradition as it grew out of its Hebrew roots and Greek and Roman influences. My hope is, however, that this tradition would become more open to a dialogue — or multilogue — with other faiths, because this is the challenge I found myself confronted with when I delved into the history of colonialism, of Inca and pre-Inca beliefs, and of the "war" situations caused by a Christendom that considered itself the owner of truth. Women's special history of resistance against this domination can be an inspiration for women today.[11] Opening Christian theology to a creative encounter with traditions it has suppressed or religions it considers "pagan" does not dilute its substance, but radically expresses the basic message of Jesus of Nazareth who did not preach himself, but the "reign of God" with its many mansions and its narrow entrance door of humility or self-limitation.[12] Global survival is not only connected with global political peace; it also depends on peace between religious faiths. As Abraham Joshua Heschel said, "We must choose between interfaith and inter-nihilism."[13]

How does the portrayal of war, peace, and survival relate to what we traditionally call literature? Over the last decades we have learned, especially from the ethnic groups represented within American literature, that tribes and traditions survive through stories and that the health of a human community is maintained by articulating experiences and visions and passing them on from one generation to the next. If only men determine the writing of history and literature — as has been the case for

centuries in many cultures — half of life is left out of the picture or appears seriously lopsided.

I am using the term "literature" in its widest sense, combining written and oral testimonies about a war that has cost about twenty-seven thousand lives in almost thirteen years.[14] I harbor no illusion that I can present an objective view of Peruvian women's confrontation with violence. As Claudia Salazar has stated about women researchers who work with "native" women: "Cultural representation cannot offer more than a constructed understanding of the constructed native's constructed point of view."[15]

There is the danger of delving into the texts of "native" writers and speakers because they represent an exotic "other" that we feel lacking in ourselves. There is also the dubious matter of using the disadvantaged people of a poor country to enrich our elitist academic research, which does not help the "natives" at all. Daphne Patai and others have eloquently stated the problem.[16] There is, however, also the opposite danger of remaining satisfied with our own turf and our traditional academic conventions and leaving the southern part of the globe to its own fate. This procedure ignores the sad history of Latin American countries' colonial dependence, the resulting brave fights for their independence, as well as the present fact of global interdependence. Each one of these stages in the history of a country like Peru shows the intimate connection between the First World and the Third World. Bankers and entrepreneurs, zoologists and agriculturalists, travel agents and televangelists have long been aware that America includes another (southern) continent representing a wide-open field of communication. American literature, however, has hardly even admitted that it bears a wrong name and should only be called "literature of the United States." Recently there are some indications that a truly intercontinental literary criticism is emerging.[17] There is also an increasing openness to a wider understanding of the term "literature":

> If we include oral accounts as literature (as in epic poetry and myths), if we admit that literature has not only the clear beginning, middle, and end prescribed by traditional stories, but also the patterns, fragmentations, and confusions of modernist writings — then these stories are also

literature. If we reject (as I think we must) the notion that literature is verbal art created purely for its own sake and ask instead how texts signify, then again it is clear that these texts too are literature. But most of all we need to challenge the assumption that literary value automatically resides in "high" cultural texts and that other examples of verbal creativity are not contenders for the much-desired label of "literature."[18]

Besides defining "witness," "theology," and "literature," we have to be clear about the terms "violence" and "war." What constitutes "violence"? In the context of these pages, it indicates social, public violence that might consist of politically motivated killings of groups or individuals, terrorist tactics by individuals or governments, disappearances and torture, armed raids by guerillas or government troops, or all-out warfare. The point is, however, that this type of violence is intricately bound up with violence in the home (rape, spouse beating, child abuse) as well as with the violence of hunger or lack of housing, education, and human rights that is at least partly caused by corrupt governments, misguided foreign policies, and economic strategies.[19]

While we have to keep all these aspects of violence in mind, my focus will be on women's portrayals of guerilla warfare and the violent counterinsurgency tactics of government troops and paramilitary groups. For countless women talking or writing about these frightening phenomena, witnessing the terror and its causes as well as the power of overcoming them means checking the terror, taming or shaming it, and thereby struggling free of its iron grip. That can happen in seemingly innocuous ways, like stitching a protest message on an *arpillera,* a colorful fabric picture made of remnants, and holding it up during a public demonstration. It can also be a widely influential and provocative action, as when a journalist exposes a secret killing in a major newspaper. Even when guerilla women choose to participate in armed violence, they usually consider themselves as moving beyond the violence of the status quo, the desperation of hungry masses without a future. Women's own "texts of terror," to use a phrase of Phyllis Trible's, can be cathartic because most stories in the history of theology and literature that deal with women have been

told by men, and often women did not even appear on the horizon of men's writings. Systems created by individual theologians in the history of the church have sometimes created oppressive structures. It is in the nature of everyday stories that they create community, and unless structures of belief are grounded in lived stories and live witnesses, they are not true to life.

How do women's words on violence and war relate to a divine Word, a challenge or mandate sensed in a conscience, taught by the elders, preached by a church, or read in Holy Scripture? Women traditionally have been tied to local and familial traditions and rites much more than men since for aeons they have been kept out of the public sphere and have been spatially restricted to the home, the children's playground, the convent, or the brothel.[20] They have therefore sometimes stubbornly held on to the faith of their ancestors or to some primal, preinstitutional cult. Good examples are some of the Andean women in colonial times and the so-called witches who were burned in Europe and America.[21] Women have been in most cultures the primary religious teachers for the next generation, and they often have had less difficulty than men in relating to their "pagan" roots, to "otherness" of belief. For centuries they were not permitted into schools and universities to learn about great systems of belief and dogmatic principles. When in the seventeenth century Angela de Carranza went from Córdoba, Spain, to Lima, Peru, she began to preach in houses and market places against the colonial authorities and about her direct communication with God and the Virgin Mary. Many people in the city called her "Angela de Dios," considered her a saint, and followed her counsels. From 1673 to 1688 she wrote a diary about her spiritual experiences, informed by a very personal interpretation of the biblical message. Her extensive writings were publicly burned, and she was sentenced to live in a convent. "The inquisitional directive was clear: paper, ink, and pen were supposed to be taken from her so that she would not communicate in writing with anybody."[22]

It is obvious that in this tradition women's heterodox ideas were likely to be prevailing under cover, and that was dangerous since women had the greatest influence on the religious education of the children. It has been estimated that today in Latin America the mother is the one who hands on the image of God to the next generation among 95 percent of the population.[23] In ad-

dition, women are much more numerous than men among school teachers. What does that tell us about the possibilities of women teaching about war and peace? Indeed, if they pass on the image of a warring, revengeful, zealous, and jealous God, they might enforce a popular warrior ideal. If they speak of a God whose mercy is justice for all, they might contribute to peace. Whatever their stories are like, they are influencing society in countless ways.

Literature, as traditionally understood in the Western world, has often had an oppressive character. Black slaves and American Indian peasants have long been kept from literacy, because sharing literacy would have implied power-sharing. To be literate was the privilege of a dominating elite. The emergence of the novel, for example, was closely related to the self-definition of the bourgeois middle class in the nineteenth century.[24] In Latin America, even the Spanish language as such was a symbol of privileges, a tool of masters, usually used to give commands or to communicate with one's equals. For centuries, native South Americans made little use of it, the Indians because they did not know the language and the mestizos because they were taught submission and timidity by the Spaniards. *Larga costumbre de callar . . . entorpece la lengua* — the long habit of being quiet thickens the tongue.[25] All of this pertains to women even more than to men, and religious structures and beliefs especially have kept women silent.

The wars of our time are increasingly fueled by religious motives. At the 1993 Parliament of Religions in Chicago, chairman David Ramage stated that "more than two-thirds of the world's conflicts tend to have religion at their core."[26] One can debate whether the Maoist Shining Path movement in Peru today shows aspects of a fundamentalist religious movement.[27] Even if that were not so, however, it is important to scrutinize, including the case of Peru, the relationship of women and war from a theological point of view. Many other aspects of women's involvement in war and their writings on war have been analyzed by critics: Military, sexual, historical, literary, philosophical, political, and ethnic views have been discussed.[28] Religion, however, has hardly been taken into consideration, especially in terms of a thorough theological study.[29]

As to Peru, the first research from a religious point of view

on women involved in violence and war came from members of some religious orders and institutions that work at the grassroots level. Examples are the booklet *Women in Peru: Voices from a Decade*[30] and various articles in the journals *Páginas* and *Signos*, published by the Instituto Bartolomé de las Casas in Lima. What ties such observations of women's role and women's voices in a violent situation to women's literature, and what impact can both have on the formation of a new theology?

Women's narratives, whether in literary or oral form, are condensed memories, tied to concrete places and experiences that create possibilities of survival and shape ethical norms for another generation. They often witness to a power that from the inside of creation lets life arise out of chaos. When we talk of "women's narrative as theological voice,"[31] it does not necessarily mean that women's experience is the only source of women's theology. Experience is by its nature always limited. When we see it, however, in constant critical and imaginative dialogue with the Scriptures, with tradition, and with reason, then it becomes an irreplaceable element in the formation of faith structures.[32] In this way the simple retelling and remembering of Peruvian women's stories that represent the first part of this book can help to establish a theological challenge in the second part, where the Peruvian women's movement is seen as the background of the stories. Every witness grows out of specific traditions that are rejected or affirmed, restricting or empowering. The two main influences on Peruvian women's stories today are the history of colonialism and the modern women's movement. They have had their impact on women from all walks of life, from Quechua migrants and mestizo teachers to *criollo* academics. A large part of the colonial heritage is the Roman Catholic faith, and it has shaped the witness of Peruvian women in myriad ways, even where they explicitly denounce it. The women's movement in contrast is largely secular and sometimes vigorously antiecclesial, but it merges at important points with the concerns of the Roman Catholic and other churches. Any testimony by Peruvian women today is therefore influenced by an intensely religious tradition, including native spirituality, or by a reaction against it.

The third part of the book will therefore merge the literary and theological concerns in more theoretical terms, asking, for example: How do Peruvian women's war stories and testimonies

relate to Peru's literary and religious tradition — and to our tradition? Can we take any ethical stand on issues of violence and war when we consider narratives, wars, and religion from a postmodern point of view? Can we move from witnessing (observing) war in Peru to shaping a witness for peace in the First World?

I believe that Peruvian women's voices on the war situation in their country can indeed engender new stories and new patterns of faith and action and contribute to a theology of peace that is realistic and radical, not romantic and utopian. It is in the end the struggle for a just peace that lies at the heart of theology.

I am not concerned here with a dogmatic formulation of peace. "We have this treasure in earthen vessels" (2 Cor. 4:7), and some of these earthen vessels are women's stories, whether oral or literary, didactic or artistic, strident or gentle. The naming and shaming of violence can be embodied in countless ways in life as well as in words. Just as we have God's word only in the often contradictory stories of the Bible, so we have the struggle for peace today only in fragile lives and often ambiguous stories. Wherever these stories, however, are not only language events, but partake of the concrete embodiment that Christians have found in the life witness of Jesus Christ and Jews have found in the history of the people of Israel, they shape and create a new reality and sustain life beyond violence. "The witness testifies about something or someone which goes beyond him," says Ricoeur, especially in view of biblical witnesses.[33] We can say the same thing, for example, of human rights organizations and their witnesses, because even the most secular among them practically imply that there is some criterion, some ultimate court of appeal, that is the origin and justification of any human witness against cruelty and injustice. The same can be said in regard to the witness of women about war: It observes, interprets, and judges on grounds of an ultimate order even where it is unaware of it. Beyond narrating, it confesses; beyond interpreting, it pleads and warns; beyond judging, it affirms a lasting truth.

The same dynamic that pertains to Christians and Jews also pertains to people of other faiths and to so-called pagans: As life is molded into stories, stories in turn are shaping lives. There are certainly also stories of death and destruction that engender more death, but as we, for example, in the Christian tradition draw to-

gether the *sophia* of Scripture, tradition, experience, and reason, we can sense whether a witness is life-born and life-giving or destructive and deadly. As Jesus took up the wisdom theology of his Hebrew tradition, he knew that "wisdom is justified by her deeds" (Matt. 11:19), namely, by deeds of justice and peace.[34]

*Part One* ——————————————

# Peruvian Women's Testimonies about War

# Chapter 1

# EARLY WITNESSES

## Lost Traces of Women's Words

The increasing literature on women's involvement in war and women's own writings on their war experiences has mostly derived from European and North American sources — an irony in view of the evidence that most wars today are fought in the Third World and most of their victims are women and children from the southern part of the globe. Since illiteracy and poverty are widespread among these women, they are often a silent majority, and reading audiences in the industrialized countries have little knowledge of the wars these women have to confront daily. In the United States, we instinctively bring North American concepts to our study of Latin American texts. The presuppositions for women's writings are, of course, very different on both continents. As Bell Gale Chevigny rightly states,

> In Third World countries where the dominant facts of daily life include war, denial of human rights, illiteracy, massive unemployment, runaway inflation, and exploitation, the issues of gender that have preoccupied U.S. feminists have seemed secondary.
> ...We do not yet have a theory with which to account in hemispheric comparative studies for the ideological impact of differences in class and religion. Class in Latin America is perceived as a more crucial variable than it is in the United States and as a more decisive factor than gender in analyzing the experiences of women; in the United States there is a complementary distortion as the ideology of egalitarian individualism blinds us to the reality of class. The influence of Catholic beliefs in Spanish America confirms and compli-

cates the ideology of gender in ways unparalleled by other religions in the United States.[1]

We do well to remember in 1993 that wars in Latin America are partly rooted in a five-hundred-year history of European encroachment that killed millions of Indians and proved especially damaging to the status and self-estimation of women.[2] Native Americans before Columbus certainly were not simply the peaceful and democratic "Indios" that pseudo-historians like to portray. Aztecs and Incas, for example, led vast empires that would not have been established without strict hierarchical control and violent warfare. However, just as in North American tribes, the mass killings of modern-day wars were unknown among South American Indians. Women played important roles in tribal politics and performed ritual functions in war. Sometimes they would participate in armed warfare. Wars were not entered without considering cosmic implications: Sun, moon, and stars, the harvest of maize, the entrails of llamas — every aspect of the universe could be considered to have a possible bearing on warfare, for good or for ill.[3] How did this different world of tribal warfare influence women's understanding of war in the past and in the present?

I will concentrate here on Peru as one Latin American example of the way women articulate their war experiences and learn to have a voice in matters of war and peace — in a literary as well as political sense — because Peru appears increasingly as the powder keg of South America and women play a special part in its insurgency movements. In all countries, women are not only victims of war but active participants, whether for or against an established government. They may be members of a grassroots peace movement or guerilla fighters; they may be fiction writers, dramatists, journalists, pilots, spies, or refugee housewives — all of them today are increasingly eager to be articulate witnesses of war because they play a part in it that has long been overlooked.

For Peru we have only archeological and anthropological evidence of women's roles in precolonial times, since the highly complex Inca empire, stretching from present-day Chile to Ecuador, was sophisticated without being literate — something the European colonizers were unable to grasp in their equation of culture and literacy. There are renditions of oral Andean pre-

Hispanic literature that were written down from colonial times on,[4] but we do not know to what extent women's voices are hidden in these texts. Moreover, during colonial times people of Spanish birth or descent would relate Peruvian facts in European categories, even where they simply rendered Andean narratives in Spanish translation.[5] The rich texts and pictures of the Indian chronicler Felipe Guamán Poma de Ayala give us much insight into the treatment of Andean women under colonial domination, but again, we do not have these women's words; we have only the silent witness of these pictures.[6]

## Micaela Bastidas

One of the most outstanding women in Peruvian history, the eighteenth-century mestiza Micaela Bastidas, is known to us through her own words, although some of them are available only in the cold-blooded, long-winded minutes of the court proceedings that led to her unspeakably cruel death. Micaela was the wife of Tupac Amaru II, a descendant of Inca kings who led the last massive revolt against Spanish colonial oppression in Peru and in the neighboring countries in 1780. As a leader in the revolution, she is thought by some historians to have been even more gifted in this role than her husband. Both considered themselves loyal subjects of the Spanish crown and devout Christians, but they were determined to fight by any means necessary against the utter corruption of the regional Spanish authorities and the deadly injustices suffered by the common people. Micaela was illiterate, but dictated orders and letters, issued passports, supplies, and weapons, directed an intensive espionage operation, and promoted the uprising through flyers and messengers. "Micaela fulfilled political, military, and administrative tasks and brought to them the determination and passion that the struggle needed."[7]

Characteristic of her leadership is a letter from her to two of the revolutionary leaders:

> I also have to inform Your Honors that my husband will soon pass through the city of Cusco with the respective garrison; therefore it is necessary that the people of Your

Honors be alerted, so that they come down as soon as this letter arrives; and if Your Honors should not be agreeable to this, I promise to do away with you.[8]

One of the Spanish chroniclers writes about her:

The wife of Tupac Amaru appeared with a reinforcement of five thousand armed men because she had been notified that this town would not obey them, and those that know both are certain that this *cacica* [wife of a chief] is more intrepid and bloody than her husband.[9]

When Tupac Amaru was in grave danger, she did not hesitate to mount her horse exclaiming that she was ready to die wherever her husband would die. After the uprising had spread to the extent that the rebels came close to taking Cusco, Micaela dictated a letter to be sent to her husband, urging him to march into Cusco immediately since the revolutionary troops were lacking supplies and the Spaniards could close in on them any time. "No longer do I have the patience to put up with this situation," she writes in her loving yet angry and desperate letter. "If you want to ruin us all, you can lie down and sleep."[10] The letter also contains the wish, "May God keep you for many years."

This wish was not fulfilled. A few months later Micaela and other indigenous women and men, like Tupac Amaru himself, were put on trial. The incredibly bureaucratic and extensive records of the trial stand in ironic contrast to the most cruel way the group was soon to be publicly tortured and killed. Micaela seems to have been very composed during her interrogations. When she was asked why she as a Christian did not abandon her husband and his cause after he had been excommunicated, she answered that her husband told her not to worry about excommunication; since God knew his intentions, they would have nothing to fear.[11]

The reports of the executions are hard to read, because they minutely detail the cutting out of tongues, the strangling with garottes, the torturing and death of a ten-year-old son of Tupac Amaru and Micaela in front of his parents and of the parents in front of another son, the cutting and sending of body parts into various provinces — nothing is left out in the reports.[12]

Micaela and her husband had acted violently — the uprising had started with the killing of an especially cruel *corregidor*

(royal representative) — but their violence appears very limited compared to the centuries of structural violence suffered by their people whose religion and culture were brutally suppressed and who slaved in mines and on haciendas for starvation wages — if they survived at all. Historians have noted the messianic aspect of the Tupac Amaru revolt, a merging of Andean beliefs and prophetic biblical thought.[13] The U.S. reader is easily reminded of the Nat Turner spirit. Micaela combined her faith with an uncompromising militancy. In one of her proclamations to the revolutionaries, she declared,

> I also admonish my Indians and Spaniards of this community that you should not do the least harm or damage to the cattle, the houses, or the fields of the neighbors wherever you pass through, that you should not hurt anything. And as to those whom you recognize as *criollos*, try to attract them and invite them to our movement without harming them at all, because we are not going to hurt the peasants; we only want to abolish the abuses of the taxes, duties, and burdens we are carrying and with which the local administrators and the Europeans threaten us.
>
> May we guard our faith with the highest respect and awe; we have to carry it through and possibly die for it. We have to hold in high regard the ministers of Jesus Christ, the priests, so that God will sustain us at our Christian end. As a token of being true and good Christians, you will bear the sign of the holy cross on your caps and hats.... And so that nobody might plead ignorance and this proclamation might reach all, I order that after the publication of this letter it be fastened at the door of my house in Tungansuca, and whoever will remove it will pay with his life.[14]

We meet here in the late eighteenth century a very contemporary problem: How do we define violence? Can some revolutions be considered just wars? Can the patriarchal mechanism of a state and its legal military establishment be considered terrorist and those branded terrorists be considered courageous resisters? Or should both be equally condemned?[15] Any judgment about the Peruvian guerilla movements of our time or of past centuries has far-reaching implications, and studying the witness of women

who were deeply involved in war can help us to shape our own witness.

## Antonia Moreno de Cáceres

Before I consider women's responses to these present-day movements as well as statements from their women members, I want to discuss the memoirs of one nineteenth-century Peruvian woman who actively participated in war. She is Antonia Moreno de Cáceres, author of *Recuerdos de la Campaña de la Breña*.[16] Her husband was Andrés A. Cáceres, a general in the army fighting the Chileans in the battle of Breña in 1882 and later a president of Peru. What Antonia describes is the long, drawn-out end of a lost war in which Peruvians angrily chafed under Chilean aggression and occupation. The war between Chile and Peru (1879–83) was a border conflict over some nitrate-rich areas that Chile finally managed to annex.

Antonia got involved in the conflict because she did not want to be away from her husband during the battle and because she was a fervent supporter of Peru's cause. Her war memoirs were first edited by one of her daughters and later by a great-granddaughter. They both contribute introductions, commenting on how Doña Antonia organized an arsenal of arms — under the pretense of needing them for a popular theater — and managed supplies of food, equipment, and medicines. "She was the great promoter of the Lima resistance committee, and the Chileans did not hesitate to intimidate and persecute her" (11). On two occasions they almost caught her, but she saved herself with the help of loyal Peruvians in adventurous ways, as her great-granddaughter relates (8).

Reading Antonia's own words, the reader can hardly doubt her courage and strength. Neither typhus nor altitude sickness nor the constant threat from the Chilean army could keep her from being with her husband at the front, first by herself and later with their three small daughters. With the loyal troops she would suffer

> the cold of the mountains, the frequent scarcity of food, the sadness of the desolate plains, the fatigue of forced marches

along canyons and deep gorges, the steps between rough rocks that bloodied the paws of the poor animals. (26)

At a time, she says, when the women of Lima practically lived behind closed doors or only went to mass early in the morning because of the presence of the Chilean occupation army, a committee of patriotic conspirators was formed that included "courageous society women and humble women servants." She describes a woman hiding two rifles under her large skirts and holding ammunition in her hands covered with vegetables.

As is typical of the more educated Peruvian society women of that time, she emphasizes the virtues of the indigenous people, and this is one of the important aspects of the book in spite of the prejudices involved in her comments:

> The Indian women of Peru worshipped [General] Cáceres; they called him "Taita" (father) and, as companions of the soldiers, they followed the campaign, lending important services as nurses or taking care of laundry and meals. Some of them were very intelligent and alert: They pretended not to be able to speak Spanish and spoke only Quechua when they went to a Chilean encampment, so that the enemies were careless, and the women listened to everything they said while they sold them fruit. (35)

What Cáceres describes here is the phenomenon of the *rabonas*, women who in the nineteenth-century wars followed their soldier men into the battlefield, receiving no pay, suffering many hardships, sometimes even participating in armed warfare.[17]

The dedication and ingenuity she praises in the Indian women are equalled by her own. When a "most illustrious" bishop, who was also a "fervent patriot," donates a small cannon to the Peruvian resistance, she hits upon the idea of hiding it in a casket, forming a "funeral procession," and thus slipping the cannon past the Chilean guards. She sees her task, however, as comprising much more than technical assistance to the troops. She wants to serve her country by acting as a self-styled diplomat between the provisional government of Francisco García Calderón and her husband, General Cáceres, to whom she carries the message that he should, in the opinion of loyal Peruvians, support García Calderón. At this time a large part of Peru was

still under the dictatorship of Nicolás Piérola, who lived in the sierra after he had lost two battles. Antonia did not succeed in getting the group of leaders around Cáceres to accept the provisional government because they feared that García might cede Peruvian territory. Only in early 1882 they acknowledged him. The Chileans, however, sent García, whom originally they had endorsed, into exile, and he became "one of Peru's martyrs" (16). At this point Cáceres is named vice-president, but he does not accept the honor. He would rather drive the Chileans out of Peru with his troops that are now more numerous because García's soldiers have joined those of Cáceres.

Antonia shows us much of her own character by the way she describes her husband. Her first visit to the front had been her idea, and she had left the children in the care of some nuns in Lima. When, however, she actually took the three daughters to come to the front, it was upon his urgent wish that she leave the turbulent, occupied Lima and be with him. His reasoning was plausible: If they took her prisoner, he wrote to Antonia, he would have to commit himself to his wife and children to keep them from being sacrificed, and "who would then keep up the national resistance? I need all my serenity to continue this fight" (22). In other words, she has to risk her life and that of her children so he can keep his serenity and his patriotic and military zeal. That is, however, only one way of interpreting his stance. We can also say that the family was certainly in great danger in occupied Lima, where rumors about impending martial law were circulating and where Antonia was known to be involved with the resistance.

Thus, she tells us, "I accepted the terrible sacrifice: a life full of suffering, risk, and anxiety during this odyssey of patriotism." It is her "duty" to go. She carries coded documents that will enable her husband to communicate with his friends in Lima, and she is accompanied by an officer of her husband dressed like a servant. A mulatto drives them, including the three little daughters, hiding them all behind green stacks of alfalfa in his coach. At different stops soldiers join them, all concealing their arms under ponchos. As the group starts to march on with mules, torrential rains make the territory around Breña more dangerous, "but the love of our country gave us the strength to suffer" (31). Silently, "like caravans in the African desert," they march along

the famous Inca ruins of Pachacamac, constantly wary of the bandits active in that area. Soon, however, the great moment arrives: Cáceres receives them, accompanied by his staff. This event "gave us the impression of a magnificent picture illuminated by a brilliant sun." It was "a heroic phalanx," with the officers' shining uniforms and the horses appearing vigorous. Antonia praises her husband: "Two noble passions dominated his noble spirit: the ardent love of his country and the sweetest tenderness of a father" (34).

In spite of this glorious moment and her vivid description of a beautiful landscape, suffering soon sets in again. The "heroic" troops are decimated by typhus and in battles with the enemy. Heavy storms aggravate the altitude sickness that hits many of them. They move on, however, "marching with vigor in search of glory." One of the Cáceres' little daughters learns to ride a rather wild horse, dons a diminutive uniform and rifle, and wants to follow her father. His officers laugh about this "Joan of Arc" (44). Again the emphasis of the incident is on the admiration of the child for the father, and this is mirrored in the "adoration" that the Indians show toward him: "For the Indians, Cáceres was the reincarnation of the Inca; that's why they prostrated themselves in front of him. But Cáceres did not like this tribute and told them: 'No person should kneel in front of another. Get up'" (47).

Cáceres's soldiers and officers are equally praised throughout the work, but it is to Antonia's credit that she also admires the toughness of many indigenous people and their loyalty to the Peruvian resistance:

> For the Indians distances don't exist, because they are indefatigable, they march for a long time, carrying only a few coca leaves and pulverized lime as their nourishment. Therefore they are excellent soldiers, very resistant in the marches. . . .
>
> The Indian, in spite of his lack of culture, realizes that all our sacrifices in the rough battle of Breña were suffered also for them, to liberate them from the yoke of the enemy who laid waste their fields, burned their poor huts, affronted their women, sowing pain and misery. (56f.)

Antonia's prejudices concerning the Indians' "lack of culture" as well as the Chileans' atrocities (as though Peruvians never

harmed an indigenous person) are obvious, but her insistence on their human dignity was not self-evident in her time. She seems intent on letting her readers know how much the Andean peasants are worthy of respect, even though she can understand these people only as a paradox: She praises their festivals and their desire to "keep the beautiful customs of the past" (65), but when they want to show her how they put the heads of dead Chileans on lances to exhibit them at the entrance of their pueblos, she is horrified and can only interpret their ferociousness as an "atavistic remnant" (77). She never doubts that they are "a noble race." One proof she gives is the story of the birth and death of her own baby boy, born at the front when she was very sick with anemia. An Indian woman offers her own child to her to be nursed so Antonia can get her milk extracted. The woman would rather endanger her own child than let *la mama grande*, as the general's wife was affectionately called, die in childbed. "What patriotic commitment!" comments Antonia, "what an ancient noble race!" (81).

Antonia was clearly able to pass on her high regard for the Indians to her children. When her daughter Hortensia watches a group of very poorly armed Indians march into battle against the Chileans, she throws herself down before a statue of the Virgin and cries. When her mother asks her why she is upset, she says she feels for these Indians who will be killed like dogs, not having any bullets to defend themselves (89).

The end of the story of Breña shows more and more the desperate situation of the Peruvian resistance, which lacked financial and human resources. The remaining troops have to fight nature as much as the Chileans. At one point Antonia is close to death from cold, hunger, and sickness. When the Cáceres family returns to Lima to get help for their cause, the troops fight on:

> The brave and noble sons of Peru marched to their sacrifice, to shed their blood, to suffer the ruin of their bodies, mutilation and death, for the sublime ideal: for honor. Nothing else besides honor! (108)

She calls the "barbarous acts of the Chileans" a *holocausto* (108), and suggests that in "this grandiose episode [of the battle of Breña]...the fate of the Peruvian soldier was elevated to a level appropriate to semigods" (109).

It is easy today to smile about this type of language. We have to remember, however, that a nineteenth-century woman writer was bound to write a "witness," not a casual report or an "objective" documentary, and that she would do so in the almost "formulaic" style of her time. Throughout the work, Antonia shows herself as a devout Christian, a patriot, and a staunch supporter of the Peruvian military, and she desires to convince the reader of Peru's righteous cause. There is no doubt discernible in phrases like "the defense of our holy cause" or "God rewarded this bold act of love for our country" (19f.). Few women in the twentieth century take this unambiguous stance. It remains Antonia Cáceres's merit, however, that she not only showed unusual courage and ingenuity, but was able to articulate the war experiences of *criollo* as well as indigenous women. She probably did not realize that the Andean *rabonas* actually continued an Inca tradition of female participation in war, even though its form was no longer ritually prescribed. The famous nineteenth-century Peruvian-French feminist Flora Tristán commented on a specific Inca tradition of the *rabonas:* their worship of the sun.[18] While she says she did not observe special religious practices among them, we can assume that the *rabonas*, like their *criollo* Christian contemporaries, had no problem combining their service to army and country with their religious beliefs. On the contrary, religion would often, among Incas as among Christians, reinforce the will to fight a war.

Many women in the twentieth century, including Peruvian women, have a more critical relationship to national or religious power. Especially indigenous women frequently question the established societal power structures and follow the example of Micaela Bastidas in resisting oppression. White and *criollo* women are trying to wield power within political parties or government offices, but they are constantly aware of the fragility of their position in a male-dominated society, and many are sensitive to their own involvement in racism and oppression. Women in Peru today are not permitted to join the army, except for related services like nursing. They do, however, serve in the police force and can now attain high ranks in the police. While this fact may indicate that women simply adapt themselves to the male system or that men are gradually permitting women's equal participation in power, in Peru it also expresses the demand of many

women to be protected by other women because they are critical of the male handling of crimes like battering and rape.[19] Around 1980 a law was introduced that requires all persons, male and female, born after 1962 to register; therefore the government can at any time decide to draft women too.

We have, then, in Antonia Moreno de Cáceres's book a double witness: on the one hand a typically nineteenth-century patriotism with Christian overtones and a conservative adoration for the male military hero; on the other hand an example of a woman's active involvement in armed violence, anticipating very different female "resistance fighters" of the twentieth century who oppose state as well as church.

# WOMEN WRITERS
# OF THE TWENTIETH CENTURY

## Aída Balta

With killings and disappearances at an all-time high, how can women in a country like Peru voice their concerns about war and violence? Literature in the Andean countries is still largely the activity of an educated elite and therefore reflects primarily the daily life of the upper classes. Peruvian women have published an impressive body of lyrical poetry and a few have published remarkable short stories. But there are very few Peruvian women novelists — for various reasons: the extreme difficulties of publishing in Peru in general, with scarcity of paper and other technical resources; the poverty of most of the population, which prevents people from buying books; the traditional male domination of the cultural market and literary criticism; and the special stresses of women's daily life. We might also remember that since colonial times women's public utterances were discouraged. What Jean Franco has stated with respect to Mexican nunneries and the influence of the church's teachings certainly fits countries like Peru: "In accepting silence and self-obliteration, the mystics legitimized the institution's separation of male rationality from female feeling and the exclusion of women from the public domains of discourse." In addition, "novels were prohibited in the New World (which does not mean that they were not read) for fear that their fictions might mislead the indigenous."[1]

When women did become known as writers, they often were rejected. One of the outstanding Peruvian women of the nineteenth century, Clorinda Matto de Turner (1854–1909), was ostracized for her courageous portrayal of injustices against the

indigenous population.[2] Magda Portal, a socialist and feminist writer of our time who died in 1989, was harassed for many of her writings. Novelists and poets who deal with matters of war are especially rare. The guerilla war of Sendero Luminoso, which began in 1980, was for years not considered a "war" by the population at large. Also, in view of the extreme political sensitivity of the subject matter, it is not surprising that there is yet little evidence of Peru's war agony in its literature.[3]

One young woman writer, however, published a novel in 1987 in which she portrayed a young man from Lima who gets drawn into the very first short-term guerilla battle in the jungles of Peru that alarmed the country in 1963. Aída Balta, descendant of a nineteenth-century Peruvian president who was murdered by the military, was born in 1957. Living with the family memory of violent death, she prefaced her novel *El legado de Caín* (The heritage of Cain) with the words from Genesis 4:10: "[Cain,] now you are cursed from the ground, which has opened its mouth to receive your brother's blood from your hand. When you till the ground it shall no longer yield to you its strength; you shall be a fugitive and a wanderer on the earth." The novel gives a vivid picture of the racially mixed lower-middle class in Lima, which tries to rise and compete with the white and *criollo* elite through hard work, increase of property, and education, but is never respected by the "proper" old families. The protagonist, Suriel Arbuzar, grows up as a sensitive, hurting child, driven by an ambitious, sometimes unscrupulous father to become a model citizen, and not understood by a submissive, weak mother who prefers his accommodating younger brother, Ahmed. Suriel's father, Jabel Arbuzar, is of Arab and mulatto ancestry and had a tragic childhood himself. His mother comes from a well-to-do, religious peasant family. While she insists on a Christian baptism for Suriel, father Jabel will later teach him to pray to Allah.

Throughout the novel there are allusions to war: Suriel's parents get married when the Second World War is starting. The constant news about the war causes the child Suriel to ask questions like: "Mama, are the Germans all bad?" "Is the war going to come to Peru?" "Is Daddy going to fight as a soldier?" (26)[4]

Meanwhile his father is more likely to fight with his mother, sometimes driving her to suicidal thoughts, and to maltreat his children. There is one bright spot, however, in young Suriel's life:

An uncle of his mother, Tío Gregorio, comes to visit the family. As the father increasingly resents the uncle's presence, Tío Gregorio is taken in by a kind widow, Hortensia, and the two become like second parents for the sensitive Suriel. They inspire him with stories from their archeological research and from their own turbulent past: Gregorio had been married to a young Jewish woman in Poland who died in a concentration camp; Hortensia's husband had been a Peruvian scholar who was harassed until his death because he defended the rights of the indigenous people. Thus the young Suriel eagerly absorbs thoughts of political resistance and vows to "do justice" (35) while also feeling the urge to take revenge against his parents for destroying his childhood.

Aída Balta skillfully weaves together a multiplicity of narrative threads to make Suriel's later involvement in guerilla warfare psychologically plausible. His grandfather had been murdered by a relative who in turn has his own death hastened by Suriel's father. The young man can never tie into his own past, because his parents deny and hide what they consider a racially and economically "tainted" ancestry. When Suriel falls deeply in love with a fifteen-year-old girl from one of Lima's most distinguished families, he is forcibly separated from her by her parents, who consider him a *cholo* (an indigenous person or mestizo of rural background) for whom they have only disdain (71).

Since the novel alternates between first-person and third-person narrative, we get a more rounded picture of Suriel's inner and outer, conscious and subconscious development. He gets a good education in London as well as in Lima, but instead of becoming the distinguished citizen his parents want him to be, he gets drawn into socialist circles interested in Cuba's liberation. He dreams of love, adventure, and liberty, and abhors the bourgeois life of his ever richer parents.

Suriel now clarifies his own faith: He wants to be a voice that regains justice for the races that suffer discrimination; he would like to imitate the courage, wisdom, and power of Gregorio; he considers Jesus Christ a man who performed miracles because he had an enormous "faith in himself," the spiritual force that Gregorio talked about (68).

Two trips to Cuba and the study of the history of guerilla warfare from Roman times until Mao and Che Guevara finally persuade him to join a group of forty guerillas who carry the

fight for liberty into Peru. A battle ensues in the jungle area of Puerto Maldonado. Suriel will later recall the event with indescribable pain (112). A poet friend and other companions died in the battle.[5] He himself ended up in prison for eighteen months. "I was no Robin Hood, I wasn't born to be a hero" (115), he admits to himself. At twenty-four years of age, he is free to start the life of a writer in Lima. On a visit to London he meets again his teenage love, Beatriz, who is married with two children, one of whom is actually Suriel's child. His hopes for a life with her are dashed again, and he sinks into desperation. On an October morning in 1968, Suriel's body is found by some fishermen on the coast of Lima. As he had told Beatriz, "in spite of my intense desire to create a more just society, I could not endure the death of my companions, the chilly violence of the weapons" (126).

El legado de Caín is a skillful portrayal of a citizen-turned-guerilla. The reader is left with an understanding of a young man's identity crisis rooted in a combination of racism, poverty, and a great sensitivity for justice. Violence developing into warfare is dealt with in a vivid narrative. As a Peruvian reviewer sees it,

> Throughout the novel [Suriel] will time and again question the unknown ground of existence, the reasons why history repeats itself simply by changing personalities; he will confront himself and his phantoms and among them the most dangerous one: the phantom of violence.[6]

Since the book is only the second novel by a young author,[7] it shows some weaknesses: The alternation between an "omniscient" narrator and first-person accounts sometimes appears arbitrary, and the historical passages could be woven into the narrative action more effectively. Balta's argument is, however, that the change between first- and third-person provides counterpoint and *choque* (shock, collision), since we are jolted back and forth between two realities, the individual and the communal or the psychological and the political. The seeming "separateness" of the historical paragraphs to her indicate the actual unrelatedness of Suriel's life to politics.[8]

In terms of our present knowledge of the Peruvian guerilla war, some readers might miss in the book the collective substratum of the country's poor masses, whose incredible sufferings

would make an individual's recourse to violence still more plausible than the psychological pain of a not-so-poor mestizo. The author mentions the enormous growth in the *barriadas* of Lima (107), but we do not get a "feel" for this world. On the other side of the social spectrum, we do not discern from the novel the structural violence committed by the Peruvian state and the military or by greed-driven national and international industries. Since Balta chose, however, to portray the very early beginnings of guerilla warfare under the influence of the Cuban revolution, she did well in emphasizing the intellectual and foreign roots of the first uprising. Moreover, the capture of Abimael Guzmán and his friends in September 1992 has shown again to the general public that Sendero Luminoso to this day is led by well-educated people inspired by foreign ideas.

While in any case a novel written in 1986/1987 cannot possibly portray today's situation, Balta has, by some artistic instinct, also expressed aspects of the guerilla movements that fit exactly into the situation of the 1990s. Whereas Sendero Luminoso has its beginnings in the pro-China part of the Communist Party of Peru, which in 1964 broke away from the pro-Moscow wing, another group, the MRTA (the Revolutionary Movement of Tupac Amaru) is much more influenced by Cuba and Nicaragua and appears on the whole more middle-class and less violent. Suriel Arbuzar certainly fits into the popular image of an MRTA fighter. The more recent Sendero recruits, however, are showing some very similar characteristics: They do not necessarily come from the countryside around Ayacucho, where the movement had its birth, but increasingly from the ranks of lower middle-class mestizos of Lima, who have no firm ethnic identity, are treated like *cholos* even if they are university-trained, and see no professional future for themselves.[9]

It is surprising to compare Balta's portrait of Suriel Arbuzar with some of the findings of the sociologists Gonzalo Portocarrero and Elisabeth Acha in their book *Violencia estructural en el Perú*.[10] The authors cite, e.g., pedagogical violence by parents as one of the reasons for violent behavior in young people. They also refer to anger against the fathers of mestizo families as an attitude that easily turns into hatred of other authorities. They consider the fundamentalist ideology of general suffering and victimization as generating feelings of revenge. In fact, one of the

young women whom they interview does not consider violence as a last resort in an effort to build a new world, but a natural reaction to repression: a revenge.[11] We might remember that Suriel was often violently treated by his father and that he wanted to take revenge against his parents for destroying his childhood.

We might miss, then, in Balta's novel a broader social spectrum, but her psychological insights into the causes of civil war are to the point. "SE BUSCA LA PAZ," is written on a "criminal search" poster that Suriel has put up in his room: "WANTED: PEACE" (109); but his whole life is a war with the world around him, so he tries to find peace in death.

Aída Balta has witnessed not only to her family's memory of violence, but also to her own experience of Lima's society today, especially to the role of racism in the eruption of war. In a time of intense ethnic hostilities in many parts of the world, Peruvian as well as North American and European readers will do well to listen to this voice.[12] As the French critic Roland Forgues sees it, the novel shows

> a dialectical balance where love and hate, innocence and terror, violence and calm, enthusiasm and depression, rebellion and resignation, tender irony and sharp criticism, song and tragedy alternate in a procession of beautiful images.... The implicit message of the work seems to be that the salvation of human beings lies metaphorically in their power to construct their fate and to regain the garden of Eden from where they were expelled, but not by way of Cain's crime; only in the solidarity of all.[13]

I think we have to qualify this statement by saying: It is Suriel who states repeatedly that "believing in oneself" is a kind of salvation. The author shows, however, in his tragic end that human power alone does not restore a garden of Eden.

### Carmen Luz Gorriti

If Aída Balta gives us a picture of an urban, middle-class young man and his attitude toward war and violence, another young Peruvian woman, Carmen Luz Gorriti, has written two short stories that focus on women and on life in the provinces. The

first one portrays a simple old country woman whose life and death witness to peace in the midst of *la guerra sucia,* as Peruvians call the "dirty war" between guerillas, the military, and the population at large.

The story, "El legado: Una historia de Huancayo," was written for a short story contest sponsored by the feminist center Flora Tristán in Lima, and Gorriti, who up to that time was a sociologist working with grassroots women's organizations, won the first and only prize for this work.[14] She is also a poet, and the story is an almost poetic evocation of a deathbed scene and a wake. The old woman, Felicitas, who sold food in the streets, has had a stroke and is near death. Her husband, a woman friend, a daughter, and a son are around her, each with his or her own fear or anger. The daughter shouts at the father that it is his fault: He has always abused his wife. The father, Juan, is inwardly furious that his wife is leaving him — as she would have liked to do earlier; the son is afraid of a life without his beloved mother.

Meanwhile, Felicitas remembers all the children she has borne and all the fears that have shadowed her life. She had been afraid to insist on becoming a student, afraid of keeping Juan from getting her pregnant, afraid to tell people that she was pregnant and would run away to become Juan's wife. Now, however, in the face of death, she tells herself: "Poor is the person who is afraid," and the fear begins to leave her. In fact, Felicitas's fearless thought now begins to wander through the room to enter other persons' hearts and minds, but her family members are still closed in on themselves with fear or anger. So Felicitas's thought wanders into the street where soon the news of her death is spreading among shopkeepers and milkmaids, burden carriers, and those whom the old woman had helped, healed, and comforted: the battered and raped, the drunk, the hungry, and the depressed. About two hundred of them come to the wake and think of the wounds of body and mind she has tended to.

Nobody realizes that during the night the terrorists have broken down the prison door, and the military has responded with an assault. Suddenly the soldiers appear before the grieving community, telling them: "Nobody is going to move. All in here are terrorists!" Since the soldiers have blackened their faces, nobody can recognize relatives or neighbors among them, some of them

perhaps recent conscripts. Gradually the mourners become conscious of all the relatives who have in recent times been sent to the prison never to return. The soldiers order everybody down on their knees.

By now the fearless thought of Felicitas enters her son Manuel, who is thinking with tenderness of all the people who mourn his mother. He feels moved to take the hand of his angry sister, who in turn takes the hand of her hated father, while the father takes the hand of a feeble washerwoman, and so all the people, from the drunk to the cafeteria waiter, take hands until "the circle of power" is closed. Nobody moves, but as the fear disappears, so also the courage of the commanding officer. He realizes that here are two hundred people whereas his soldiers are only twenty. Besides, this is a regular wake, and people do have some civil rights.

When Felicitas was buried the next day, she looked very happy.

The story is told in sparse language on barely four pages. The frequent repetition of the word "fear" and the penetrating insight that fear more than anything else makes a person a poor and pitiful being cause the reader to feel an almost physical tension, release, and liberation. It is a courageous story because the "blame" is here primarily laid on the military, and that is not a stance agreeable to Peruvian authorities. It is, however, also a complex story that goes far beyond blame or guilt on any side. The mourners have relatives, friends, and neighbors among both the military and the imprisoned suspected terrorists. They can therefore not possibly be on one side only. Moreover, the author clearly connects the attitude of the military with the abusive acts of the father: Wife, daughter, and son have always been afraid of being beaten by him and resented his demanding their services. The cause of "war" is obviously not just located in terrorists or the military, but in a patriarchal system of society that rules by instilling fear.[15] Felicitas emerges as an individual symbol of a collective force: Having grown up with innumerable fears, she has developed the sensitivity to heal other people's fears and wounds, and they in turn can now sense her final fearlessness and can act upon it. Thus a "circle of power" is set over against an authoritarian system of family and state. Felicitas becomes a pacifying force, a "witness for peace." She is, however,

not a "heroic" individual, but simply a source of power, harboring a spirit that is left free to enter and energize other human beings.

It is a strange coincidence that Aída Balta and Carmen Luz Gorriti both use the word *legado* (heritage) in their titles. Suriel Arbuzar bears the heritage of Cain, of war; Felicitas bears that of peace. Both authors portray responses to violence, indicating that each generation and each individual leaves a certain legacy to the next, witnessing with their whole life, whether they know it or not. Both see the connection between war in the family and war in society.

The second story by Carmen Luz Gorriti is still unpublished, because it was written only recently after the capture of Abimael Guzmán and in response to the media pictures and statements of incarcerated Senderista women leaders. Many years ago Gorriti was active in a leftist political party, and many of her friends and acquaintances at that time sympathized with Sendero Luminoso, a party that until 1980 had simply been known for its Maoist ideology. She knew how a person would almost inadvertently cross that fine line from nonviolent activism to armed revolution. She not only avoided that step, but changed her whole outlook on life during recent years. She is no longer working as a sociologist and social worker, but went through special training as a "somatic therapist" and is now treating people with psychological problems through somatic methods.

Her new profession explains an important aspect of the story, "Victoria poseída" (Victoria possessed). It describes Victoria, a young woman acting as a leader of a Senderista attack on a mountain village. The people have realized that the war has finally engulfed them, that with the police the tourists have also left, the stores have little to sell, and the children go hungry. The villagers, however, do not want to flee, because they have never been crushed by anybody, and they believe that the warm springs near the village are proof of the continued blessings from their land.

Victoria gives the usual orders: First the "demon governor" is to be liquidated. The desperate cries of his wife, who offers to die in his place, are cynically ignored as he gets shot. Next Victoria tells her detachment to organize a "people's trial" for the mayor. When she, however, has determined who will bring forth

the routine accusations and who will give the *coup de grâce*, a feeling of tiredness overcomes her: It is always the same procedure in every village. Her boredom soon turns into suspicion: Why did the mayor not fall on his knees? Why did his children not beg for his life? Why are the people, after five other executions, remaining so silent? Where are the young people?

A collaborator tells them the young are hiding in the hills, and some are calling the military. There is danger. She sends some of her troops to "clean the village of traitorous dogs" and takes the rest with her to search for the youths. She feels more tired now, and finally, when they have come close to the source of the warm springs, she separates herself from her comrades. A peaceful path [literally a *sendero!*] leads past a poplar grove to a small lake. She looks into the water and sees her aged face. "Every death brings a wrinkle." She cries out for her friend Carlos whom she lost in the course of a battle. The bubbling spring in the middle of the lake tempts her to put her gun on a rock and relax in the morning sun. She watches a tranquil lizard, the waving trees — and suddenly she finds herself immersed in the soothing water.

Gorriti now describes the caresses of the water, loosening gradually her body and soul, rippling over her clenched teeth and soothing her bad conscience for neglecting "the cause." The water becomes a tender lover, tempting her to sense her body as beautiful and her spirit as "delicate," even though she has been trained to think that the spirit does not exist.

She washes her hair in the foam of the lake and covers herself with leaves while befriending birds and butterflies. She feels hungry and suddenly is aware of her nakedness. She hears the noise of arms and the "Spartan" voices of her companions. Should she hurriedly dress and return or run and hide? "Victoria never ran away from anything." So she rejoins her group without looking back at the "trembling paradise" she left behind. The military has arrived, there is the smell of blood. As Victoria marches on, she sees many dead bodies of humans and animals. "We have cleaned out the place," says one of her men, "and we installed new authorities." Victoria, however, begins to tremble at every trace of blood: " 'No, no,' begged the life from her body, but her closed lips lulled her into silence."

The army is now nearby, and the guerillas do not have the fire power to meet them. They retreat — without Victoria. When later

her comrades ask the villagers about her, many had seen her, but nobody knew anything more about her.

Victoria in the end is no longer "possessed" by the demon of destructiveness, but by that power of creation that she first sensed physically in the lake. It is clear that Gorriti's personal and professional interest in healing psychological problems somatically finds expression in this story. She could have chosen other psychological states to make her point, but her interpretation of Sendero Luminoso as a movement that is trying to kill the spirit by deadening the body is very appropriate and shows the author's sensitivity to the psychological substratum of terrorist movements.

It is perhaps paradigmatic that one of the special friends of Abimael Guzmán who was captured with him is Maritza Garrido Lecca, a dance instructor. Her dancing school was the cover for Guzmán's hideout. Professional dance needs utter discipline and relentless practice. The complete control of the body that makes the beauty of dance possible can be driven to a perverse pitch in persons who have to kill routinely, and authoritarian heads of state, just like guerilla leaders, have usually overemphasized sports and physical toughness as a means to train casual or fierce warriors. Carmen Luz Gorriti does well in exploring the psychosomatic aspects of guerilla warfare.

She does the same in a recent unpublished poem[16] that shall be quoted here in full:

### I Am the Dynamite

I walk the streets
of my trembling Lima
something presses in on me
everything around me agitates me.

> The scrawl of faces,
> the softness of memories
> chained;
> I walk
> a skyscraper world
> I walk
> wearing away my rage.

> I am, I,
> the dynamite,
> I who destroyed
> the very center
> of the city.
>
> The firefighters already came
> doing their professional work;
> they found a little one, his smile
> perhaps formed a dimple
> they did not find any more.
>
> They gathered corpses,
> there were scattered
> some souls,
> but in the rubble
> they did not manage to recover
> this rage, these furies,
> the world that ended up
> shattered and in pieces,
> the hours of hunger,
> the quivering lament,
> the drippings, the tremblings,
> all the hate,
> so much screaming...
> this riotous desire
> to love.

A fierce and unfulfilled love and a past of hunger and suffering are here seen as causing a person to vent her (or his?) fury in destructiveness. We are made aware that "killers" are not necessarily automatons, but can be passionate people whose "love" nobody discerns and whose rage is out of control. Just as Victoria in the short story gives us a glimpse of her buried sensitivity when she cries out for her friend Carlos or when she rediscovers the joy of her body, so the "dynamite" person deep down has a tremendous desire to love.

We are not told, however, whether this is meant to be a love for all the people who suffered what this person suffered or whether it is simply the cry of a hurting, lonely soul. Perhaps this is Gorriti's point: Wars are not necessarily fought for the rea-

sons that are named — defending a country or a cause. They more likely grow out of physical suffering and psychological confusion, personal rage and collective hate.

The persons whom Gorriti describes grow out of her memory as an eyewitness: She has known people who opted for violence, and she knows they are not Frankenstein monsters, but human beings who are caught in some psychological or ideological trap. In another poem with the title "Ella está loca" (She is crazy) she describes a hysterical woman from an aristocratic family who is afraid of her own image in the mirror:

> Her eyes are not seeing
> her skin is not feeling
> the joyous order
> of simple things,
> she is crazy
> because she does not discover
> the open door
> of her prison.

Gorriti has told me that she thinks women are trained to feel guilty when they are simply happy. *El placer es culpa* — pleasure gives many women a guilt feeling. To her that explains some aspects of women's intense involvement in good causes that demand sacrifice, and in the Latin American context this observation is even more understandable than in the U.S. or European context. She also mentioned another aspect of Peruvian violence that pertains to women as well as men: Revenging an injustice, especially murder, for more traditional Peruvians is not just a matter of instinct or old custom, but of moral duty: *la venganza es deuda*. When a person loses a close relative through some barbarous act of the military, he or she feels obligated to kill a soldier in revenge. We might well ask why Christianity in five hundred years did not wipe out such "pagan" remnants, but we will discuss later that Christianity frequently followed the same practice. The witness of the institutional church has always been ambiguous. It is therefore all the more important that we have individual witnesses who help us unmask violence from different eyewitness perspectives, which we can then weigh in terms of Scripture, tradition, experience, and conscience in our own context.

## A Journalist: Mariella Balbi

If we move outside the circle of fiction and poetry, we find a wide variety of women's voices, from journalism to folk theater, from songs to oral *testimonios*, from public statements before some investigating group to interviews with women prisoners. In the context of the Latin American reality, with populations of high illiteracy and the written, published discourse as the privilege of a small upper class, the transition between fiction and documentary narrative or *testimonio* is very fluid. David William Foster has pointed out that, from the late Renaissance chronicles of the Conquest until today, Latin American literature has shown "an overwhelming testimonial quality" and a "continuity between imaginative literature and documentary."[17]

Therefore, under Peruvian circumstances we should not look only for "literature" in the traditional sense. Documentary writing and oral testimonies in comparison with fiction will give us a more rounded picture of women's experiences, dreams, actions, persistent inquiries, and imaginative proposals concerning matters of war and peace.

One of the most exposed and influential jobs of women in Latin America is that of a journalist. Peru has many highly talented women working in the media. Famous among those located in Lima is Mariella Balbi, a journalist who during recent years has also become a TV personality through hosting a popular program called "Crossfire" ("Fuego Cruzado"), in which she invites people from all walks of life to discuss controversial issues from various perspectives. For years she has published interviews with well-known politicians, academicians, and leaders of grassroots movements in *La República*, one of the two leading newspapers in Lima. Most of these interviews are directly or indirectly related to the civil war situation. She dialogues, e.g., with so-called senderologists (*senderólogos*), sociologists and anthropologists who have studied the phenomenon of Sendero Luminoso since its beginnings. She lets politicians from the left as well as the right give their opinions on the antisubversive strategies of the Peruvian government. She interviews representatives of the military or the church, of the Mothers of the Disappeared or the politically influential Vaso de Leche (Glass of milk) program, which tries to provide a daily glass of milk to as many

Peruvian children as possible.[18] She has published interviews with women politicians in the feminist periodical *VIVA*.[19] All in all, her work has won praises and prizes even beyond the borders of Peru, especially for her imaginative and courageous reporting on the human rights situation and the violence against noncombatants.[20]

From a First World perspective, it may appear as a relatively easy job for a journalist to interview "experts" over the telephone, in front of a TV camera, or in a newspaper office. Mariella Balbi, however, knows she is in danger for her life, whether she goes where the action is or stays in her office. In 1983, eight journalists were murdered in Uchuraccay, in the mountains near Ayacucho, because they had wanted to investigate the murder of seven young men in the same district. In November 1988 the Peruvian journalist Hugo Bustios was killed, probably by a military or paramilitary group.[21] On May 31, 1989, an outstanding Peruvian woman journalist, Bárbara D'Achille, who did pioneering reporting on matters of ecology, was killed by Sendero Luminoso when she visited an agricultural project that was supposed to benefit poor Andean farmers.[22] More recently, in the fall of 1991, a twenty-three-year-old woman journalist was killed when a letter bomb exploded that was actually meant for the editor of the paper she worked for.[23] Balbi herself was threatened with death after she had written reports on the paramilitary group Comando Rodrigo Franco.[24] During 1992, some prominent journalists were incarcerated because the Fujimori government suspected them of being Sendero sympathizers or because they openly criticized some aspect of Fujimori's regime.[25] It is clear, then, that journalists in a country like Peru are eyewitnesses in a very committed way. Except for their courage, many human rights violations would never be known, and training in democracy would hardly be possible.

Balbi's interview method is straightforward, asking pointed questions that do not permit vague answers, but they give the person interviewed much latitude in explaining his or her position. Her essays show her attempt at impartiality in citing different voices, but leave no doubt about her intense concern in matters of human rights on whatever side. What makes Sendero so powerful? she asks three "senderologists." It's the ideology, says anthropologist Manuel Granados from Ayacucho, the origi-

nal center of Sendero violence. It's the strong social base of people pushing for revolutionary change, says sociologist Raúl Gonzales. There is a lack of common viewpoints and strategies between the government and the military, and it contributes to Sendero's push for power, adds the journalist Gustavo Gorriti. Balbi weaves together the opinions of these three men in a remarkable essay that gives Lima citizens an insight into a movement that for a long time was hermetically closed and silent and yet frighteningly inched its way into neighborhoods and schools. Sendero is not really intent on rooting itself in ancient Inca traditions, say these three men. Its ideology is a cosmopolitan Marxism (Maoism) that fits the mind of the long oppressed *campesinos* (peasants, country people) whom they try to convince or intimidate to gain their support. They recruit very young teenagers because they realize that many of them have no identity or future and that in the year 2000 the majority of Latin Americans will be young people and children. Since the leftist parties have become much too ideological, teenagers are impressed with the wordless action and power of Sendero. If they are at all interested in its ideology, they find its scientific fundamentalism attractive.

In a roundtable discussion in 1988, Balbi brought together Raúl Gonzales with a retired general and a former prison chaplain. They tell her that the government is actually abdicating its power and transferring it to the military, which has no consistent strategy except to hunt down armed groups and suspected subversives. There is no attempt at a political strategy, and all those very different groups that feel ignored by the government — impoverished farmers, rich coca traders, young people under nineteen who make up 51 percent of the population, and street vendors — find the revolutionary rhetoric appealing. The government and the military do not understand that the situation is a "social war" and not a "war of extermination."[26]

In her essays on the right-wing paramilitary group Rodrigo Franco, Balbi revealed several facts that pointed to its liaison with government forces: It was, e.g., especially active in areas under strict military control of the government, and military manuals suggest to soldiers that in nonconventional warfare they should use the same terror tactics that subversive groups are known for. When Balbi, however, interviewed Angélica Mendoza, a peasant woman from Ayacucho internationally known for her leadership

in the Committee of Families of the Disappeared, she pressed her repeatedly for information on Sendero brutalities since Angélica kept blaming only government troops: "Señora, Sendero is also killing people.... Why don't you denounce them likewise?" Yet Angélica insisted again that they only hear about these murders without knowing any Senderistas; that Sendero does not, e.g., rape women and young girls — as members of the armed forces do — and that some people use Sendero to punish abusive authorities.[27] We will see later that Angélica's views in this regard were very limited and that they changed. Balbi lets her tell the whole story of cruel disappearances and torture, but also of the amazing courage and patience of the women who gather legal information on documented disappearances and, under constant danger to themselves and their families, keep demonstrating in the streets and visiting government and police offices to find out about the fate of their relatives.

Mariella Balbi's potential influence, e.g., on the election process — and therefore on matters of war and peace — cannot easily be overestimated. Before the last presidential elections, she published statistics on the violence in Peru and put the same urgent questions to the leaders of the various political parties: "What are you planning to do about the violence in the country? How many members does Sendero have according to your estimate? How can we guarantee free elections in the embattled rural provinces? Are you in favor of arming the peasants for their self-defense? Are you in favor of capital punishment for subversives?"[28] This practice was repeated in 1992 before the election for the Constitutional Assembly.

When the head of a government-appointed commission to investigate paramilitary groups was accused of being himself linked to these right-wing radicals, she pressed him hard: "You could leave the commission...." "That would mean I admit the accusations," answered the representative. "No," she insisted, "you could deny them and say that you leave in order not to hinder the investigation."[29]

Balbi also got the historian Juan Granda to describe the changing tactics of Sendero Luminoso, its relationship to peasants, to high-school and university students, and to the population at large. She elicited from him a surprising amount of information that up to that time had not been available to the public. Ac-

cording to Granda, Sendero's main force consists in its political power, but one out of every five Sendero groups is armed. He estimated in 1989 that there were perhaps twelve hundred to fifteen hundred armed members. Sendero was at that time trying to pressure labor unions into submission. The movement first found followers among the peasants of the highest mountain villages, where there are no doctors and no schools. Sendero helped with the harvest. Later, however, the tactic turned into threats: The peasants were kept from bringing their produce to public markets; Sendero wanted them to be self-sufficient in their agriculture. So the relationship became based on fear, and the same would soon pertain to the military: The peasants became afraid of the military raids that were supposed to protect them.[30]

Balbi also went abroad to look at the Peruvian guerillas from a foreign perspective. To her surprise, she found in San Francisco an internationally connected group that supported Sendero wholeheartedly. Its members shrugged off her questions about Sendero's violence as lies, misunderstandings, or accidental happenings in a "revolutionary war" against the Peruvian military. These people assumed that Sendero would eventually come to power, that the majority of Peruvians supports them, and that the leftist politicians of Peru are criminals and agents of the Soviet Union. Thus Balbi very early gave the average Lima newspaper reader a glimpse of an international Maoist network in support of a Peruvian revolution long before the intensity of this network became known around the world after the capture of Guzmán.[31]

Balbi also presented the "normal" background of a person like Abimael Guzmán, the leader of Sendero, at a time when he was still in hiding and was by many people considered dead. Interviewing a former colleague of his, David Scott Palmer, who is now teaching at Boston University, she elicited from him the picture of a very popular professor who was disturbed about the sufferings of the peasants around Ayacucho. The strong interaction between the university and the surrounding communities, the influence of many foreigners working at the university, and Guzmán's visit to China — all these factors contributed to the formation of Sendero ideology.[32]

In 1990 Balbi was named "the best interviewer" of the year, and after President Fujimori's election she became the media personality who most often interviewed him. In December 1990

she published an overview of his government's strengths and weaknesses during its first 120 days.[33]

Balbi in her earlier days spent four years in France and considered getting a doctorate in psychology. Those plans were put aside when she became a journalist. Today she continues to write for *La República*, but she is more famous as a TV personality and deals with "war" issues also in this capacity. After the brutal murder of the community organizer María Elena Moyano, which I will describe later, Balbi produced a "Fuego Cruzado" program about the event. Similarly, after the capture of Guzmán and his friends, she gathered experts from various fields to discuss the phenomenon of women in Sendero Luminoso. For this program of about two hours, Balbi and her co-host of "Fuego Cruzado," Eduardo Guzmán, gathered feminist professionals, leaders of grassroots women's movements, lawyers, psychologists, sociologists, and anthropologists to give their opinion on the role of women in Sendero. As in all "Fuego Cruzado" programs, forty to fifty people from the general public were admitted, but the discussion was mostly led by six or seven experts, in this case male and female professionals and activists. Their personal statements are interspersed with telephone interviews and with historical sketches about the most famous women of the early movement, about cults and marches by Sendero women in prison, and about the recent capture of Sendero leaders.

The resulting picture of course does not answer all questions, but it gives a multifaceted and sometimes paradoxical view of the issue: The women in the movement are theoretically completely equal, but also totally submissive to Guzmán and party policy — if not to other male leaders. They act in highest leadership roles, yet frequently join Sendero because they follow a lover or husband into the movement. The party leadership takes advantage of the fact that the government, the churches, the unions, and the political parties have neglected to deal with the concrete problems of women's daily life. Sendero also attracts intellectual women because they do not find positions adequate to their gifts and training. In order to harden women for the violence prescribed, they train very young girls to become warrior women and to substitute gradually a desire for affection and maternity with a mystic cult for the father figure "President Gonzalo" (Guzmán) and with a collective party identity. The clandestine

aspects of the movement foster a sense of reality that is actually a fabricated pseudoworld.

The comprehensive program ends with the reading of letters from people whom the Fujimori government termed "ambassadors" of Sendero Luminoso abroad and who categorically reject this accusation, some of them even proving that they were actually in Lima during the time frame given and had actively opposed Sendero.

When the Lima paper *El Comercio* interviewed Mariella Balbi in September 1991, she was asked whether the "passionate" quality of her TV discussions was not actually a touch of sensationalism. "Why?" she answers. "I call 'passionate' that which is authentic, exalted, showing arguments. It is the interchange of ideas that is needed in Peru, not the fights." "But your program ["Fuego Cruzado"] appears to be intent on fights," comments the interviewer. "It is intent on not being boring," she replies. "People have to present their opinions with conviction, with analysis. There is very little analysis on TV. I think we are helping people to study events in detail so they can see all the angles."[34]

Undoubtedly Balbi's voice is being heard by millions of Peruvians, and she is to be commended for trying to view things from all angles. She is not at all a religious person and would not consider her work a "witness" in a religious sense of the term.[35] She is, however, an eyewitness with a passion for democracy and justice who is helping many other women to shape their witness about war, as we will see later in the discussion of her interviews with María Elena Moyano. When another woman journalist asked her last year in what form she would like to be reincarnated, she answered, "In a shoe, in order to be closer to the earth."[36]

## A Scholar: Piedad Pareja Pflücker

Besides Mariella Balbi, other highly educated women of Peru are conscious of the responsibilities and opportunities they have in trying to discover the roots of violence and the possibilities for peace. I am mentioning some of them in other contexts, e.g., Elisabeth Acha's contribution to a sociological study or the research of Margarita Giesecke and Cecilia Blondet on Villa El

Salvador.[37] Many others could be found in Peruvian universities and independent research centers. I wish to mention here only one example: Piedad Pareja Pflücker, a labor historian and legal scholar, because her work is "testimonial" besides being scholarly. In 1981 she published *Terrorismo y sindicalismo en Ayacucho (1980)* (Terrorism and unionism in Ayacucho [1980]).[38] This book grew out of her personal experience of having been the president of a mining company in the Ayacucho area in 1980 when Sendero Luminoso for the first time spread the message of armed violence and acted on it. Pareja had been for nine years a university professor specializing in the history of the Peruvian working class, but family circumstances made it necessary for her to assume the management of the mine — presumably only for a few months. Half a year later, however, a strike would break out at the mine that was to last sixty-eight days and that would entangle her in an intense struggle between union leaders under the influence of Sendero Luminoso and her own family's attempt to keep violence from destroying the workers' lives as well as the mines.

She warns in the beginning of the book that she lacks an objective distance to the events. Even though the work merges her own diary notes, archival documentation, some later reflection on the events, extensive statistics, and reports on meetings with many of the individuals and agencies involved, she does not attempt to give a "disinterested" view:

> Our version of the events has a testimonial character even though we refer constantly to the comments of third persons. . . . There was a choice to be made between gaining an "apparent" objectivity or keeping the spontaneity of the initial narration. I opted for the latter, accepting the risks it involved: that the emotional perception of the events would overrun the intellectual power to explain them.[39]

The "emotional perception," however, is here clearly that of a trained historian and legal scholar who from the beginning is conscious of the history of labor law, the political events leading up to the founding of Sendero Luminoso, the social conditions that drive peasants to become miners, and the ambiguous role of politicians who try to mediate between governmental decrees, unions, the police force, and private business.

In 1980 Peru entered a new era. After twelve years of military government, a general election decided that a civilian, the architect Fernando Belaúnde Terry, would lead the country. An enormous number of new voters had contributed to the change, especially since in 1979 the vote had been given to illiterate people. In Ayacucho almost 42 percent of the voters were illiterate.[40] Paradoxically, the massive increase in violence started when the country was on the verge of a true democratic opening. During the final years of the military government the legal right to strike had been intensely debated. Massive strikes would constantly paralyze large sectors of the national workforce, and yet an increasingly desperate economy would drive workers into more strikes. The unions now put pressure on Belaúnde to enforce a general amnesty for those who had been arrested in the context of a demonstration or strike.

In this tense situation a disagreement or animosity between the representative for "industrial relations" for the Canaria mines, presided over by Pareja, and two union leaders led to the dismissal of the latter, a move that the representative did not discuss with the management of the mines. The union ignored all possibilities of arbitration or simple dialogue and immediately declared a general strike of indefinite duration.

What occurred in the sixty-eight following days of the strike cannot be told here in detail. Pareja's point is that she witnessed firsthand the manipulation of union leaders by Sendero Luminoso, which had recently begun the armed insurrection propaganda, and that the conflict had little to do with the rights of workers and much with a political power play. While government officials, unions, and many representatives of the media still denied the presence of terrorism, the immediate participants in the mine conflict found it intensely at work.

We cannot decide here where the documents that Pareja shares with us — including those that contain wild accusations against her and other members of her family — contain truth or falsehood: Were the workers justified when they called the strike? Would they have acted aggressively even without the influence of Sendero? Did the police fire wildly into a peaceful crowd of workers, or did they have to defend themselves from a stone-throwing, partly drunk crowd of workers who were trying to force a confrontation and were on the verge of a killing

spree? The statements of a leftist politician whom Pareja called on for mediation are too general to be helpful. When an accord was finally reached, the strikers celebrated it as a victory since Pareja made some concessions, like firing the representative whose dismissal of two union leaders had started the trouble. The union had considered the whole conflict as caused by reactionary and imperialistic forces opposed to the new government and still under the influence of the military government. Pareja comments: "What we intend to offer here is not a justification — if that would be possible — of the role we played in that conflict, but to denounce the tremendous political manipulation of the [unions]."[41]

Many of the documents she includes in the book seem to prove her right. We can learn, however, something more from the work. Neither newspaper reports from the left or the right nor government reports nor historical essays can alone give us a picture of how violence is caused and experienced. Eyewitnesses, in spite of the limited perspective inherent in their viewpoint, can provide a deeper insight, especially when it is undergirded by much "objective" knowledge.

Piedad Pareja Pflücker has followed up her book on the mine strike with a study of terrorism as it affected municipal governments over nine years (1980–89). This book, co-authored with Eric Torres Montes, details in essays as well as statistics the immense loss of lives and local government structures caused by Sendero's tactics of assassinations and bombings. It also wisely counsels that the arming of civilians is not an appropriate answer to the breakdown of the political infrastructure:

> To arm the general public gives the impression that the state is avoiding its primordial responsibility to guarantee security and internal order. The police force can fulfill this purpose. In emergency situations like today the president can delegate the control of internal order to the armed forces.... To arm the civilian population means to plug into the very logic of terrorist violence.[42]

It is to be hoped that the Fujimori government listens to witnesses like these.

# WITNESSING IN DIFFERENT FORMS

## Voices of American Indian Women Today[1]

Mariella Balbi and Piedad Pareja Pflücker come from the highly educated Peruvian elite. What about the voices on the opposite side of the spectrum, the voices of indigenous women in Peru, those who suffer most from the war situation? We might remember that about 46 percent of the Peruvian population is Amerindian, 37 percent is of mixed ancestry (mestizo), 12 percent is "white" or *criollo*, meaning of European descent, and 5 percent is African or mulatto. The largest ethnic groups are the Quechua and the Aymara. For years, Quechua was officially the second language of Peru. Many of the migrants to Lima do not speak Spanish at all, and the level of illiteracy among them is imaginable when we consider that in the mountain area of Ayacucho, from where many of them came, seventy of every one hundred women are illiterates. The resulting public "silence" of indigenous women — or our ignorance of their voices — is especially tragic in view of their rich cultural heritage. As Robin Kirk says in her report on Peru's internal refugees, "Ayacucho, once the rich heart of modern Andean culture, is now a society modelled on war. Most of its weavers, painters, sculptors, and musicians have left." The war, says Kirk, "is low intensity only for those who do not live it."[2] When out of this situation we want to hear the voices of indigenous women, we have to quilt them together from various odd sources. Sometimes the voices of those silenced by murder seem to rise from the lips of their children. As a fourteen-year-old boy from a Lima shantytown recounts:

> From the hill, we saw how they killed all the people. They also burned the houses. After they left, I returned with my

grandmother. They had gouged my mother's eyes out. They had also slit her throat and belly. She lay with my father, both full of blood. . . . My three brothers and sisters and I stayed with my grandmother. Then my youngest brother died. He was two years old. An uncle brought us to Lima, because my grandmother could no longer care for us. . . . I don't go to school. I sell cigarettes in the street. That's so my sisters can eat.[3]

We cannot expect what is usually considered "great literature" to come from women who "live war" every day. We can only hear the desperate voices of the survivors. "We came without eating, cold all night long, and I had only given birth two weeks earlier," says a refugee woman in Lima.[4]

In Ayacucho guerilla violence started in 1980, and the government soon practiced massive retaliation. The people were caught between two fronts, each one trying to coerce them into cooperation. Over the years thousands were murdered or disappeared. Every day long lines of peasant women wait outside government offices and police stations hoping for news of their loved ones. Three hundred family members of the missing have formed the Association of Family Members of the Disappeared, which is affiliated with the continent-wide Federation of Family Members of the Disappeared (FEDEFAM). Señora Guadalupe is a member of the Ayacucho Association. She has travelled to national and international human rights conferences to meet with women from different countries who share her plight:

> What drives us on is our missing family members; we want to see them because we have children. I am the mother of four children; my husband was the economic support of the family, and when my children ask about their father, what am I supposed to say? . . . We are here asking for justice, for the freedom of our family members, and if not that, then, well, if they are guilty, let them be tried in the courts; that's why there are laws. . . . We are prepared to take on any kind of risk, so that there will be justice.[5]

Besides the relatives of the disappeared, there are the women who are themselves direct victims of violence. As Linda Rupert writes,

Juana Lidia was arrested and falsely accused of terrorism by the military in August 1984. She was tortured and gang-raped for one week, before being released to the hospital under police guard. The military had a reason for wanting to silence her: her testimony at an upcoming human rights trial implicated members of the Armed Forces in the brutal death of eight Peruvian journalists. The government did nothing to protect her although Peruvian and international human rights organizations have taken up her case. Here is her cry: "What more evidence do they want? They killed my two brothers in Uchuraccay. They just killed my sister and her son. The Marine Infantry tortured and raped me and my entire family has been threatened with death. What more evidence do they want? They're going to kill us all....Who can guarantee my safety? Haven't they threatened to disappear me, to kill me?"[6]

I will later describe how this woman, Juana Lidia Argumedo, survived to become a singer, sharing the story of her suffering and hope in music.

At a Lima conference of Women in the Media in February 1989, Rosa María Alfaro, a professor of education and communication, presented a paper on the topic "Comunicar entre violencias: Una estrategia de paz" (Communicating in the midst of violences: A strategy of peace). "Communication is a type of legitimation," she said. "Speaking is a form of being, expressed and underlined." "To tell means to validate a lived experience."[7] With this understanding the conference organizers had invited a peasant woman from the Andes to give a *testimonio* to the gathered media representatives about her experiences. This thirty-three-year-old woman, Francisca, describes her life, and her words clearly indicate what we learned from the fiction-writing women and from the sociologists: that domestic and political warfare are intricately connected. Francisca comes from the province of Ayacucho, was abused by father and stepmother, and grew up working in the fields.

I left the house of my father because I could no longer stand being beaten, and I went to live with my sister and her family, but they too beat me.[8]

She had all in all about three months of school, got married at fourteen, and earned money by washing and cooking while her husband worked in a factory. Then the political violence starts: Her husband's employer, a mayor, is murdered by guerillas. Her husband turns to drink and beats her and the children. Then the soldiers come, killing at random:

> Actually they did not examine the people closely, but killed for the sake of killing....Nothing happened to me, but I have seen many cases, for example, my neighbor who had a restaurant, they kept her for two weeks....They killed her by carrying her to the mountain. They cut her throat as if she were an animal.

She describes how the soldiers abused the women in front of their men. She sees so many cadavers lying around that she loses the taste for meat and rice. She moves with her husband to Huancayo, but the people there suspect them to be terrorists since they are from Ayacucho. Finally the husband takes off to find a job in the jungle area. Francisca now has to take care of four children by washing and knitting. She sends the oldest daughter to Lima to work as a maid, and she can no longer keep the other three children in school because she cannot pay for books and school uniforms. She lives in a rented apartment in Lima without running water or electricity. When she once managed to visit her home village in order to sell her house and the belongings she left behind, she found hardly anything. She then joined an organization of women with similar experiences.[9]

The testimony speaks clearly of the pain of communication:

> They accuse us of aiding the terrorists and order us to tell them who those *compañeros* are. If we don't know any, what are we going to say so they won't kill us? Whom are we going to accuse, just arbitrarily; those who have been *compañeros* know it in their heart, but what really can we innocent people say? Since we are ignorant, we don't know how to handle this politically.[10]

Every word here becomes a trap, and as Rosa María Alfaro puts it, "To torture in order to make somebody talk and to kill if somebody talks 'too much,' that is the law of power in Peru today. The word is cause and object of violence."[11]

However, telling a story, as Francisca did, to people who are eager listeners gives women self-respect, hope, and identity. Moreover, in sharing these experiences within an organization and with certain authorities, women can gradually gain political influence. The same story that might be "cause and object of violence" can also have liberating power.

Thinking once more of Angélica Mendoza de Azcarza, president of ANFESAP, the Association of Families of the Disappeared in Ayacucho, we can begin to appreciate the international impact a woman's story can have. In a 1991 interview in New York, she once again narrated her experiences: the forcible abduction of her son, the founding of her organization by forty women on September 2, 1983, their discovery of mass graves with bodies that definitely showed signs of torture and mutilation, and their present work of caring for 240 orphans from the area of Ayacucho whose parents died or disappeared in the "dirty war." At this point she explained that not only have members of the military ordered her to abandon her work, but Sendero has inquired into her sources of money for the organization. This fact did not keep the Fujimori government in the fall of 1992 from putting Angélica on the list of sympathizers of Sendero Luminoso, and she is therefore now in hiding. It is generally known that this list contained many names of innocent people who simply worked for human rights.[12] Angélica's life, then, is in constant danger, but, as she said to Mariella Balbi, "If all of us do not shout, they will kill us like dogs."[13]

Peasant women like Angélica Mendoza have an uncommon strength that has deep roots in their Andean history. They have been steeled for their present-day war experience through centuries of warring for survival. Many Andean women are still instinctually aware of the power they held in pre-Conquest communities. There was a tradition of a relative gender balance, of separate but complementary roles of men and women, and of matrilineal inheritance rules. Andean women are conscious also of their individual strength, which is handed down from one generation of women to the next.[14] Supported by a strong *ayllu,* or network of matrilineal kinship, these women still today sing in their work songs about their *supay,* or spirit force, originally received from *Chacra Mama,* Mother of the Fields, a mythical figure credited with teaching humans about cultivated plants and

still aiding women if called upon. Some of the Quechua women's songs express a fighting spirit in reference to the men whom they are certain to be equal to:

> I am, perhaps, man-woman.
> I will do all kinds of work.
> I'll only lie down to die.
> Now, for sure, I'm on my feet.
> Spirit force in the *chacra* (field).
> [Nothing] will be lacking [in me].
> Nobody will equal [me].[15]

It is important to know that the *supay*, or spirit force, can also have a "devilish" connotation, especially since the Spaniards used the term to point to the devil. *Supay* can represent good or bad spirits, although it usually carries positive connotations.[16] Knowing the ambiguity of *supay*, we might better understand the thoughts and words of Sendero Luminoso women who indeed appear "devilish" to a large part of Peruvian society, whether they are Indian, mestizo, or *criollo*.

Not only Sendero women, however, are feared and persecuted. We have seen what happened to Angélica Mendoza. Many innocent *campesinas* (country women) are suspected of being Sendero sympathizers and are treated like devils by antisubversive government forces. An example is the already mentioned Juana Lidia Argumedo. Amazingly, she has survived disappearance, torture, and incarceration to become a popular singer, sharing in song her own fate, which mirrors that of her people, the Indians and mestizos of the Ayacucho area.[17]

Juana Lidia was born in 1956 in a village of the district that experienced the highest number of murders, disappearances, and other violent acts from the left as well as the right. The meaning of Ayacucho in Quechua, "Corner of the Dead," appears tragically fitting. When on January 26, 1983, Juan Argumedo, a brother of Juana Lidia, accompanied a group of eight journalists on a fact-finding mission because they wanted to discover the circumstances behind the recent murder of seven young men in a nearby village, he never returned — nor did the journalists, among whom was a half-brother of Juana Lidia. Close to the village of Uchuraccay they had all been beaten and savagely killed. Juana Lidia later found the place where her brother's body had

been dumped. Up to this day, the case has not been closed, although in 1987 three *campesinos* were sentenced to six to ten years in prison for allegedly having been involved.

When in 1984 the first trial for the case had been set and Juana Lidia was to be a witness, she "was disappeared" while going to the market on a Sunday morning. Today she credits her mother with saving her life through relentless inquiries about her whereabouts. She had been taken to a military post in Tambo, her hometown. The installation is known as a place where torture is practiced. After a month of most severe abuses she was delivered to the special police and was supposed to be charged as a terrorist. She was, however, unable to testify in the case of Uchuraccay or stand trial. The court ordered her to be taken to the hospital where she was to spend the next four months in slow recovery. That she lived through it all gave her the name "the survivor" among her people.

While in the hospital, she had lost the will to live, but it was the music that brought her back to life and gave her hope. Before her disappearance, she had been singing only with her family, but now she felt the desire to reach a wider audience. "If you talk with the people," she said, "you can perhaps explain things to one person or another. But when you compose a song and in it talk about the injustice, then it will be carried further; then people will understand and you will get support, because more and more people will demand justice."[18]

After many operations in Lima, Juana Lidia was well enough to give her first public concert, supported by the women of the Flora Tristán Center. She later married a musician and still lives today with her husband and two small children in Ayacucho, despite another short arrest in 1989 and repeated threats of death. She taught music to children of disappeared parents in order to help them overcome their trauma, but the level of violence escalated to the extent that the organization sponsoring her workshops could no longer function.

Two songs might here give an inkling of Juana Lidia's simple style. She adds to the traditional Ayacucho form of the *huayno* a contemporary note, and she prefers to sing in Quechua, although she also uses Spanish or a kind of "code-switching" mixture of Spanish and Quechua.[19]

### THEY TOOK ME PRISONER

At the outskirts of my village,
in front of my house,
they took me prisoner,
they carried me to the jail.

I don't know why,
I don't know for what
I am imprisoned,
how long I will be held.

Don't cry, mother,
don't worry, father,
your daughter simply is in jail,
your son is just imprisoned.

Suddenly I understood,
suddenly I realized:
It was because I loved,
it was because I showed love.

*Fuga:*
Fate,
carry me away from here,
I want to die far away from here, alone.

### QUERIDO TAMBO[20]

Beloved Tambo
my dear Tambo,
here is your daughter,
longing for you today,
singing your praises today.

Today I am here,
and tomorrow no more.
But your name
I will never deny.

Tambo, my home,
place of my agony,

you are the witness
of all my suffering.
*Fuga:*
Tambo, how sweet your name,
home of valiant men.
With our blood
we will make fertile your soil.

Juana Lidia's songs are not what we usually consider protest songs. Most of them are *dulce* and *triste*, sweet and sad at the same time, and yet they refer to concrete injustices.[21]

Not all Indians and mestizos are fighting nonviolently, with words and songs, for survival and justice. Some feel they have to arm themselves, either by joining the guerillas or, as in most cases, by fighting them. Some have been forced by the state to bear arms.

The present government of Peru has made a point of befriending certain native tribes in order to arm them and have them help the military in fighting Sendero Luminoso. Especially the Asháninkas, who have fought Sendero independently for many years, have been publicly praised for their *rondas*, meaning armed self-defense groups.[22] Critics say the government is thereby increasing the general level of violence and is simply exploiting the ancient warrior spirit that in certain tribes is more prevalent than in others. While the participation of women in the traditional self-help *rondas* is very limited, President Fujimori made a special point of parading a group of armed peasant women in front of the Air Force Administration building during the national holiday celebrations of 1991 (see the photograph on p. 63).[23] Looking at the guns these women are shouldering and considering all the dynamite that Sendero uses, I am reminded of the young daughter of Antonia Moreno de Cáceres who broke into tears when she saw a group of primitively armed Indians march into battle against the Chileans. She feared they might be killed like dogs. Not much has changed since the 1880s in terms of indigenous people being used in the name of national defense. Nobody would dream of parading a detachment of middle-class Lima housewives or professionals with guns on their shoulders.

We should not forget the African element in Peruvian society. The first blacks came to Peru in the sixteenth century, and the

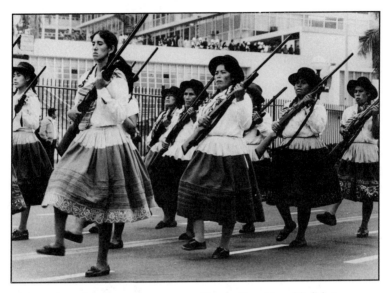

A *ronda* of armed women parading on the national holiday
(July 28, 1991) in front of the Air Force Ministry building in Lima.

black influence on Peruvian culture is so strong that the historian
María Rostworowski insists we have to talk about an encounter
of three worlds, not two, when we consider the country's colonial
history.[24] I will describe later the life and death of María Elena
Moyano, who represents the black heritage of Peru. In contrast
to the United States, however, the Indians constitute such a large
part of the population in general and of the poor Peruvians in
particular that racism is hitting them especially hard. Sendero is
taking advantage of this fact, but masses of the indigenous peo-
ple have built up their own defenses against Sendero violence
as well as against government violence. Wherever they are not
only eyewitnesses of war, but also witnesses to the power of non-
violence, they usually draw strength from their own traditions.
That does not mean they are aloof from the modern world. In
fact, they are blending Andean and Western traits in ambiguous
and fluent ways, culturally as well as spiritually.[25]

There is the example of María Sumire. She is a Methodist
laywoman from Cusco, the Andean city near the Incas' sacred
mountain of Machu Picchu. She is proud of her Quechua her-

itage and of the fact that she comes from an area where over two hundred years ago Micaela Bastidas established a tradition of women's resistance to injustice. María helps her husband, who is working in the administration of Cusco's university, in pastoring many Methodist congregations in the area, small groups of people that can be reached only by walking, sometimes for hours or days. María also, however, does her own work. She leads interdenominational women's groups and keeps them in contact with people and institutions in Lima. She edits a newsletter with information about churches in the whole Andean area and distributes material about human rights — with many pictures so that people with little literacy can understand it. She does crafts work with women's groups and with political prisoners to provide people with extra income, and she sings and speaks before many groups. In Lima she knows how to raise her voice for the rights of the Indian people from the highlands when the sophisticated church representatives of the capital would rather ignore her great stubbornness. She is also a representative to the Association of Methodist Churches of Latin America. In recent years María has studied law at the University of Cusco, and she hopes to finish her degree work soon. She knows that only with the knowledge of Peruvian law can her people insist on their rights, and only by getting their rights will they be able to resist the violence of guerillas or government forces.

As María talked about these things during a visit of some theologians from North Carolina, she did not show the group the beautiful old churches of Cusco, but the hidden places in the mountains around the city where the Incas celebrated their rituals, gathered herbs, cured the sick, built irrigation systems, dug underground tunnels, and listened to the voices of their deities in rocks and rivers.

María and her family are now, in 1993, considering leaving the Methodist Church of Peru, which in their opinion never acknowledged the indigenous mountain churches and their lay pastors as equal partners. Paradoxically, this is happening when the Methodist Church of Peru finally has a Quechua bishop. It is very difficult to judge right and wrong in this struggle. It is mentioned here only to show that the gulf between *criollos* and Quechuas or Aymaras, which has existed for five hundred years, is still far from being bridged and has even created tensions within

the indigenous community. The old spirit of resistance erupts in ambiguous ways, for example, in women like María Sumire. It would be foolish to romanticize the heritage of the Incas, who represented another type of imperialism before the rule of the Spaniards. Pre-Columbian cultures, however, also contained elements that modern Peru can forget only at its own peril. Communal organization, a sense for the needs of the land, a tendency to balance all contrasting forces of life — these are merely some of the traditional Andean traits that any witness for peace today has to take into consideration. While the life of Andean peasants has been changing fast — not only among migrants to the coast, but also in the mountains — modernization has not extinguished the inherited power of resistance to any authority felt as oppressive.

## Women of Sendero Luminoso

In a highly controversial article published by *NACLA Report on the Americas,* Carol Andreas gives us a very sympathetic picture of Sendero women. She contends that women are attracted to Sendero in much larger numbers than men, that many of the military operations of Sendero are headed by women, and that the phenomenon can be explained by the "breakdown of traditional Peruvian society, particularly in the highlands over the last thirty years."[26] While men have been recruited into factories, mines, and farm cooperatives oriented toward export, women increasingly had to fend for themselves, defend communal lands, and keep alive the traditional rural culture without being able to participate in political leadership. Since Sendero is promoting the overthrow of all structures that serve national and international commercial interests and wants to establish local "people's committees" that redress old wrongs and redirect agriculture to the immediate needs of the villagers in a "subsistence economy," many women are eager to participate in the new order.

Sendero's work toward abolition of prostitution, delinquency, drug addiction, and domestic violence is another attraction for the long-oppressed women, according to Andreas. When she asks a female leader of Shining Path how she, a well-educated professional, could submit herself blindly to the authority of a powerful male, while she did not even let her husband know

about her clandestine political life, the woman answered that "having overall leadership that was dependable, not vacillating, was an inspiration." Another woman explained that "El Guía" or "El Presidente Gonzalo" (Abimael Guzmán) "asked revolutionary cadres to envision constantly the kind of society they would like to achieve, and to be ready to overcome every obstacle in the realization of that vision."[27]

Andreas does not mention that today Sendero wins most of its followers among people who know little of the peasant tradition, who are predominantly lower middle-class mestizos and feel excluded by the *criollo* elite. As Carlos Iván Degregori points out, ethnic cohesion plays a role in Sendero, but it is not an indigenous movement. It is a Maoist ideology that fits in with certain Inca traditions and accommodates, or makes use of, the needs and expectations of oppressed indigenous peasants.[28]

The now forbidden newspaper *El Diario*, which is known as the mouthpiece of Sendero Luminoso, in May 1990 carried an article on "the new type of woman" that is being "forged by the people's war." Women are not only incorporated into the class struggle, but they take leadership positions in certain "precise attacks against the reaction" — this probably being a euphemism for Sendero women's known role as leaders of assassination squads. " 'At first I was afraid to join the party,' " a nineteen-year-old woman named Deyanira is quoted as saying, "while her large and vivid eyes were glowing."

> Now I am happy, I feel more secure, I have started to live more intensely. I have understood my responsibility, and that is what counts. I understand the class struggle, and I participate in the offensive of the world revolution that is being created in Peru, that is what counts.…
> The first task the party gave me was to organize schools for the people of the different settlements of the capital. The main goal was to help them understand why it was necessary to fight for the destruction of this unwieldy old lump of a state, this bureaucratic land-holder.

The article emphasizes once more that Deyanira's eyes kept glowing while she explained that after a while her family no longer believed the pretexts she used for covering up her party activities.

If we center ourselves in the family, nobody can accomplish anything; it would just be individualism. The party needs perfect and complete combatants, not leisure-time warriors. The challenge is also to do the political work with our families, to seek their assistance, that's what counts.[29]

A large part of Sendero training and "conversion" has been going on in Peruvian prisons, although President Fujimori has stopped this practice as much as possible. Listening to the voices of women prisoners in the 1980s, we can understand how the mind of the present guerilla generation was shaped by party ideology. An unusual report on the conditions of a Peruvian prison is available in the German documentary narrative by Ingrid Bettin, *Seele aus Stein und Taube* (Soul of stone and dove).[30] Bettin is a German writer who with her husband and four children lived in Peru from 1981 to 1986. Two years later she returned to Peru to meet the widow of the renowned Peruvian writer José María Arguedas (1911–69). His life work was dedicated to the rediscovery and revaluation of indigenous culture and language. His widow, Sybila Arredondo, a Chilean woman, was arrested repeatedly and since 1990 has been again in prison. The Supreme Court of Peru in March 1992 sentenced her to prison for five years. The accusations go back to 1985 when she was found in a meeting place with other Sendero sympathizers and on another occasion in a car that carried weapons.[31]

Ingrid Bettin visited her in the huge prison of Canto Grande on the outskirts of Lima in 1988. She felt overwhelmed by what she saw: The political prisoners happened to be celebrating the anniversary of the prison massacre of June 18, 1986, when the government had responded to an uprising of prisoners — who had long been petitioning for more humane treatment — with the killing of nearly three hundred inmates. There had been general outrage when it became known that more than a hundred of the prisoners had already given themselves up before they were shot. Now Bettin found prisoners celebrating, singing, sharing a small food supply brought by friends and relatives, and enthusiastically supporting the cause of Sendero. In contrast to the imprisoned "ordinary criminals," the political prisoners were well organized and highly disciplined, fighting for cleanliness and basic human prison rights and using their incarceration as

an opportunity for teaching each other any subject they knew, above all the principles of Maoist revolution. "We are not terrorists," declares a woman named Teresa when Bettin asks her about the prisoners.

> We are in the midst of a war; we understand ourselves as prisoners of war and want to be treated as such. That was, among other things, also the point of the prison uprisings in the three prisons [in 1986].... To brand the armed struggle, which will introduce the world revolution, as terrorism is the evil method of inciting the masses against us. They are supposed to think of the kind of terrorism growing out of anarchic and individualistic motives that we are strictly against. We are not criminals and will not tolerate being treated like them.[32]

Teresa describes what they are able to teach each other in prison, like sports, music, literature, political science, crafts. She then communicates in terms of the party line:

> We have taken sides with the proletariat of the world. The proletariat will constantly lead the peoples of the world toward communism, the only and unique New Society without exploited and exploiters, without classes, without state, without parties, without weapons, without wars. Beforehand, however, humankind will experience class struggles and civil wars of unimaginable severity. The weapons in the hands of the people will finally beat the counterrevolution, will eradicate imperialism and change the face of the earth.[33]

Bettin is bored with this type of rhetoric, but her visits to Canto Grande have opened her eyes to the fact that "the prison, which is supposed to break the strength of the revolutionaries, is the party school of the revolution."[34] While she is unable to spend much time with Sybila Arredondo, she learns from her and her daughter that both stand enthusiastically with the Sendero women, supporting their struggle. Thinking of the joyous celebration in memory of the prison uprising, Sybila tells Ingrid that her husband, Arguedas, would have been very happy to see this day:

That was what he wanted, to change the society, to prepare the revolution. He suffered for the people, his Indios, and fought against the class society and the exploitation. He was desperate because he did not see any justice in this country, only oppression and shameless exploitation and a disdain for the people. He would have seen [today] that something is happening, that his people are waking up and gradually learning to resist by all means.... The time of waiting is over, the storm is breaking loose, we have been quiet for centuries, have hoped and prayed and waited. This society has to be changed, meaning changed by force, with weapons, because they laugh about the tolerance of the masses, their capacity to suffer, their patience.[35]

Away from the prison, Ingrid Bettin asks a woman friend, Zoila, the wife of her children's former swim teacher, what the people in her settlement, Comas, at the edge of Lima, think of Sendero Luminoso. Zoila answers that apparently more and more people sympathize with Sendero.

That does not mean they cooperate. Look, all parties have their mouth full of promises, and our situation is getting worse every day. People hope that Sendero will help; at least, they assume Sendero is on the people's side. Here in Comas there are probably many sympathizers. You should have been here after the massacre of the political prisoners in June of 1986. You should have seen it! Comas was red. Everywhere, on every house, on the hills, suddenly there were red flags.... People do not understand the actions of Sendero, but they accept them. They have gotten used to them [e.g., the dynamiting of power stations and the resulting lack of electricity]. What do we care about the hours of discussions on TV about the government's taking over the banks? Who of us knows what a bank looks like on the inside?... We are interested in feeding our children.... No, we don't understand anything of politics; we only want to live and give our children a better education than we had.[36]

"Are Senderista women reclaiming a 'warrior calling'?" reads a caption in Carol Andreas's article.[37] Perhaps they are, but women warriors in another sense are those who like Zoila fight

for feeding their children or help to provide "a glass of milk" or a community meal to other people's children. Carol Andreas insists that the Shining Path movement from the beginning addressed the special needs of women, e.g., through the work of Abimael Guzmán's wife, Augusta de la Torre, "credited with pushing her husband to move beyond armchair theorizing about revolution." Other observers, however, strictly deny that Sendero promotes gender equality. As Julia Vicuña writes in an essay published by *VIVA*, the journal published for several years by the feminist center Flora Tristán: When a woman enters Sendero, she becomes masculinized. While indeed the movement started emphasizing the work with women around 1984, every Sendero woman has to prove that she is "more macho than the man."[38] Vicuña quotes the Sendero leader Laura Zambrano Padilla, who stated, while a prisoner accused of terrorism, that

> Sendero presents to its militant members *war as daily life*. . . . Feminism is a bourgeois theory based on the sexual opposition between men and women. It seeks to oppose the development of a feminism led by the working class and through the Communist Party by way of *the people's war*.[39]

Margot, the cousin of a militant Sendero woman, is quoted by Vicuña as saying that Sendero women and men are involved in the same actions, but that the women are still subject to male control. They have to take care of the comrades in prison; they might be able to choose a partner for sexual relations, but they can usually marry only a designated man who is above them in rank. If they get pregnant "by mistake," they have to abort or leave the party[40] — the latter meaning total isolation since Sendero will always try to find and kill any traitor to their cause, and society at large will never trust a former guerilla.

Why would teenagers choose this kind of life? Gonzalo Portocarrero and Elisabeth Acha have tried to discern what lies at the root of violence perpetrated by young Peruvians. They emphasize three points: (1) a childhood of suffering, whether simply from poverty or from some authoritarianism; (2) an ideology that promises improvement if the individual participates in a struggle to destroy the evil forces of society; and (3) the gradual erasure of the taboos surrounding the use of violence, a process intensified by media violence.[41] The two authors base their analytical study

on a series of statistics as well as individual *testimonios* by some of the young people they interviewed. Among them is Raquel, a twenty-two-year-old woman from one of the older, deteriorating districts of Lima. She is the youngest of eight siblings who often felt humiliated by her father, a man interested only in making money and having a good time, including having various women. Raquel was ill-treated also at school. Her mother was submissive and silently suffering. Raquel tried hard to run a little store from her home and to study education, but the money was never enough to succeed with either plan. Consequently, she was often depressed.

In 1988 Raquel was asked by the interviewer what she thought of Sendero Luminoso. Her answers are rambling and sometimes contradictory, but they reveal her instincts and sentiments.

> As to killing, they do kill, but rich people, not peasants....
>
> It would suit me if [Sendero] would accomplish a few things, like make it possible that those who have money would give it away...and that such money would be shared by all equally.
>
> Those who destroy people or electricity towers...perhaps...are people who become aware of something, you see, perhaps people are like that, there will always be killing, but I don't believe that Sendero does these things.
>
> Well, one has told me that Sendero accepts...young people that have gone through a process, those who know much or are the most desperate, those people enter Sendero, they are, if you want to put it that way, the most intelligent ones.
>
> Those who today have money are those who exploit everybody, all the Peruvians.... And that is what we don't want, and perhaps in this respect some killing is necessary.[42]

The interviewers conclude that Raquel considers Sendero an elite of intelligent young people. She is ambivalent about their violence, but seems to condone it when it is a matter of punishing rich people.

She was also asked what she thinks of the upper classes, and she says,

They come from other countries. They have money and come here to make money, right? Or let's say they take away some of what we have.... When they communicate with the people from the sierra who, you know, are somewhat innocent, ... they exploit them all the more.[43]

Raquel then vents her anger on the younger generation of the upper class who think of nothing but enjoying themselves and wasting money on luxuries. She is indignant about the light-skinned ladies in Miraflores (the wealthiest part of Lima) who talk about spending millions of dollars.

It becomes clear, then, to Portocarrero and Acha that Raquel has a Manichean worldview of good and bad people; that her sentiments, which are clearer than her opinions, lead her to accept violence, and that violence to her is not a last resort to build a better world, but a natural reaction to oppression — vengeance pure and simple. The revenge that she would condone has little to do with the specific sins of particular persons, but is an instinctive revenge against hated structures. She does not want to become a long-suffering martyr-victim like her mother, and she hates in the young wealthy people what she hates in her father: focussing only on money and enjoying oneself at the expense of others.

The example of Raquel shows that a completely different discourse determines the lives of poor people. Violence to them is first of all the way of life they have been forced to live — for generations. It is a kind of daily war. The hopelessness of their situation is reminiscent of the lives of black slaves in the nineteenth century when armed violence seemed the only way out of the structural violence of slavery. This comparison becomes understandable when one considers Ingrid Bettin's points about Inca beliefs. In the Inca traditions, nothing is only good or only bad. Everything exists in complementarity: light and dark, above and below, frost and heat. What is down will rise, what is up will decline again. History moves in cycles; cultures will disintegrate, but a new order will arise out of an earlier one. The expectation of an apocalyptic turning point that will bring justice to the poor is very similar in the traditions of Andean people and in those of black American slaves. In both cases the apocalypse is not seen as the end of all time, but as a sudden destruction of all oppres-

sion and a liberation of the enslaved.[44] Therefore the future is seen as bringing terror and redemption at the same time. Rosemary Ruether has rightly observed that apocalyptic visions are "a way of coping with incomprehensible and seemingly unmanageable social chaos." In certain groups "the extermination of evil is... tribalized.... The impulse to apocalyptic thus becomes genocidal, the extermination of those people who are seen as 'Satan's people.' "[45] According to Carol Andreas, women are especially open to the idea of a complete turning over of the old world order, and they aggressively help to make it happen "because they suffer a double repression, that of their own sexual companion and of a society governed by men."[46]

The capture of Abimael Guzmán and his companions on September 12, 1992, in an innocent-looking middle-class home of suburban Lima has focussed public attention on the women working for the movement in leadership positions. A huge television audience suddenly realized that they were all well educated and looked like normal Peruvian citizens. There is first of all Elena Iparraguirre, considered the mistress of Guzmán and number two in the movement. She is the forty-five-year-old widow of another revolutionary leader and has studied psychology. The above-mentioned Laura Zambrano had been a teacher. She was imprisoned in 1982 and 1984 and again more recently, but the intelligent lawyer Martha Huatay, who was captured about five weeks after Guzmán and the others, had managed to get her once more legally free. Huatay was president of the Association of Democratic Lawyers, probably a front for Sendero sympathizers, and had also defended Sybila Arredondo. There are furthermore the psychologist and computer specialist María Pantoja Sánchez, thirty-nine years old, and the professional dancer Maritza Garrido Lecca, twenty-six years old, whose dancing school in the suburban house was a front for Guzmán's hideout.

The whole capture appeared to many TV viewers like a soap opera, especially since Maritza's uncle, the internationally famous composer Celso Garrido Lecca, happened to be caught, together with his mistress, also a dancer, at the same location and time, presumably not knowing anything about the hidden inhabitants of the house's second story and simply dropping by because his woman friend was preparing some dance event together with Maritza. These two visitors were set free after a few

days because of international support for them and because Garrido Lecca's ex-wife communicated from Chile that Celso was certainly not a Senderista, only a woman chaser who followed his dancer mistress around. While these two, then, were no longer of public interest, people speculated on the communal life of Guzmán and the women who lived in his house. The police and some journalists made the most of some ladies' underwear and a good number of empty liquor bottles in the house and concluded that the capture was preceded by "orgies of liquor and sex."[47]

Nobody was able to confirm or deny this, but experts on the Sendero syndrome emphasize a very different point. The movement is organized like a cult, with fundamentalistically interpreted sacred texts, a revered leader, and an apocalyptic or millennial spirit. Many of the women feel an almost mystical devotion to the father figure Guzmán and to the "cause." They also receive a special name when they enter the party. When the police wanted to arrest Guzmán, Elena Iparraguirre (in the party known as "Miriam") insisted that they had no right to "touch him." When in prison she was allowed a last goodbye to Guzmán, prison officials expected to see an amorous kiss and embrace. What they saw instead was her hand offered to him like the hand of a Virgin of the Sun greeting the Inca, as Mariella Balbi was told. Whether there are sex orgies or not taking place among Sendero members, many of the women might simply be reacting against the traditional Latin American image of women as child bearers and housewives, and their participation in a "cult" makes up for lost family and church ties.

Feminists have always argued that "giving voice" to women will empower them: "To name is to cure...and it's women who must do the naming."[48] It is a valid question, however, whether we want to "empower" Sendero women — or any other women and men who commit cruel acts of violence — by giving them their voice. The answer is for me that we cannot afford to keep any part of society silent. The atrocities committed by the Peruvian military and by paramilitary death squads, the long-range, mostly hidden cruelties inflicted on whole nations by the international financial system or some transnational corporations — all of these have to be named, and the public has a right to hear the arguments from all sides, including from those who seem to be the most guilty ones and especially from those who have

always been silenced or ignored. Where voices are suppressed, more enemy images are taking on mythical proportions. Every accused criminal has a right to his or her voice. Many Peruvians were astounded when President Fujimori paraded Guzmán in front of the public like an animal in a cage and permitted him to deliver a public harangue about the continuation of the revolution. Maritza Garrido Lecca was able to shout defiantly into the crowd of journalists as she was presented in her striped prison clothes. Whether this was politically wise or not, it was humanly good because human beings have the right to be witnesses in their own cause, especially if they have risked life and liberty for this cause. Our own witness about war and peace has to be informed by as many other witnesses as possible. The Israeli government this year declared that it is no longer a crime to communicate with a member of the PLO. Such a move is the first presupposition for ending a war — in any country. Only on this basis the recent peace accord in the Middle East was made possible.

## Women in Folk Theater: Yuyachkani

Women's experience of war and violence can also be expressed in symbolic forms that combine the verbal and the visual: in theater or film, on banner or poster. In some cases women are not the only "authors," but the material they present focuses on women or on gender issues. There is, for example, a play by the folk theater group Yuyachkani, which has become internationally known for its innovative dramatizations of ancient Peruvian traditions, its commitment to a collective creation of plays, and a democratic understanding of the theater.[49] The group, founded in 1971, includes two women who originally were cofounders of a theater group within the Methodist student movement. Yuyachkani members live a large part of the year in the Peruvian countryside to research ancient myths and modern celebrations and to learn from the peasants about their way of life, their stories, costumes, masks, and music. While in Lima, they present their plays in schools, parks, universities, or labor unions, but also in their permanent theater near the Lima coast. In between they play in various European as well as North and South American cities.

"Yuyachkani" means in Quechua, "I am thinking, I am remembering." By re-membering ancient myths and folk traditions, they try to understand, for example, the roots of violence. The play "Contraelviento" (Against the wind) centers on two women and their father. Anybody familiar with Peruvian mythology will consider that the daughters reflect the tradition of two ancient Inca and pre-Inca goddesses, one more peaceful, meditative, and domestic, Mama Occlo, the other a pragmatic warrior woman, Mama Huaco.[50] Throughout the play, however, they are simply two young women from an Andean village who approach life in different ways. Moreover, the more meditative woman is here not at all the domestic type, but a dreamer, a true visionary. Since the narrative implicit in the play is a unique metaphoric expression of different attitudes toward violence and war, the story will be told here in some detail.[51]

The father, a kind of shaman of the community, practices a rite that allows his daughter Colla, who has the gift of visions, to relate her dreams. She has the vision that her brothers and sisters are fighting among each other; she sees that her family is being divided while the earth is breaking open and drying up.

Meanwhile the father remembers the myth of the devouring foxes: the white fox that comes down to the ocean and devours people of hard hearts and the black fox that goes up to the mountains to devour the rich people.[52] The father's only wish is to go in search of the seeds of life and to sow them in fulfillment of an ancient tradition. Father and daughter begin their travel and are attacked by Huayra, the bad wind. Colla is kidnapped, and the father sends his other daughter, Huaco, to search for her sister.

Colla has been psychologically and physically captured by a demonic couple, the Archangel and the satanic China (meaning in Peruvian colloquial language "mestiza").[53] They trick her into healing their master, the farm overseer (*caporal*, meaning also military corporal or boss), who is suffering from a mysterious illness. Colla believes she has been saved by the couple from the bad wind.

When Huaco finds out that the overseer and his people are destroying the towns and when she envisions her sister Colla among the dead, she refuses to go with the father in search of the seeds of life and instead asks the father to revenge Colla's fate.

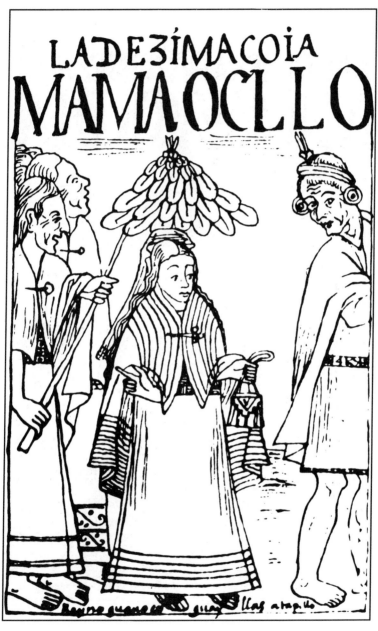

Mama Occlo, "the tenth queen," wife of Tupac Inca Yupanqui and maternal grandmother of Guamán Poma (historical queens had the names of their mythical ancestors).

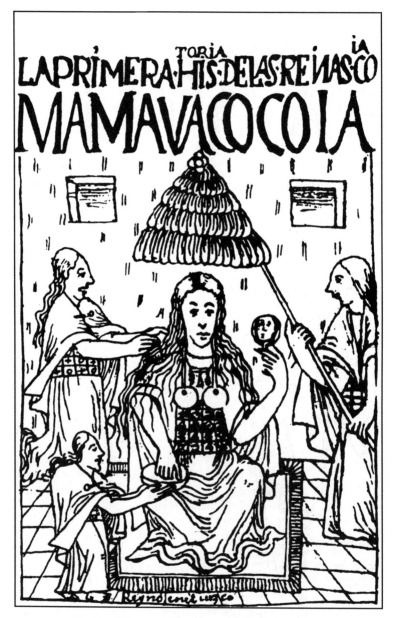

"The First History of the Queens, Mama Huaco Queen."

She herself goes as a black fox to the high mountains to fight the destroyers.

The father finally finds Colla inside a rock and learns from her visions about the continuing work of the destroyers and the spirits of the dead that cannot rest. He gives Colla of his breath and continues his search for the seeds of life.

Colla, however, now goes before a tribunal to denounce the overseer. The agony she has lived through makes her unable to speak clearly, but her father's "breath" enables her to communicate by playing the flute. She tries to let the court know that the dead are speaking to her about an unspeakable crime. The corrupt judges declare her a crazy witch and throw her out of court.

When Colla and Huaco finally meet again, Huaco tells her sister that she and others are fighting the overseer and that they discovered a secret: Only fire makes him weak. Colla replies that fire can destroy everything. So each chooses her own path; the one continues fighting, while the other starts looking for the father, finds him, and saves his life by revealing Huaco's secret to his enemies: that it is the fire (of "foxes" like Huaco) that is debilitating the overseer. When Huaco learns of Colla's "treason," the two start fighting. That means the beginning of death for the father, who has actually found the seeds of life. He accuses the daughters of becoming the devouring foxes who bring death and not life. The fighting now stops, and the daughters give back to the father breath and strength. He in turn gives them the seeds, and together they sow them. The overseer and his people recuperate. They are now in control of the fire. The father and his daughters return to the earth.

Equequo, an Aymara god and storyteller who appears in between the scenes and actually narrates the events, comes on stage once more in the end and fulfills Colla's wish: to continue telling the story and planting the corn of life:

> so that one day the sun and the moon shall meet,
> that the bull and the amaru [snake] might see each other,
> that the world will move,
> that the earth might tremble.
> It will dawn at dusk,
> and the reptiles will turn into fireflies,
> illuminating everything.[54]

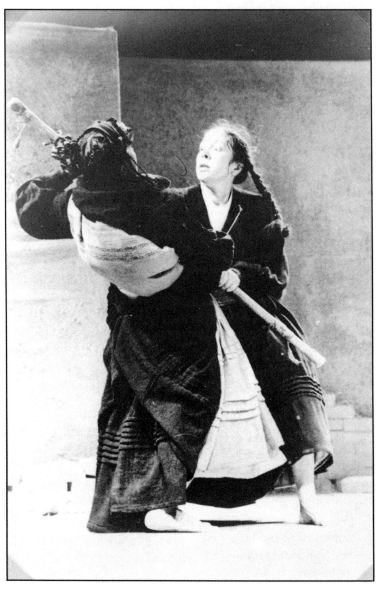

**Yuyachkani's "Contraelviento": Colla and Huaco start fighting.**

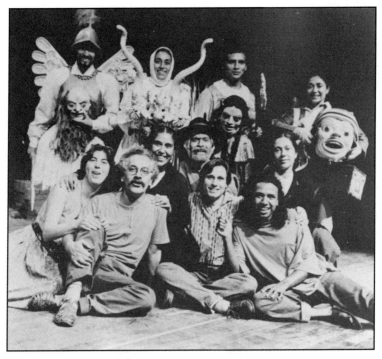

Yuyachkani: Players of "Contraelviento." The big mask at the right
is that of the storyteller, Equequo.

This summary of the narrative cannot, of course, reflect the
multitude of visual and audible means of dramatic presenta-
tion: colorful, sometimes oversized masks copied from actual
folk masks used in the fiestas; ritual dance movements in which
the roles of good and evil characters are intentionally blurred;
Andean music, traditional peasant clothing mixed with fantasy
costumes that feature angelic or satanic aspects; firecrackers and
"dust" clouds, a stark scenery of broken walls and menacing
mountains in which occasionally the human figures appear as
part of the landscape.

For the portrayal of Colla the group used the actual *testimonio*
(court witness) of a woman who survived a massacre by police
of forty-seven villagers in Soccos, near Ayacucho, in 1983.[55] The
woman was "crazed" by the experience and hid herself for one
year. Later, however, she felt urged by the spirit of her dead
daughter to tell the authorities what she witnessed. The court

considered her insane and did not want to credit her testimony of "talk with the spirits of the dead." It was in the end through her, however, that the guilty officers were incarcerated. The play portrays two women as wielding a power equal to that of the men, for good or for bad. The sisters are divided by the pressures of terror: To Huaco, only armed power ("fire") seems to conquer the political and military power of the *caporal* and his people; to Colla, the use of violence means that all life is being destroyed. The father appears at times like a Job figure, puzzled about the suffering inflicted on him and his family in spite of having lived a faithful life. He also shows, however, traits of a divinity, giving "breath" and "strength" and sowing the seeds of life. Yuyachkani interprets the father as expressing the Andean culture and its spiritual dimension and the Indian people as continually dying and yet keeping the spirit alive.

The triple dimension of father and two daughters or mother and two sons is characteristic of Andean mythology. The father can also be called an *auki*, which is actually more than a shaman, namely, a holy being with divine powers. When he gives Colla, who is speechless from pain, of his "breath," he gives her the power to be a witness in spite of herself and to overcome all odds of danger to her life, ridicule, and fear of misunderstanding. Her ability to express herself through the sound of the flute indicates that new and imaginative ways of witnessing are needed. When in the end both daughters decide to give up the armed fight because it would bring on the death of the father, we might understand their decision to give back to the father the "breath" as an acknowledgment of divine power or an awe of the spirit of life in the earth that has to be nurtured.

Militarily the three remain losers: The "destroyers" recuperate and continue their "fire." The play ends in near-tragedy as father and daughters "return to earth." The fire, however, is at least controlled, and only in renouncing the cycle of violence and returning their strength to its source are the sisters able to sow the seeds of life. "Going back to the earth" in Andean terms means they are becoming *apus*, or spirits of the mountains, where they keep alive and keep the seeds of life growing.[56] As in northern Native American traditions, sowing life, sustaining the creation, demands divine-human cooperation. Equequo continues to sow the seeds of life by telling the story — an important

act of survival for all tribes threatened by oppression or extinction. Equequo does not act himself, but the people act through him. He keeps their actions going through storytelling, and so Colla wants him to tell this story. The play ends with an apocalyptic vision of a peaceful world in which old oppositions are overcome, and Equequo throws real kernels of corn on the stage and in front of the spectators, as if inviting them to take part in the sowing.

"Contraelviento" appears to show two options for Peruvian women: to fight with "fire" power like Huaco — the Sendero option — or to act nonviolently, which means not only to be concerned with healing, but also with denouncing atrocities in court, as Colla did courageously and as, for example, the Mothers of the Disappeared do to this day. (Significantly, Equequo in this play has a photo pinned on him, just as the Mothers of the Disappeared wear or carry photos of their missing loved ones). The two options are, however, both ambiguous. On the one hand, Colla, in trying to save her father, gets tricked into healing one of the main destroyers and into divulging a secret that aids the enemies of her people. (Every contemporary war nurse is confronted with the same ambiguity of healing soldiers who soon may be fit again to kill and be killed.) On the other hand, Huaco is not a heartless warrior woman. She searches for her sister Colla when she is kidnapped and walks with her as long as she can. At the very end she agrees with Colla's decision for nonviolence.

This play is not, then, a "lesson" about women and men who act right or wrong in view of terror and war. The main figures try to make an imperfect decision to keep death at bay and to enable life to continue in its divine challenge.

"Contraelviento" has been criticized by Sendero Luminoso in their newspaper *El Diario* as well as in an article published in Hamburg, Germany, after the group presented the play there in 1992. Sendero considers the message of the play as pacifist, even though no character in the play is absolutely nonviolent. Yuyachkani, however, does not want to offer a political solution at all. The group wants instead to stimulate the national discussion on possible ways to peace. They believe that three forces have to come to an agreement if the country is to be pacified: the ancestral culture as far as it expressed social justice, the right to revolt as the right of peasants that were oppressed for centuries, and

## Yuyachkani's "Contraelviento."

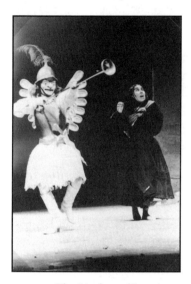

The "Archangel"
(neither male nor female,
neither good nor evil looking)

One of the ridiculous judges.

the legal forces (*la legalidad*). They do not consider it their task to show as artists how these three forces could be working together.

All the members of the group, men and women, create the plays together, from script to masks, music, and costumes. "Contraelviento" is, however, written from a woman's point of view, as one of the actors stated it. Moreover, it reflects specifically the world of Andean women where in the tradition of Mama Huaco and Mama Occlo women can be peacekeepers as well as warriors, dreamers as well as public forces. Both types of women have the power to keep the "fire" at bay and to make continuing life possible, but they put their lives on the line in the process.

The refreshing aspect of "Contraelviento" is its avoidance of didacticism. Even though coming close to being a tragedy, its seriousness is presented with much humor and satire. For example, the bureaucratic superficiality of the judges is brought out in a hilarious chatter, and the many dance movements bring a lighthearted note even to the portrayal of serious conflict. The figure of Equequo, the storyteller god of luck with the face of a wise simpleton, looks altogether "funny."

Even apart from the humorous aspects of the performance, in trying to express the ancient Andean spirit the play could not possibly feature a tidy, unambiguous moral. In Peruvian mythologies, the moral and spiritual power wins, and wise, poor people win over rich, heartless people. That never happens, however, in absolute terms.[57] There is always a remnant of evil and an expectation of some final cataclysm that will bring back the balance of the cosmos. "Contraelviento" alludes in its final apocalyptic vision of a trembling earth and the union of bull and snake to the myth of Incarrí, a story that relates to the coming of the Europeans and that is still being told in different versions in the Peruvian highlands. It tells of a culture hero who is born as the son of a very poor, abandoned mother and the father sun. Before his birth, the land is as impoverished and forgotten as Incarrí's mother. The hero, however, has power over nature and brings new hope. When Spain calls him, he builds a bridge of gold over the ocean. Before it is finished, Pizarro kills him and cuts off his head. While the trunk remains in Peruvian soil, the head is sent to Spain. It is said that the blood of his body is still alive under the Peruvian soil and that in Spain the head is growing into a whole body again. When the world turns, the Inca will come again, and all people will meet him. This is known by the hills and highlands. The highest mountains, which know everything, have seen him and talked with him. At the return of Incarrí the earth will tremble, and sun and moon, steer and snake, Spain and Incaland will be united.[58]

It is easy to see how a contemporary revolutionary movement could use such a story to stir up more rebellion and a millennial expectation. Just as with Bible stories, however, this myth can also express a vision of healing and peace that might come in painful, "trembling" ways, and in this understanding it may be seen as a background of "Contraelviento."

The basic philosophy of Yuyachkani is expressed, for example, in one of the sentences sometimes displayed at the entrance of their theater: "In their origin, liturgy, theater, and ritual were a single creative center in which actors and spectators found their common home base." It is in this overcoming of false polarities — including those of "peaceful women" and "warlike men," or politics and religion, aesthetics and ethics — that Yuyachkani witnesses to an integrated life that women especially continue to fight for.

## Gender and Film: *La boca del lobo*

If "Contraelviento" shows different options for women in confronting violence, the film *La boca del lobo* (In the lion's den or, literally, The mouth of the wolf) shows the tragedy and destructiveness of gender stereotypes in war.[59] The script for this internationally acclaimed film was written jointly by a woman and a man, Giovanna Pollarolo and Augusto Cabada; Francisco Lombardi was the producer. The three had no intention of making a statement on gender through this film — except in one of the scenes where a soldier rapes a young peasant woman. The intention was to produce a film that would stimulate the national discussion on violence, urging people to analyze what has been happening in Peru since 1980. The immediate stimulus for doing a film of this kind was the famous prison massacre mentioned earlier, but the model was the same 1983 massacre of forty-seven peasants in Soccos that Yuyachkani had earlier used for "Contraelviento."

Two characters at the center of the action are an officer, Lieutenant Roca, who wants to make up for some serious trouble in his previous military life by being successful in an anti-subversive campaign, and a young enlistee, Vitín Luna, who wants to rise quickly in his officer's career by asking for a dangerous assignment. Sendero Luminoso is a silent, invisible presence throughout the film: We see the banners it raises, the slogans it paints on walls, and the dead bodies it leaves around. We sense the fear it instills. The atrocities of the armed forces, however, are shown as well as given voice. With growing terror the audience can trace the development of an ambitious, unhappy officer who

ends up ordering the killing of thirty villagers, including many women and children, because he is unable to locate the killers of some of his soldiers. With equal suspense one sees the young soldier changing from an innocent youth into an agonized adult who manages to stay away from raping and killing peasants, but is not strong enough to avoid involvement in a game of Russian roulette with Lieutenant Roca.

Throughout the film, from the private meditations of the officer and the chatting of the young soldiers to the tense wordplay during the Russian roulette, comments are made concerning "manliness," and the film leaves the impression that the final mass murder is intricately related to a misguided understanding of manhood.

The action begins with a nightly conversation between Vitín and his buddy Quique, who reminds his friend that they will be without girls for three weeks. Vitín comments that this is a small price to pay for rapid military advancement later. With this short exchange the theme of gender roles in war is clearly indicated: women as objects for the worst soldiers, and ambition for military honor and status as objects for the best. None of the two young men suspects, however, how deadly serious their assignment will turn out to be. When in the morning Vitín raises the Peruvian flag, he suddenly sees the inscrutable faces of peasants staring at him. The next night the flag has been exchanged for the red Sendero banner without any of the soldiers on guard noticing it. When houses are searched, Quique finds hidden in some beautifully handcrafted altar pictures a sketch of the military post. The artisan is horribly tortured with burning cigarettes because he does not give them information about the origin of the sketch. An outraged officer scolds Quique and Vitín for their abuse of the peasant, who perhaps does not even understand Spanish. We never find out whether the man is guilty or not. He is to be taken to another post in a truck, but while the troops are celebrating a noisy party, a bloody comrade brings the news that the truck was attacked and the guards accompanying the peasant were killed.

At this point Lieutenant Roca arrives and is determined to toughen the morale of the frightened troops and to "succeed," whatever the price may be. He tells the men a story of some almost extinct animals, the manatees, who always showed so much sympathy when one of them got attacked and hurt that they hud-

dled around the victim instead of protecting themselves. That stupidity cannot be tolerated in war. "Wars are won by attacking." Roca now drills his troops relentlessly, and they will soon shout songs about the *terrucos* (guerillas) whom they will "fuck over" and whose "fat" they will "rip from their guts" and give to their dog. When the food supply is getting low, Roca shoots down a peasant's cow in front of his soldiers and the helpless peasants.

In spite of his growing cruelty, however, Roca is not shown without a conscience. He takes young Vitín aside and asks him whether in his mind he did wrong to shoot the cow. He then declares that in war all soft feelings have to be forgotten. To be a man is to be ready to kill instead of being killed. He also explains what Vitín knows from rumors: that Roca once got into a fight with another man over a woman and that the other man died in a game of Russian roulette with him. It is for this reason that Roca was never promoted. "My sin?" he tells Vitín Luna, "I was a man and I had honor." His opponent had challenged him to prove that he "had balls." So he had to show he was a man. Roca is also shown as a suicidal man. He holds the revolver to his head in pensive moments.

Meanwhile the silent killing by Sendero goes on with no traces of the killers to be found. In the midst of a constant fear of death Quique is lusting for a peasant girl, Julia, who runs a little store, and he finally manages to rape her. Vitín happens to find out what he did, but on interrogation by Roca, who is visited by the abused girl and her father, he neither affirms nor denies that Quique is guilty. Roca knows very well that the young woman speaks the truth when she points to Quique as the rapist, but he simply sends the peasant and his daughter away and lets Quique off with a slap on the face. He gathers the villagers in the market place, forces them to sing the national anthem, and announces that he will "exterminate" all the communist terrorists of the village.

After the symbolic incidents of the cow being shot down and the young woman being raped, the stage is set for the final crime. When the peasants happily and peacefully celebrate a wedding, Quique and another soldier, eager for good food and drink, break up the party under the pretense that the villagers needed a permit to celebrate. The enraged people recognize Quique as a

chicken thief and the rapist of Julia and finally throw a stone at him. Back at the post the wounded Quique invents a story that these people are all the same terrorists who killed the soldiers. Roca believes him and flies into a rage. The peasants are herded together and some of them are tortured. Roca himself bangs a prisoner against a wall so violently that he dies. Some of the soldiers are now outraged about their leader, but Roca orders them to put the body of the dead man on a mule and let the thirty prisoners march in line up into the mountains. In front of a ravine, the group of about eight soldiers is ordered to shoot down the frightened villagers. In confusion and panic the soldiers finally shoot — except for Vitín, who is unable to do so. When a single surviving peasant crawls around begging for help, Roca orders Vitín to shoot him. "Don't you have the balls?" he shouts. "Shoot if you are a man!" But Vitín cries out, "I don't want to!" Roca then throws him down and does the shooting himself. The bodies are pushed over the ravine, and a string of dynamite will soon make the scene appear like any rocky mountain side.

Vitín Luna is next seen in prison at the post, taunting Roca for his cowardice. He now cynically uses the same language as Roca: "Show me you are a man!" Soon the two men sit at a table playing Russian roulette, even though the comrades around them exasperatingly try to keep them from killing themselves. Again we get the sexually laden dialogue as Moncada, one of the reasonable men, begs them to let off: "You have both shown you have balls . . . so why not stop?"

In the end Roca does not kill himself as he should have done according to the rules of the game, and the other men excitedly tell Vitín that he has the right to kill Roca. He comes close to doing so, but instead shoots into the wall and says: "You are dead, Roca." Vitín then runs out of the building, and when Quique runs after him warning him that he is a deserter who has no place to flee to, he tells himself that *anything* would be better than staying in that place. The film ends with Vitín passing by a ragged little shepherd girl amid her sheep. He had met her once before, and both times the two exchange wondering glances that seem to evoke the unspeakable mystery of life and the awe of an "other" that is yet part of the human self.

The film is wisely done in not giving us a simplistic picture of "good versus bad." On the one hand, the viewer feels the

frustrations of the officer in not being able to control subversive peasants and keep his soldiers alive and fed. Having been taught only one version of "manliness," he goes out of his mind when he is unable to be the "man in control." On the other hand, we feel the instinctual revulsion of the young soldier against such bravado maleness. Even though in the beginning of the story he participates in the torture of a peasant and believes in all the military jargon, he refuses to condone, or participate in, rape and is unable to kill unarmed peasants. The pressure of the macho crowd around him is too strong, however, to keep him from risking his own life and that of his opponent in a reckless game. The other military men are each different in their reactions to the events and not at all stereotypical killers. Even the young peasant woman is skillfully presented. She is not simply a victim, but is courageous enough to go with her father to the military commander to denounce the rape and identify the perpetrator.

Giovanna Pollarolo, one of the two script-writers of *La boca del lobo*, has stated that "el *machismo* is a sub-theme of the film."[60] The main goal of the film team was a consciousness raising in regard to the issue of violence in Peru, a representation of race, class, and culture prejudices, of military hierarchism, and a mistaken antisubversive strategy.[61] Perhaps they did not quite realize how well they used the pervasiveness of gender stereotypes within this tangle of prejudices, thereby making the violence more understandable. It is not only the rape scene that indicates gender relations in wartime. It is the obsessive preoccupation with a popular notion of manliness that leads to irrational acts of violence. When Roca tells Vitín about his past experience with Russian roulette, Vitín declares pensively that war itself is like such a game. The end of the film seems to prove his statement: This war is nothing but a game of roulette.

Understandably, the Peruvian military was not especially happy with the film. However, Francisco Lombardi stated in 1988 that the military did not directly censor the film. They simply asked him to change the introduction, which seemed to indicate that violence in Peru started only with the military's antisubversive campaign. Lombardi agreed to modify the introductory text.

*La boca del lobo* remains a courageous witness in a country at war. There is hardly a testimony about the Peruvian civil war

of the present time that is as powerful as this film. The magnificent mountain scenery and the innocent or inscrutable faces of peasant families stand in stark contrast to the unspeakable crime of the massacre. The "banality of evil" is made psychologically believable, and the crime's intricate relationship to gender concepts as well as to racism becomes clear. Where "manliness" and "honor" are equated with military status and sexual power, women, Indians, and animals are likely to be degraded, and the instinctual human taboo against killing is gradually eroded.

Giovanna Pollarolo does not consider herself a feminist in terms of belonging to a group or movement, but she appreciates the work of Peruvian feminists.[62] Her poetic work, for which she won several prizes, clearly shows an intense preoccupation with women's daily experiences, often in autobiographical terms. One reviewer of her last book of poetry, *Entre mujeres solas* (Among women alone) speaks of her "enormous testimonial power."[63] In a very different way, the script she coauthored for *La boca del lobo* also expresses the power of testimony.

## Stitched Words of Pain and Hope: *Arpilleras*

There is another way for women to raise their voices against the war raging in Peru, and it is especially important for women who have little education and little to live on. The colorful fabric pictures called *arpilleras,* literally "burlap," have become a distinctive art form in countries like Chile and Peru. While many of them simply depict lively country scenes designed to be sold to foreign tourists and to provide a minimum income for women who are unable to be formally employed, others have a definitely political character and often contain even subversive messages. Under the Pinochet regime in Chile, *arpilleras* became voices of political protest to such an extent that the government forbade their export.[64]

Workshops for *arpilleristas* from the settlements of Lima are organized by the women's centers, among others. The work is not only a source of income for poor women, but teaches them skills of marketing, cooperation, and artistic design. Beyond all these goals, however, lies the importance of the *arpilleras* for giving a voice to women who are officially voiceless and unrecognized.

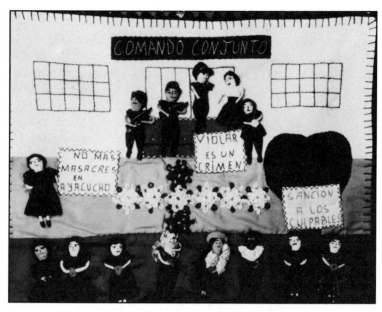

*Arpillera* of women demonstrating in front of a military post. The small signs read (top, then left to right): "The Joint Armed Services"; "No more massacres in Ayacucho"; "Rape is a crime"; "Punish the guilty."

By using small remnants of fabric to recreate scenes of their daily life, they literally salvage remnants of their society and their own experience, stitching their messages of hope and protest into the fabric of Peruvian life. In her book *Arpilleras: Cuadros que hablan* (Pictures that speak), Gaby Franger has put together pictures and words of Peruvian *arpilleristas*. In one of the pictures, the Joint Command of the military is shown in the background. Beside some soldiers with machine-guns one sees another soldier with two women and a sign underneath saying, "Rape is a crime." On the street in front of the military building two garlands of flowers are spread out in the shape of a cross, and the street is lined by many women bearing a flower each. Two signs express their messages to the military and the population at large: "No more massacres in Ayacucho" and "Punish the guilty." Franger's text quotes one of the women who worked on the picture:

> In October of 1985 there was a massacre in Ayacucho, and nobody protested. We demonstrated in front of the Joint Command of the armed forces in Lima. The feminist organ-

izations Flora Tristán and Manuela Ramos had organized the demonstration.
We carried a chain of flowers to protest the needless death of so many people. During the night of our demonstration a massacre of political prisoners took place in the prison of Lurigancho.
Then five of us had the idea to make an *arpillera* of this event so we could make it known that we are not in agreement with such things.[65]

The *arpillera* represents the event that the woman describes, but it says even more: It connects rape and massacres as expressions of the same societal structure, and it indicates by the greater number of women over against a few soldiers, by the large chain of flowers, and by the women's messages that here is the real power and the real communication, whereas the soldiers appear as silent as the guns in their hands.

This contrast is even stronger in another picture, showing four policemen or soldiers with machine-guns and a paddy wagon in front of a huge crowd of women carrying many signs with messages like, "Stop the violence, no more deaths," "Women, join the struggle," "We women give life, we don't want them to take it away," "We demand peace and justice." Here, too, are flowers, and a peace dove on one of the signs underlines the nonviolent nature of the protest. The bright colors of the women seem to celebrate life over against the deadening grey of the soldiers' uniforms.

There are also *arpilleras* of the less visible works of peace: of community kitchens and Vaso de Leche programs, of medical posts and help for battered women, of communal gardens and the building of homes in a settlement. A group of *arpilleristas* that is related to one of the women's centers of Lima, Manuela Ramos, calls itself "Creative Women." One of them, Marina Haro, writes,

Our standard of living is very low.... In the poor settlements of Lima there is usually no water, no light, no school, no public transportation.... The people of the suburbs just look at us. They don't have these problems; they take water and light for granted. But what awaits us in the center of the city? The police who scold and beat us.[66]

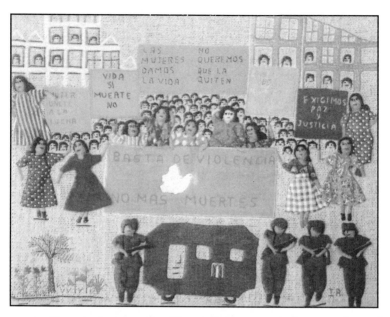

*Arpillera* of a demonstration. The small signs read: "Women, join the struggle"; "Life yes, death no"; "We women give life, we don't want them to take it away"; "Stop the death of innocents"; "We demand peace and justice"; and the large sign says: "Stop the violence, no more deaths." In the background is a prison, in the foreground an armored car with four policemen or soldiers.

Marina then describes the vast unemployment that began with the problems in the fishing industry around 1970. People began to sell anything from bubble gum to magazines, or the women cooked meals in the streets to earn a few pennies. Even when the whole family works, however, the money often does not feed everybody because of the enormous inflation rate. So borrowing money seems the only way out, but the huge interest that rapidly increases begins to destroy the families, "and we women bear the main burden."

> So where lies the root of the problem? In the dependence on foreign capital, because other nations take away our natural resources and pay only very low prices. The poor are those who are actually paying.... In the final crisis of the 1980s, the women began to organize.... We had the idea to organize community kitchens. But we, as women, do not organize

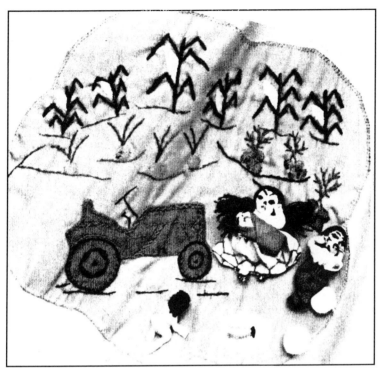

Detail from an *arpillera* on the *deuda externa*, the foreign debt, as it affects women. Even when the whole family helps with the harvest — which is for export — the income is insufficient to feed all.

solely for sharing what little we have. We want work, paid work. In the Creative Women group we unite in order to sell our *arpilleras*. That is the way we wish to support our families financially. Also, however, we want to teach the world, especially women, how we live and how we struggle to get ahead.[67]

The *arpillera* that accompanies these statements is about the *deuda externa*, the foreign debt, symbolized by women with huge sacks of dollars that are much too heavy for them. Marina certainly does not see through all the complexities of the foreign debt, but she and her co-workers know what it means when children cannot be fed. The frustration of these women is directly related to the war situation, because it provides fertile soil for guerilla propaganda. *Arpillera* workshops are then not only im-

portant for giving the women some income. Such cooperatives also raise their consciousness about the roots of violence in family life or in an unjust financial system, and they show what women can achieve if they organize: in community kitchens and countless other self-help programs.

The one disadvantage of programs like *arpillera* workshops is that they are largely financed by foreign — mostly European — foundations. The women would otherwise not have enough start-up money for supplies, rooms to work in, and teachers who help them with design and marketing. This situation can create new dependencies.[68] Sendero Luminoso makes the most of this dilemma and threatens every institution that lives on foreign assistance, conveniently forgetting that they themselves could not exist without foreign help. The women's centers are, however, working on developing different income-producing strategies, and for the time being they still serve an important purpose in spite of their "dependence." They are needed to help women, who have usually been kept out of the public decision-making process, make their voices heard. *Arpilleras* are one way of doing that. Even illiterate women and those with very little education can stitch simple words like *paz* or *justicia* to publicize their witness against war and violence.

## The Most Difficult Testimony: Rape

Millions of Peruvian women have been and still are witnesses of war and of the most atrocious acts of violence. The majority of them have learned to speak and act on these experiences and have become witnesses in an active, articulate way. They testify in courts and police stations, in women's groups and the media. They turn ideas into praxis by organizing survival groups like soup kitchens and milk programs, and some of them opt for armed insurrection and themselves contribute to the general level of violence. Whichever way they choose, most of them are no longer invisible and inaudible. When it comes to rape as a part of war, however, a woman is caught between all fronts and is likely to keep silent about it. I am not talking here of rape as it occurs in all countries and all classes of society at all times, but of rape as a deliberate strategy in war to terrify, humiliate, and render

powerless "the enemy." The recent pioneering study by Robin Kirk, written for the human rights group Americas Watch, gives a devastating overview of the situation.[69] While the repeated news reports about rape as a military strategy in the former Yugoslavia have finally alerted the world to this type of war crime, there is an overwhelming amount of documentation available for Peru that even human rights groups have until now largely ignored.

> Abuses against women figure only briefly in most reports. ... In particular, rape by the security forces has been at best overlooked, at worst virtually ignored.... Despite the numerous accounts of rape detailed in this report, including for 1991, the Human Rights Defenders Office lists only one case for that year.[70]

Rape is used by the security forces in the rural areas to intimidate or coerce women whom they suspect of being guerilla sympathizers, and in Lima and other cities it serves to humiliate and pressure women during detention or interrogation by the secret police. While rape by members of Sendero Luminoso is less common because Sendero violence consists more often in killing and because the racial and class difference favoring rape is often missing between the guerillas and peasant or migrant women, it is definitely happening too. There is evidence that some women were raped from both sides of the political spectrum. The problem is compounded, however, by a social climate that puts an indelible mark on a raped woman so that a husband will not take her back or an "honorable" man will not marry her. In addition, there are few clinics available where a woman can go immediately after a rape in order later to show proof in court. If she is lucky enough to get a doctor to certify the crime, there is the probability that military officers or police personnel will somehow cover up the evidence and protect "their man." Since military courts can work in secret — especially after the recent antisubversive legislation — a woman has no recourse as long as the court does not act.

In one infamous case involving the murder and rape of 69 peasants in Accomarca in 1985, only the most junior officer involved, Lt. Telmo Hurtado, was eventually charged. Moreover, even though Hurtado was found guilty by a mil-

itary court of "disobeying orders," he never served time in prison. In fact, he was promoted normally during his "sentence" of six years, and is currently a captain. This is one of only two cases we are aware of in which an officer has been found guilty of a human rights related offense.... From 1985 to 1990, only 10 police officers were formally sanctioned and dismissed from the force for rape.[71]

Until 1991, according to a Peruvian penal code of 1915, rape was simply a crime against *las buenas costumbres*, against good morals and customs or against honor. This means that even today, when it is considered a crime against the right to choose a sexual partner, a court is likely to take into consideration how "honorable" a woman was when she was raped.[72] At the same time, the husband's "honor" is at stake. Kirk quotes a community activist who works with rape victims as saying,

> For a Peruvian woman, to have been raped is a great shame which she must hide from society and especially her family. In society's eyes, she has been dirtied and perhaps wanted it to happen. Gossip and machismo combine to make life hard for the husband as well, who is ridiculed by people who say the rapist is more macho than him. All the weight of the act, the blame, falls on the woman.[73]

Such attitudes in civilian life are intensely aggravated in war. In many of the known rape cases, a power game between men is involved: The "white" (*criollo*) officer rapes the Quechua peasant woman before his soldiers are allowed to do the same, and frequently the peasant husband of the victim is forced to look on.

Countless rapes are accompanied by the threat that any report on the event will mean the death of the victim herself or of one of her family members. After some of the more famous massacres, witnesses have been murdered and individuals giving public testimony have been harassed. Even where disappearances and murders are reported, women will not easily tell that they have been raped. As a strategic measure of warfare, rape is effective because it silences women. All the more admirable are those women who still come forth to denounce the crime, but their courage sometimes still leads to nothing. When a sixteen-year-old girl was taken from her home and raped by police officers before

they abandoned her in a deserted area, she managed to get home to her mother, and the two reported what happened. However, the main perpetrator of the crime visited the mother, saw that she was extremely poor, and talked her into not prosecuting the case if he provided her with food for three months. The young girl was legally unable to continue the prosecution when her mother gave in to the police officer.[74]

Since over half the population of Peru lives under "emergency rule,"[75] security forces may enter homes and carry out arrests in these districts without warrants, and prisoners can be kept fifteen days in incommunicado detention. It is in this setting that most extrajudicial killings, disappearances, and other abuses occur. Thinking back to the film *La boca del lobo*, we can understand that in spite of these powers which soldiers hold over civilians, they live in constant fear of their own lives because Sendero tries to trick them everywhere. So there is a "strategic" reason for gang rapes instead of individual rapes. As one army soldier reported:

> We raped in all the villages. We would grab a girl, and we were five, six for every one.... We would pin them with the FAL [automatic weapon] and that's how we passed the time. It's because the officers told us we shouldn't find a girl friend because there you'd be and she'd stick a knife in you, so you have to be in a gang to be able to have sex.[76]

It is not the place here to describe the horrible details of rape and other tortures of the female body that Kirk and others have uncovered. The point is the importance of women's witness about it so that in the future any consideration of a country's human rights record will take women's bodily victimization seriously. In December of 1990, the feminist journal *VIVA* published an issue emphasizing the legal struggle of Peruvian women to win the right of abortion in cases of rape and incest. One angry woman politician writes:

> We women and men who are united in the defense of life and social justice have to oppose the injustice that protects the "seed of violence" of torturers, of murderers, of molesters, of men who commit incest, when they perpetrate the crime of rape and attack life itself, because they injure the

right of a woman to free motherhood, which should never be the product of imposition or violence.[77]

Many women's groups hoped in 1990 that the criminal laws would be changed, but even today, when there is massive evidence of rape, especially in the emergency zones, no legal abortion is possible, unless the mother's life is in danger.

One Peruvian woman's testimony about rape has become internationally famous because it was presented to the Inter-American Commission for Human Rights. Raquel Martín Castillo de Mejía, a teacher, was married to Dr. Fernando Mejía Egocheaga, a journalist and lawyer. On the night of June 15, 1989, they were in their home with their three-year-old daughter.

At about 11:00 P.M., as the Mejíases slept, hooded men bearing machine-guns and wearing military uniforms pounded on the door. Dr. Mejía, clad in pajamas, answered. He was beaten and forced from the house.

Six men entered.... In the bright moonlight, Señora Martín saw her husband blindfolded and forced into a waiting vehicle which departed.

About fifteen minutes later, the tall man who had given the orders again pounded on the door. Señora Martín remembers seeing about six or ten men behind him.... He demanded her husband's identity documents and followed her into the bedroom as she searched for them. Then he showed her a list of names....

The man told her that she too was on the list as a "suspected subversive." However, he asked no questions.... He sprayed himself with her perfume and told her she was "pretty." Then he removed his munitions belt, tore off her pants and raped her.[78]

Señora Martín then sat in a state of shock. She had no telephone nearby and did not want to leave the house in case her husband was brought back. Shortly afterward the same man came again and raped her again. She put up little physical resistance out of fear for her husband's safety and that of her daughter asleep in the next room.

All of Señora Martín's efforts over the next three days to locate her husband were unsuccessful. On June 18, the body of her

husband and that of a professor were found with marks of brutal torture. Señora Martín reported her husband's murder, but not her rape. She states the reason for this silence:

> Victims do not report the rape because in a sense we are humiliated.... It's the horror of how their husbands will respond. The physical integrity of the family is at stake, the humiliation for the children to know that this happened to their mother.[79]

When various threatening phone calls made it necessary for her to leave Peru for exile in Sweden, she finally talked about the rape. Her story proves that this type of testimony needs special courage and is sorely needed in the struggle for women's rights as part of human rights.

## Voice of a Martyr: María Elena Moyano

Raquel Martín Castillo de Mejía survived, while many similarly threatened and abused women did not. When women are confronted with Sendero Luminoso, they are not necessarily raped; Sendero has many women in its own ranks and usually tries to keep the cadres disciplined. Women are, however, special targets of Sendero when they are community organizers and/or feminists. All democratic grassroots organizations are hindering Sendero from winning people for their own movement. Organizing a community kitchen can therefore make a woman a target for Sendero harassment, and speaking openly against Sendero violence can be deadly. This is the point where the witness becomes a martyr, a martyr for a spoken and lived truth.

After February 15, 1992, the women's movement in Peru would never be the same. Other Peruvian women have died for their convictions, but when María Elena Moyano died, thousands of women had lost a leader, an example, an inspiration. As Helen Orvig, director of the women's documentation center CENDOC, described it:

> The newspapers have been filled up with news, articles, letters, etc., in an incredible way. Up to date, we have collected about two hundred different clippings. This overwhelming expression of love and admiration, hatred and

repugnance, fear and an exalted collective feeling of unity and strength vis-à-vis SL [Sendero Luminoso] is really worth a deep, psycho-social analysis. Does it mean that we *needed* a martyr?[80]

Moyano at the time of her death was acting mayor of Villa El Salvador, the huge settlement on the outskirts of Lima that has become internationally famous for its self-development from a stretch of desert land to a model city, governed by grassroots organizations and guided by socialist ideals. Its leaders had been threatened repeatedly by Sendero Luminoso since they publicly denounced the guerillas and tried to organize the masses against them. Four "cells" of perhaps forty Senderistas had infiltrated this city of three hundred thousand during recent years.[81] The Sendero newspaper, *El Diario*, which used to be sold half-clandestinely in Lima, but serves now mainly Sendero propaganda abroad, had described María Elena as a puppet of imperialism. She knew she was a target. Like other leaders on Sendero's hit list, she changed her habitation frequently for security reasons, but she refused to give up her work and her goals. Family members had encouraged her to go abroad. She had been to Spain once and was scheduled to go there again soon to share her knowledge of grassroots organizing. She knew, however, that as acting mayor and as the leading symbol of the powerful women's organization of Villa El Salvador she could have a tremendous influence in organizing the masses against Sendero.

When she openly defied a general strike called by the guerillas for February 14, 1992, urged the people to work as usual, and led a great march for peace, her fate was sealed. Having attended with her two young sons a fundraising chicken barbecue for the benefit of the Glass of Milk program for children, she was about to get into her car, with her bodyguards near her, when six Senderistas, one of them a woman, came toward her, shot and wounded one of the security agents, shot her from the back — in front of her two sons and a nephew — and then exploded about ten pounds of dynamite. Five other people were seriously wounded. Her body parts were found in a circle of more than a hundred yards, on roofs, in a park, and in nearby streets. Her brains were found "in a house at the corner."[82] The person sup-

María Elena Moyano.

posed to have carried the dynamite in a backpack was dressed like a peasant woman from the Andes.

"They have finally killed her," reflected one journal writer; "and so that there would be no doubt about the moral level of her executioners and about the profound fear they had of her, they blew her up, shattered her into pieces."[83]

Thousands gathered for María Elena's funeral. From the poorest Villa El Salvador settlers whom she had helped during much of her life of thirty-three years, to heads of state and church, including the ambassadors of Spain and France, the people cried, spoke, and protested. "María Elena Moyano, for life and peace," chanted twenty thousand voices.[84] A bishop celebrated mass, and Gustavo Gutiérrez in a homily reminded the people that María Elena showed the way to fight hunger and terror. She was the hope and joy of a people, he said. "Those that shattered her to pieces, wishing to make her disappear, have only managed to spread more seeds of life that will germinate very soon."[85]

Having listened to voices about María Elena, we now have to listen to her own voice. After her death her mother revealed a letter the daughter had written two months before her death:

> If I die or something serious happens to me, the women of Villa El Salvador have to continue my work and the example I gave them to serve the people in an impartial [*desinteresada*] way.
>
> I am not afraid of death, but I beg you, my companions and neighbors of Villa El Salvador, that you do not let yourself be intimidated by terror.[86]

It is not surprising that one of the last, most revealing interviews with María Elena was done by Mariella Balbi. It was printed the day after her death and contained beautiful pictures of the acting mayor herself, her carpenter-husband, and her two sons of eleven and nine years. Balbi asks her about the death threats she received. María Elena describes that a year earlier Sendero had already attacked the women's movement of Villa El Salvador as well as herself, saying they were nothing but "the mattress of the system," revisionists depending on charity, and they were not liberating any women because emancipation comes only through war. Gradually María Elena had changed her mind on Sendero:

> Until recently I thought that Sendero was a group that was simply mistaken, that tried in some way to fight for justice. But when they assassinated the labor leader Castilla, I repudiated them completely. . . . I venture to condemn this terrorist attitude of Sendero. Now they have touched the grassroots organizations to which most of the poor belong.

Who else belongs to the communal kitchens and the Vaso de Leche (Glass of milk)? Those who cannot eat in their home.[87]

Balbi wonders whether Moyano's earlier, somewhat tolerant attitude toward Sendero is something she has in common with the political left.

Yes, I think so. If the left had wanted to, they could have defeated Sendero. In this country, the only force that in any way can defeat Sendero is the left.

Why? wonders Balbi.

Because in view of the programs of the right, with which the people cannot identify, the only alternative was the left. That is, before it split. Those are the people that have the closest ties to the most needy, the poorest. When the left split, Sendero advanced.

Balbi asks her what makes Sendero's infiltration in Villa El Salvador possible. Moyano mentions the economic crisis, the tensions within the governmental structures of Villa, and the tendency of the left to keep hegemonic control over individual sectors instead of working in unity. And why are the young people attracted by Sendero's discourse? "Because [Sendero] displays a certain mystique and commitment. The young are rebellious, impulsive, vehement; therefore they see here expressed in some form their restlessness and frustration." What happens if the communal kitchens have to close because Sendero tries to starve Lima?

I believe that we women have great strength. We believe in what we are building up; there is no need for fear. We are struggling for the welfare of the people, for solidarity, for justice. It would be much better to have discussions with the people from Sendero. I have had them. I tell them if you are ready to risk your life, so are others, and they are ready to fight in this way for development, for justice, but without terror and assassination.

Balbi then touches on a point that would later be lifted out in the Sendero press as proving Moyano's criminality. Is she organizing urban *rondas* (self-defense groups)? Yes, says Moyano. We

are organizing in neighborhood groups because we do not trust the military or the police in this country. They often commit acts of violence and even assassinations. They could instead build roads and dig ditches to improve our water supply. They could change their image by clearing up "disappearances." Would she be in favor of arming the urban *rondas?* "Until now I have opposed it. In any case it will be the people who will do and decide this. I am not in favor of the military coming and arming the people." She has argued with Sendero members, Moyano says, that they should think harder: Sendero is driving the country into misery. Balbi answers that such a recommendation is futile. Sendero does not listen. Can she suggest something more practical?

> I don't believe they are all assassins. . . . We have to continue fighting Sendero, rejecting acts of terror. But you cannot fight terror with terror. You also have to call for dialogue and reflection. Parties are not monolithic and strong, that is just their outside image. Within Sendero there are [different] lines and tendencies, and one has to take advantage of this fact.

Will Moyano give up her job if Sendero continues to assassinate popular leaders?

> Not at all, it is part of my life. There are people who ask me whether I am scared. Sometimes I am, but I have a lot of strength and moral stamina. I have always been ready to give up my life. I have faith. If the women in all of Lima respond, something can be done. If the people organize themselves, centralize their forces, we can defeat Sendero. These matters are not easy, but neither are they impossible.[88]

Turning from such an interview and from the moving reports on Moyano's massive funeral to the Sendero press is a chilling experience:

> Long live the just sanction against the agent of imperialism, the counterrevolutionary, recalcitrant, revisionist informer María Elena Moyano!

In a long article, *El Diario* explains that they are not against communal kitchens and Glass of Milk programs, as their enemies

pretend. They are only against those that defend the decaying old state apparatus with its exploitation and oppression. What has bureaucratic capitalism led to? Look at the twenty-two hundred poor settlements that surround Lima. None of the reactionary governments has helped them. Now the mercenary of imperialism, President Fujimori, wants to organize urban *rondas* (armed self-help groups) to defend the old state. And María Elena Moyano states in an interview with Mariella Balbi that she is also in favor of urban *rondas*, of neighborhood groups that identify Senderistas to find out where they live or come from.[89]

What Sendero does here is a skillful manipulation: The undeniable fact that the past and present governments have not been concerned with the plight of the poor and that sheer capitalism is not likely to help them ever is combined with a literal quote from Moyano that out of context totally distorts her meaning. She did say to Balbi that neighborhood *rondas* would identify guerillas and warn them, but she did not say they would identify them to the police or military. In fact, she emphasized repeatedly that the people do not trust the government forces and therefore would not cooperate with them. She thought more of the ideological influence the *rondas* could have. "The defeat of Sendero has to be political and ideological. They do not only fight militarily."[90]

In an interview for a Mexican paper, Moyano also speaks about the *rondas:*

> They have always existed. They are the neighborhood watches that are part of a twenty-year history. They have fought crime, drug addiction. They have nothing to do with the program of forming urban *rondas* directed by the military. It is the people who decide when and how to form *rondas* and how to respect the internal democracy.[91]

Several months before her death, a journal had asked Moyano to write an article commenting on the assassination of Juana López, a leader in the Glass of Milk organization. The still-unedited essay was published after Moyano's own death. She emphasizes that change can come only by providing jobs, better salaries, and better nutrition, and by letting people govern themselves instead of giving over the government to an elite. "Instead of giving people arms to fight Sendero, let them receive

machines, seeds, assistance." It is the women who have worked in the communal kitchens since 1978 and in the Glass of Milk program since 1984, Moyano emphasizes, and they have given an example of constructing democracy from the bottom up. It is the women who demand that the government sign a new law that officially recognizes grassroots organizations and creates a program of assistance for those who work in food management. "It is the women who day after day show the ability to organize and who daily forge unity because they know that only in unity can they provide for the welfare of their children."[92]

In a book on four community leaders of Villa El Salvador published a year-and-a-half before María Elena's death, Margarita Giesecke and her coauthors described the life of María Elena on the basis of her autobiographical notes.[93] She had a happy childhood until her parents separated when she was barely ten years old. Her mother later moved with the children to the pioneer settlement Villa El Salvador.

In school María Elena liked history:

> I loved the story of the liberation from the yoke of Spain, above all the actions of Tupac Amaru, Micaela Bastidas, José Olaya. I admired them, but I also was inspired by Christianity, and we had a great ideal of equality, justice, and love among us.[94]

She sometimes had to go to school hungry, because her mother thought that education was more important than anything else. The violence of poverty and hunger, she said, had a great impact on her. She joined a theater group formed in the Catholic parish, and — like a strange foreshadowing of her death — participated in a passion play during Holy Week for several years. As an unsettled teenager she wavered between a plan to become a nun and turning atheist, but through the influence of an Italian nun she matured and came to be a believer. She also felt she was part of an effervescent generation that did not hesitate to believe it could change the world. "In my mind I pictured the war," she wrote in her autobiography, anticipating a harsh struggle to bring about social change.[95]

For a while she studied sociology at one of the universities of Lima, but then dropped out to find a job in Villa El Salvador. She soon was elected as organizer of preschool affairs and

would from then on be a successful organizer, especially in the women's movement. She married with the wish to have children who would grow up — unlike herself — with a "model father," and her husband always gave her the possibility to work for the community. (After her death her family had to move to Spain for security reasons and even there were for a while persecuted by Sendero.) Whereas her mother and her sisters occasionally remarked that Peruvians cannot really develop themselves without going to a country like the United States, María Elena believed with all her heart in her community of Villa El Salvador and the possibilities for social change. Her great concern was the shaping of a Peruvian identity in which all races and classes, peasants and city dwellers, lived in solidarity. Being black herself she knew about discrimination. Religion, she thought, was very important in the shaping of new, unifying social structures from the grass roots of the people, because it "awakens the individual, the conscience of a person, whereas politics awakens the masses."[96]

"María Elena is not dead — she lives in her people!" shouted the mourners at her funeral. "There were almost no tears," writes *La República.* "Instead there were cries, songs, voices of triumph rising to the sky, banners and posters beaten by the wind."[97] "The fear is gone," they shouted. "Mother Courage" they called the woman they mourned. Perhaps Gustavo Gutiérrez was right: The killers planted the seeds of life. Hers was an embodied witness that cannot be killed.

# Chapter 4

# THE SEXUALITY OF TERRORISM, RELIGIOUS TEACHING, AND WOMEN'S SILENCE

After listening to so many voices of women, we have to pause and ask some much-discussed theoretical questions to see whether the Peruvian witnesses can help to answer them. Is war related to patriarchy? If women suffer so much in war, are men basically those who are always causing and perpetuating war? Given the fact that there are women guerillas, are they as much a minority as "husband batterers" are compared to wife batterers?

Similar questions are affirmatively answered in a book by Robin Morgan, *The Demon Lover: On the Sexuality of Terrorism*.[1] While Morgan begins her book with the friendly warning that she wants to "prove" or "solve" nothing, she asserts throughout the work that warring women or women terrorists are simply imitating the male system of violence that has dominated the globe for aeons. In view of the Peruvian situation, I consider the problem to be more complex, but since her study is informed by a wide knowledge of international affairs and contains excellent insights, I would like to use her argument to take a closer look at what we can learn from the witness of Peruvian women.

Considering all the women's statements related above, the first observation might be that of a great diversity of voices. Moreover, they are different from the voices of European or North American women because they grow out of a situation of terror and hunger. They arise from a country not officially at war and not experiencing traditional war "fronts," massive air raids, or vast army movements. Very likely, this situation is foreshadowing the wars of the future for all of us. Instead of getting involved in "world wars," we seem to be moving toward a mul-

110

tiplicity of "low-intensity" wars and "terrorist wars" that at times flare into disastrous regional conflicts like the one in the former Yugoslavia. After the bombing of the World Trade Center in New York, an "expert" speaking on National Public Radio declared that the U.S. population has to count on more terrorist attacks in the future.

In Peru the "civil war" has displaced from their homes at least two hundred thousand people and has created thousands of traumatized orphans who are "invisible" because of their continued displacement.[2] In a culture that usually still expects mothers to be the only caretakers of children[3] and where on the average at least every third household is headed by a woman, women have a profound knowledge of the effects of war. They also have a hard time making their voices heard where it counts: in parliament and court sessions, political elections and military strategy. It is not surprising that some of them choose to join the guerillas, who substitute deadly actions for ineffective, unheeded words.

Can we, however, fit these women into Morgan's thesis that terrorism, whether from the left or the right, whether in highly industrialized or Third World countries, is always a symptom of the patriarchal order that thrives on many forms of violence? If women participate in it, are they simply emulating the male syndrome? While I agree with Morgan's emphasis on the parallels between "state terrorism" and individual or group terrorism, while I find her critique of the senseless cycles of violence very convincing, I think she underestimates the extent to which women like those in the Sendero movement are acting out of total desperation or hunger and have absorbed the "patriarchal" syndrome of violence to the extent that it is no longer simply "genderized," or a male characteristic. In a battle for sheer survival men and women become more alike than ever before. Likewise, the alternative movements to counteract violence, e.g., the nonviolent organizations of peasants who try to defend their land and their rights, are no longer just women's movements. "Throughout the length and the breadth of the country these organizations, representing men, women, and youths, have struggled to defend life and build strength and unity."[4] It does not help again to divide up humankind into the warring males and the nonviolent females — some of whom imitate males. As Laura Donaldson states in a different context,

This concept of gender as sexual difference also works to disempower feminist thought to the extent that it constructs a universalized woman and reifies her difference from a universalized man. Defining women in terms of their difference from men actually prevents an adequate critique because it distorts race and class differences not only among women but also *within* women.[5]

Morgan is right, however, in pointing to the devastating myth of "necessary violence" or "necessary sacrifice," which constantly leads to more of the same and is based on the traditional notion of male killing to "defend life." Women indeed tend more to celebrate and cling to life without the notion that only death can preserve it — as a wrongheaded patriarchal theology would often teach it. I have quoted Gutiérrez as saying María Elena's death might sow the seeds of life, but there is a difference between dying and killing, between risking death by living the truth and "sacrificing" oneself and others in a killing enterprise that is called war. As more women are gaining access to public life and to the temptation of power games and more men are discerning the deadening abstraction of the warrior mentality, the "sacrifices" that society asks of men and women become more alike. Moreover, gender distinctions are less pronounced in a survival situation where the women of the labor class, for example, were never shielded from public life like middle-class Western women. To the extent that a difference still exists between male and female stances toward war — whether self-chosen or dictated by social and religious codes — we can probably explain it as a social conditioning of thousands of years. Robin Morgan, however, points also to new biological evidence.[6]

In the end it matters little whether we focus on the "difference" between the genders — however it has evolved — or on the "equality." The question is: To what use do we put these categories? As long as difference does not mean inferiority and exclusion from certain aspects of life — as traditionally it has — and equality does not mean "sameness" in the sense of women having to act like men, we can celebrate difference as the basis for a diversification of power, also among *different* men and *different* women, and "equality" as the balance between these various sources of power. In this respect Morgan makes the excellent

point that the more diversified the various "powers" of our world are, the less likely they can be controlled or destroyed.[7] The dissolution of the U.S.S.R. and East Germany has shown again the power of nonviolent transformation by an odd coalition of political groups, and the example of the former Yugoslavia proves that military control alone by whatever faction does nothing to solve political problems. However, the latter example also shows that a substitution of multiple powers for a superpower is no improvement unless the new powers are democratic and willing to live with diversity and self-limitation.

One of the diverse, fluid, and democratic forms of power is the power to witness in speaking and writing. Focussing on the voices of women in one of the countries that get very little media attention means becoming conscious of hidden sources of power in other parts of the world, places that usually appear "silent," especially in terms of its women. Woman, says Robin Morgan,

> heads one third of all the families on earth. Nowhere does her reproduction of the species count as "productivity." She constitutes the majority of the twenty million persons who die annually of hunger-related causes, and of the one billion who endure chronic undernourishment and other poverty deprivations. She suffers earliest and longest from toxic and nuclear waste, acid rain, chemical warfare, and deadly pesticides, because such lethal pollutants take their first toll as a rise in cancers of the female reproductive system, and in stillbirths, miscarriages, and congenital deformities. Wherever she exists, she labors: her work as a homemaker, or mother, as prostitute or nun, is erased because it is considered natural; her work in farm, factory or office is marginalized because it's considered unskilled, transient, or migratory.[8]

Much of this pertains also to Peru — and more so because of its war situation. Since there are, however, women who speak up, write down, cry out, unfold a banner, sing out their anger, and stitch their "sign language" into colorful *arpilleras*, they have unleashed an uncontrollable power of witness. Not all Peruvian women's voices are nonviolent, but all cry out for justice. Instead of just chastising those who opt for armed struggle, it is up to us in the rich industrialized nations to ask how our politics and our

way of life are impacting an agonized country like Peru and are contributing to the "terrorism of hunger" — hunger for food, education, justice, and peace — and thereby to any other terrorism. How are we justifying that "incomes from the richest fifth of the world population average fifty times the incomes of the poorest fifth"?[9] "A child that dies of starvation, or a person forced to work fourteen hours a day is also terrorism and it exists throughout the third world."[10]

There is strong evidence that the so-called drug war directed by U.S. military advisers is intensifying the suffering of the Andean people. The Peruvian army does not like to cooperate with U.S. military strategy, since it is thereby forced to fight on three fronts instead of the one front against Sendero: The peasants resent any military interference because they have to choose between starving and growing coca, and the drug traders become more belligerent by making deals with Sendero.[11]

Any investigation of the sexuality of terrorism also has to take account of the sexuality of the drug trade because the two support each other even when they follow completely different goals. A study by a Peruvian woman criminologist points out why so many women are imprisoned for their involvement with the drug trade.[12] Statistics from a prison in Lima show that most of them are children of migrants from the sierra, growing up in marginal urban circumstances, getting only minimal education or none at all, finding only menial jobs or being street vendors from childhood on, living in the most primitive homes, and as adult women being the sole support of their children. "I went to a *curandera* [native healer] in Huacho," says one woman prisoner. "I had no money, and my husband needed treatment for cancer. So I carried a small amount of drugs because the healer said it could be sold there to pay what [the treatment] costs."[13]

If there is a genderized component in the drug trade, it is related to the feminization of poverty. If women cannot feed their families and cannot find work, they will be tempted to join Sendero, sell drugs, or go into prostitution. No amount of military intervention can rectify this situation; it will instead intensify the war. Working for legislation that supports alternate crops instead of coca and establishes markets for these crops within Peru as well as in countries the world over will actually help hungry peasants, mitigate the misery of urban settlements, and pave the

way for peace. Listening to the witness of women who are hardest hit by the economic crisis, we have to shape our own witness in our own countries to work for change, especially as it pertains to military intervention abroad.

Is the terror of war genderized? The answer has to be complex. Many Sendero witnesses prove that women can be as savage as men when they get the chance. That fact pertains not only to the poor women who have to fight for survival, but also to educated women who buy into the ideology of killing. However, women are affected by the violence of war much more than men, because they represent the majority of refugees and of heads of households and have even fewer chances than men to find work adequate to their gifts and skills. Moreover, the popular perception of what is "violent" and what constitutes "terror" is very much genderized: When the Peruvian government introduces an economic policy that improves the life of the small middle class, but forces millions of the poor into hunger and sickness, these consequences do not make as many headlines as women guerillas who throw bombs into banks or assassinate politicians. The invisibility or justification of a (predominantly male) "state terrorism" keeps the public focussing almost exclusively on guerilla terrorism, especially when women are involved in it. It is clear, then, that "the designation of terrorist is a highly political choice."[14]

One knowledgeable person in Peru told me that María Elena Moyano could have saved her life if she had called the military into Villa El Salvador and had put herself under military protection. María Elena, however, was wise enough to know that, in view of the armed forces' human rights record, this move would have simply substituted one violence for another. Her life instead witnessed to "a more excellent way," as the apostle Paul calls it (1 Corinthians 12:31).

Besides the problem of "genderized" terror, there is another theoretical question to be asked: To what extent is any war witness of Peruvian women based on religious tradition, personal faith, the official teaching of the church, or a reaction against any of these? The answer to this question is just as difficult as the first one, because the picture of the Peruvian churches and their social location is very diverse. On the one hand, the Roman Catholic Church, to which most Peruvians belong, and large parts of

the Protestant churches (which comprise about 4.7 percent of the population) have avoided taking a clear stand on the issues of violence and human rights and have traditionally taught women to adapt themselves to the male-determined status quo in the family as well as the state. Conservative Roman Catholic as well as fundamentalist Protestant tendencies often make it difficult to discuss violence against women frankly and publicly. Especially the deeply religious poor women with little education frequently suffer from guilt feelings when they try against the counsel of the church to break out of the relentless cycle of bearing and nurturing children or if they try to leave an abusive husband.[15] The glorification of motherhood by state and church can become a painful burden for women. Education for girls in church-related schools has often meant a very limited and elitist outlook on life and has emphasized training in "turning the other cheek."[16] It is not surprising, then, that many "proper" religious women are far removed from politics or, as in some fundamentalist circles, support the ecclesiastical, military, and governmental structures in power.[17] They try to avoid the war as much as they can and are not likely to speak much about it except for deploring the terrorist violence.

A very different world exists, however, in many groups and places at the grassroots level where priests, nuns, pastors, and lay people (whether orthodox, liberal, liberationist, or "evangelical") lay their lives on the line in the struggle for those who are most vulnerable and suffering. Many of them organize human rights groups and lobby for a social legislation that takes hungry Peruvian peasants more seriously than the so-called necessities of the international market. Others simply accompany the poor in their struggles. Many speak out against violence from whatever side and thereby risk being considered dangerous: Right-wing radicals call them friends of the Communists, and left-wing fanatics object to their use of foreign money and their attempts to organize the poor whom they themselves would like to control. Where the church comes alive in this way, women are in the forefront and speak out, whether in Bible studies — with new translations and interpretations — street demonstrations, soup kitchens, health workshops, or human rights organizations. Latin American women theologians, among them some Protestants like Elsa Tamez, are discovering alternative — and sometimes sub-

versive — traditions in which women are not fallen Eves who initiated sin in this world, as some church fathers emphasized, but equal partners with men.[18] This emphasis is related to matters of war and peace, because it causes women to be more critical of established power structures and more active in trying to change them.

In this context we are challenged to rediscover Andean women's spiritual traditions as they relate to the circumstances that contribute to war. These traditions may not have been in any way "better" than the Western tradition. The Incas waged wars, ordered women to be given in marriage to certain men as political prizes, and in general built up their kingdom on strictly hierarchical terms.[19] The world of Inca wars, in spite of their ritual and limited nature, their involvement of women, and their ecological aspects, perhaps did not represent a qualitative difference from modern wars.[20] Why, then, try to rediscover Inca women's traditions in considering women's voices on war? The reason lies simply in the fact that only out of their own roots can American Indian women contribute to a solution of the worldwide problem of wars. As long as their own history, culture, and religion remain suppressed and their daily experience is only the devastating heritage of five hundred years of "conquest," they cannot be a force for peace. Moreover, if non-Indian Peruvian women do not become more conscious of the Andean heritage of their Indian sisters, any peace in the country will remain an uneasy truce. The same pertains, of course, to the heritage of blacks or Orientals in Peru who have suffered similar discrimination. The Sendero syndrome shows clearly that racism plays a role in the origin and perpetuation of this violent movement, and one aspect of racism is the negation of a minority's history, culture, and religion, usually being especially evident in the silencing of women's history.

The churches are confronted, then, with a special challenge. They formally unite members of different races and ethnic groups and could be in the forefront of helping women to rise out of illiteracy in the widest sense of the term: out of the ignorance of their traditions. Instead of continuing only the teaching of the Western religious heritage, churches need to strengthen the Indians' awareness of their spiritual roots, which would also imply a rediscovery of female power, dignity, and self-estimation. The

forced transformation required of every Indian at the time of the Conquest implied a change in the relationship of human beings and the divine as well as between men and women. Wiraqocha, the supreme God invoked by the Incas, was not an avenging deity.

While pre-Columbian religious verse tended to be characterised by an attitude of joyful gratitude towards the Creator, the colonial hymns often evoke a wrathful God and preach the sombre doctrine that happiness can be attained only in the next world and only by resignation to the miseries of this and absolute submission to the divine will.[21]

This change was to become especially damaging to the self-image of women since submission to the will of human husbands, priests, and other male authorities was also expected of them. Their educational possibilities were severely limited, their roles as nuns, mothers, or whores considered "natural," and their involvement in public life discouraged or prevented. Historically, however, Andean women had been able to be queens and warriors, and their role had been complementary to men's. "Pre-eminence and greater prestige was accorded to men, but their dominance has been regarded in the nature of 'first among equals.' "[22]

In the second part of this book we will examine Inca and pre-Inca religion in more detail and consider the refusal of many women to suppress this tradition upon the orders of the colonial state and church. The awareness of a heritage in which women resisted oppression and managed to retain social and spiritual power can help to confront and change an explosive situation of injustice and can thereby help to restrain violence and war.

Awareness will also lead to speech. Speaking and writing about war, many women name and shame violence and gain their rightful share of power to work for peace. In this respect, women in the United States and in Latin America have much in common. In fact, their experience in the past two centuries "can be viewed as a single story, at once historical and literary, of women's emergence as self-conscious subjects."[23] In this emergence Peruvian women become credible witnesses — a role that the colonial government did not grant them in either legal, spiritual, or literary terms.

*Part Two*

# The Women's Movement of Peru and the Theology of the First World

# Chapter 5

# THE GENEALOGY OF
# THE PERUVIAN WOMEN'S MOVEMENT

## History and Diversity of the Movement

> What emerges out of this is something one might call a ge-
> nealogy, or rather a multiplicity of genealogical researches,
> a painstaking rediscovery of struggles together with the
> rude memory of their conflicts. And these genealogies, that
> are the combined product of an erudite knowledge and a
> popular knowledge, were not possible and could not even
> have been attempted except on one condition, namely, that
> the tyranny of globalising discourses with their hierarchy
> and all their privileges of a theoretical avant-garde was
> eliminated.[1]

In order to understand Peruvian women's witnesses of war
within their proper context, we have to know the women's
movement of Peru, not only in its recent, very vital form, but
also historically, as it emerged in continuity with suppressed
precolonial power structures or in opposition to an oppressive re-
ligious regime and a disregard for indigenous cultural identity as
well as gender equality. What Michel Foucault calls "archeology"
or "genealogy," the careful unearthing of covered-up cultures
that had hardly been noticed by Western scholars, can reveal to
us an Andean world that has something in common with life
in biblical times while at the same time being intensely contem-
porary. While many *criollo* women do not have Andean roots
and many peasant women are not determined by industrializa-
tion and high technology, there is an overlapping of these two
spheres of life, and any Peruvian woman who finds her voice

in the present situation has to take both into account. The same pertains to women's organizations.

The women's movement of Peru has been one of the largest in South America, perhaps the one with the most varied forms of organization. This fact stands in paradoxical contrast to the real and legal situation of the Peruvian woman. She is still hemmed in by traditional authoritarian structures of church and state.[2] Even more restricting at this time is the repression and flagrant attack by Sendero Luminoso. I will in the following pages describe the women's movement as it developed historically until it had its greatest impact in the 1970s and 1980s. I will then consider its present dilemma.

Peru is a microcosm of Latin America's multicultural society. The contrasts between classes, landscapes, and ethnic groups are so striking that it is difficult to remember the unity of the country. The differences between social groups as also between men and women have been sharply intensified during recent years by a tremendous economic crisis. The social structures that for several decades have been democratized are also increasingly exposed to pressure from the guerilla movements and to counterpressure by the government and the military. Social order might in the long run break down completely if the economic situation, which benefits the guerillas, does not improve. By now, in the spring of 1993, it has improved for the small middle and upper classes, but has become worse for the masses of the poor.

The sociologist Virginia Vargas distinguishes three main streams of the Peruvian women's movement: the specifically feminist one; the "popular" one that grew out of labor unions, local self-help organizations, and other workers' groups; and the traditional one, which is attached to churches and political parties.

The feminist stream finds its space mainly within the big feminist centers that work, in practical as well as theoretical terms, toward abolishing the subordinate role of women. The popular stream starts with the traditional role of woman as mother and caretaker and expands this role into the public sphere. Thus individual and family activities become collective enterprises, as, e.g., the organizing of community kitchens and programs for better child nutrition. This part of the movement is mainly represented by women from the poor settlements around the

big cities, especially Lima with its eight million or more people. The third stream emphasizes the need for women to hold positions of responsibility in churches, political parties, or government offices, but it does not appear as radical or controversial as the other two do at times. These three streams, of course, often merge or overlap. There is tension between them and often lack of understanding, but also excellent cooperation. Different women simply try out of different daily circumstances to gain some free space within society that can give them identity, the right to participate in democratic processes, or sheer survival strategies.

Today's Peruvian women's movement has a distinct historical background. An important pioneer was the French-Peruvian socialist and proto-feminist Flora Tristán (1803–44), who influenced Marx and Engels.[3] Francisca Zubiaga Bernales (1803–35), wife of Agustín Gamarra, who became president of the Republic of Peru in 1829, was good at fencing, shooting, and horseback riding, and took part in military operations with the same ease with which she entered into high-level political diplomacy or elaborate societal festivities. Her courage during a battle in Bolivia is undisputed, and her ingenuity lives on in an (undocumented) story about her quelling of a soldiers' rebellion: Since the soldiers complained of hunger and lack of payment, she donned a military uniform, took her horse, and went to the military barracks. With a whip in one hand and a money bag in the other, she entered and said: "What? You, my *cholos*, against me?" The rebellion supposedly was quenched immediately.[4] Manuela Sáenz de Thorne, main mistress of Simón Bolívar, would wear a colonel's uniform when she tried to rally pro-Bolívar troops and did not mind handling a pistol or a sword in defense of Bolívar or herself.[5]

In the 1870s, groups of society women who worked for the rights of American Indians as well as for women's rights met in the old Inca city of Cusco. In their literary salons they emphasized the right of girls to get an education equal to that of boys and the right of women to be productive in literature and culture. In the next generation especially women teachers fought for equal rights of young girls to enter academic careers or practical training.

Around the turn of the century and up to the late 1920s, the

protest of women became more diversified and more visible. Anarchists, indigenous women, feminists, women workers — all these groups found their public voice. Many became politically active, demanding the vote for women and the right to hold positions of responsibility in organizations of workers.

Women from the lower classes had already been publicly active in the nineteenth century in two ways: They went with their men into war to become camp followers or even participated in armed warfare, and in the time of the struggles for national liberation they fought as guerillas. In the 1920s a first link was forged between feminist, socialist, and ethnic movements through the work of the renowned socialist José Carlos Mariátegui. In his newspapers and journals he often gave women the opportunity to write about topics like women's suffrage, the rights of the Indians, or sexuality.

How difficult it was for many women to voice opposition to traditional structures becomes clear in the example of María Jesús Alvarado (1879–1971). She fought for educational reforms and for the rights of young women workers. She founded a school, was active as a writer, and was president of a national council of women. Her criticism of the government of her time led to her incarceration and to many years of exile in Argentina. Today a large and distinguished Methodist school in Lima still carries her name, but only in the last decade have students become aware of the role and stature of this woman and how she suffered for her commitment. While this circumstance might indicate a lack of knowledge in churches and mission schools with respect to the history of the women's movement, it also can be explained by the fact that a Peruvian poet of the seventeenth century carried the same name of María Alvarado, and the school had always assumed that it received its name from this woman.

From the 1930s to the 1960s many Peruvian women fought for social rights alongside their men, but political parties and labor unions gave them little space. The increasing industrialization and the flight from the country to the city contributed massively to the increase of women-headed households. Men often did not find work where the family lived, or they abandoned the family under the pressures of poverty and migration.

## Outspoken Feminists

Since the early 1970s feminist groups have formed in Peru. One of their first aims was opposition to the exploitation of women as sexual objects, specifically against the popular beauty contests. Under the influence of the United Nations International Decade of Women and the reform efforts of a military government, a national discussion about the status of women in Peruvian society was initiated in 1975. Since 1979 various feminist groups and centers have been organized, largely supported by European and — to a lesser extent — North American NGOs (Nongovernmental Organizations). Many of the women active in the centers came out of leftist political parties in which they had fought for the rights of workers and ethnic minorities, but not for women's rights. Gradually they had learned that the hierarchical structures and the ideologies of the parties left no room for grappling with concrete women's problems; so they distanced themselves from the parties.

During the last fourteen years, a network of feminist centers has arisen in various cities of Peru. They began to work locally, regionally, and nationally in terms of consciousness-raising and concrete actions: from medical, nutritional, legal, or economic counseling to conferences of poets, journalists, and film producers. An excellent documentation center continually works on a computerized listing of all articles in newspapers and journals that deal with women's issues.[6] A well-stocked feminist library that is open to any visitor can be found in the Flora Tristán Center, which also brings out its own publications. Needlework and crafts that were created by women's groups in the poor settlements around Lima are mainly sold in the Manuela Ramos Center and provide unemployed women with a small income. This is only one example of the way in which the predominantly middle-class staff of the women's centers works with women at the grass roots and encourages women with little education to build self-help organizations or to take on leadership roles in organizing, for example, a crafts cooperative. The poor settlement women reached by these efforts are, of course, only a small number compared to the millions who need assistance in Lima alone, not to speak of the provinces, and their groups have been shrinking drastically since the threats by Sendero and other groups.

A beginning has been made, however, and the media are playing a part in raising the consciousness of the population at large concerning women's issues. The feminist periodical *Mujer y Sociedad*, for example, in 1989 became incorporated into one of the two largest Lima newspapers once a month as a special supplement. It is at this time again trying to survive as an independent magazine.

## The Women's Movement of the Working Class

The second — and largest — stream of the women's movement described by Virginia Vargas is the stream of the "rebellious mothers" or of the "mothers who became aware of being women."[7] The millions of migrants who have gone to Lima and other coastal cities since the 1940s in order to flee poverty, unemployment, and political violence in the mountains had to conquer a little piece of land legally or illegally in battles with the police. Sometimes these struggles did not end before lives were lost. After years or even decades some settlements still remain without water, electricity, or garbage collection. In this situation an intensive communal spirit is necessary for survival. When the men are away at work — if they have work at all — the tough battle for the next meal or the next canister of kerosene for cooking is left to the women. Above all, there is the fight for the next filling of the water barrels since water is trucked into many settlements only twice a week and has to be paid for.

In these surroundings violence against women — which in Peru as in other countries occurs, of course, in all classes of society — often becomes an insoluble problem: The men who are without work, underemployed, or exploited in the most menial kinds of jobs or who often have to take a two-hour bus trip into town to work in a factory come home frustrated and vent their anger on the women, trying to feel like masters of their lives at least in the home. The state and the church have over the centuries not only ignored the physical and psychological submission of women, but — knowingly or unknowingly — supported it ideologically. There are now local women's groups that work specifically with women who have been beaten or in other ways abused.[8]

Often a woman has to use courage, imagination, and hard work to find the time and possibility to work in self-help organizations against the will of her husband who wants her to stay home with the children. Working in organizations, however, has given these women education, self-confidence, and survival skills. The largest organizations are the Glass of Milk (Vaso de Leche) program, which is supported by the government and is supposed to provide each child with a portion of milk (fortified with oatmeal, cocoa, etc.) every day, and the communal kitchens that unite a large number of families to bring down the price of a meal for everybody. The present crisis is enormously hampering all of these, but women who were or still are active in either one of these programs have learned the basics of nutrition, hygiene, cooperative organization, accounting, and political action to get contributions of food or money. Thus they have extended their domestic activities into the public realm. In one of the most famous settlements on the outskirts of Lima, the above-mentioned Villa El Salvador, more than ten thousand women of very different organizations, from communal kitchens to voluntary nurses and nursery teachers, formed a massive women's organization.[9] Since María Elena Moyano's death and the constant threats to anybody who would take her place, this giant movement is hardly able to act.

## The Traditional Women's Movement

The third, more traditional stream of the women's movement grew more slowly. Women in labor unions and churches found out that besides class issues and religious problems there were women's concerns that could effectively be introduced only by women into organizational structures. Peasant women fought for years to be accepted into the membership and leadership of *rondas* (self-defense groups), and in some places they succeeded.[10] In the political parties it was similar: A woman representative, for example, managed to have a law passed according to which policewomen can rise into the highest ranks and another one that guaranteed housewives some Social Security.[11] So-called Mothers' Clubs (Clubes de Madres) within the political parties were

in 1986 asked by the government to organize the emergency help for the neediest part of the population.

In the Roman Catholic Church the scarcity of priests contributed to women's opportunity to take on more tasks. That happened not only in base communities, but also in very normal parishes.[12] Women who would not think of calling themselves feminists play an important role in the organization of literacy programs, of courses offering political, legal, or economic information, or of programs that benefit children. As in other Latin American countries, hunger, political terror, and lack of education endanger children every day, and women within churches and political parties are fighting for the rights of children.

In the labor unions the activities of women are often especially risky. As early as 1919 a group of women was murdered in a rural area north of Lima because they had supported their husbands in the struggle for workers' rights.[13] The wives of miners have always had special problems because ever since colonial times the mines have been places of the most brutal exploitation. In February 1989 Consuelo García, a woman who had committed herself to helping the wives of miners, was cruelly murdered, together with a labor leader, by paramilitary forces. Even in the large, widely accepted women's projects like Vaso de Leche women's activities can be utterly dangerous: In September of 1991, the Shining Path guerillas murdered a Vaso de Leche representative who had established an antiguerilla neighborhood program, and since then many more such assassinations have happened, apart from the case of María Elena Moyano, who was known as an outright feminist. These examples show that the more traditional women's groups within and outside the churches, parties, or unions can appear very radical — whether seen from the right or from the left.

### The Movement Today

Today, in 1993, the women's movement is in a very serious situation, but it is alive and active within its great limitations. What the people are going through is evident from the testimonies during a municipal meeting of 150 women in September 1991 after the murder of the Vaso de Leche leader. The meeting turned

into an impassioned exchange of ideas, emotions, and proposals. There were fear, anger, helplessness, protest, courage, and — yes — even guilt feelings. As one woman said,

> To confront Sendero implies reflection on two levels: that of what we are and that of what we should be, . . . a review of what we as leaders are doing or should be doing, . . . what we might be doing wrong.[14]

No, says another woman, if you consider Sendero as someone to whom you owe an account of what you are doing, you are in complicity with Sendero. But we have to dialogue with Sendero, argued another:

> We have to deny all that they are saying about us; we have to explain to them . . . we don't believe in [your kind of] solution for the country, we believe in democracy. . . . One of the arguments for the dialogue with Sendero is that we are not on the side of the government and that will mean that we are not painting Sendero as the enemy.

More women were in favor of dialogue and of explaining to Sendero that they know the community kitchens and milk programs actually should not have to exist. There should instead be job programs and workshops, and many of the women's groups had been working toward these goals. But in a survival situation "we have to defend life, and nobody has the right to take it away from us." All the governments have taken advantage of our work in the community kitchens. "Instead of giving arms to the peasants they should give them loans."

The overriding issue of the meeting was the need to speak up, to find new and more effective ways to communicate, to engage the media in the struggle, to have a massive demonstration, a march, a mass in a church, and a press conference. "If we keep our mouth shut, four, five, six will be dying."

A year and five months after this meeting, María Elena was blown to pieces. That was the end of any attempt to dialogue with Sendero. Another seven months later Guzmán was captured, and soon the government would brand certain leaders of the women's movement as Sendero sympathizers. Members of the feminist centers have received death threats from the far right and the far left. They have taken extra-strict security measures

around their buildings, are constantly changing the location of their meetings, and are restricting their activities to places with a relative measure of safety. Since they know that none of these measures can in the end protect them, the sheer miracle is that they are still working and still speaking up. The fate of María Elena and many others who died scares them, but their witnesses give them strength.

# THE CHURCHES' ROLE IN WOMEN'S CONFRONTATION WITH VIOLENCE

When women speak up about violence and war, they have been influenced by many social forces and, especially in Latin American countries, by institutional religion or personal faith. Whether they have been brought up within a traditional Christian setting or react against it as avowed atheists, in a country like Peru some native belief, some guideline of the church, or some popular religious symbolism will have influenced a person's reaction to a violent crisis situation. This is even more the case for women than for men, because women in all countries represent a larger percentage of churchgoers, and in a conservative setting they are expected to be more "religious" than men.

In abbreviated and simplified terms, the relationship between the Peruvian churches and the women's movement can be seen in a threefold way: (1) A consciously active and thematic feminism is opposed by the institutional churches and is therefore supported only by small Christian groups. (2) The broad stream of a women's movement in the settlements of the poor is influenced by lay people and theologians who represent some form of liberation theology, and they in turn influence this theology. (3) The traditional women's groups in the parishes are supported by the church hierarchy in the same way that political parties and unions support their women's organizations. Such support carries with it, however, the danger of neutralization and cooptation. When the government asks Mothers' Clubs to distribute food, it actually increases the caretaker burdens of the women and secures their uncritical support. When the church glorifies the role of mothers or of mothers' work in the parish and at the same time opposes any artificial family planning, it increases the compul-

sion of many women to "sacrifice" themselves continually. It also intensifies the guilt feelings of women who are trying to break out of the cycle of an uninterrupted bearing and nurturing of children or to separate themselves from an abusive husband.

The relationship of the churches to the three streams of the women's movement is, however, complex and has to be more thoroughly analyzed. A distinctively Christian-feminist group in Lima is Talitha Cumi, an ecumenical circle of lay women, members of religious orders, social workers, and Protestant pastors. Some of them work with the poor in the settlements — for example, among the thousands of prostitutes of Lima — and know their problems firsthand. They are partly influenced by North American or European feminist theology, but above all they feel solidarity with the broad mass of Peruvian women and would like to sensitize their churches to the plight of these women. Talitha Cumi is a small group with a fluctuating membership. About a dozen women gather regularly for worship and meditation, discussion of feminist theological literature, or the planning of activities. When, for example, the pope visited Peru in February 1985, Talitha Cumi published a document about the role of women in Peru and the failure of the church to help women effectively. For one Mothers' Day Talitha Cumi sent a flyer to countless parishes, schools, and public media, criticizing the commercialization and sentimentalization of the day and challenging readers to discern the real needs of women. At the International Day of Women (March 8), which in Lima is always celebrated as a huge folk festival, Talitha Cumi in 1989 presented a photo exhibit with the title, "Poverty Bears the Face of Woman." In the accompanying text it said:

- Of one hundred illiterates, sixty-four are women.

- For every unemployed man there are two unemployed women.

- Of 4 million mothers 1.6 million are single.

- As on the global level, so in Peru seven out of ten poor people are women.

(These statistics have become much more drastic since the economic shock program introduced by President Fujimori in 1990

and the escalated violence of Sendero Luminoso.) Talitha Cumi also produces small publications in mimeograph form, some of them translations of North American or European articles. The women's movement of the millions of migrants who have settled in the coastal cities and especially in Lima is in part attached to the Roman Catholic *parroquias* (parishes) or has at least a loose connection with many parishes. Communal kitchens and Glass of Milk programs are usually secular organizations, but they often receive space and money from a parish or have been founded by women active in a congregation. When, however, a women's group becomes politically involved, it might lose the support of the church, and that can have concrete material consequences when, for example, no more groceries are donated by the church. The women's organization in Villa El Salvador had such an experience. When in 1983 the government undertook a mass arrest of young people in this settlement and treated them badly because they were suspected of terrorism, the mothers rebelled in public demonstrations. The local priest then threatened to deny the women the groceries for the communal kitchen and the church's space for women's gatherings. The women finally decided to cut their ties to the parish. They joined together with other women's groups in the neighborhood and managed to receive food donations from the international Catholic relief network CARITAS instead of the local parish.

The relationship of the churches to organizations of any kind is especially difficult in the areas in which the guerillas practically control public life. In the area of Ayacucho, for example, where the Shining Path movement started its violent activities in 1980, the official representatives of the church have hardly ever taken a stand on human rights violations by either guerillas or the military. The church in the area had traditionally stood on the side of the *criollo* elite and the big landowners, especially since much land was owned by the church itself. It is understandable, then, that today a woman like Angélica Mendoza, president of the organization of Mothers and Families of the Disappeared, cannot count on the support of the church, especially since the Shining Path in recent years has murdered some priests, and the military can "disappear" all those that disagree with its strategy of anti-guerilla warfare. The women who risk their lives in searching for

disappeared husbands, sons, sisters, and brothers are therefore often completely on their own.

However ambiguous the stance of the institutional church might be, there are always individual priests, nuns, and lawyers who courageously assist these women — many of whom are illiterate — in documenting individual cases and accompanying them on visits to prisons and police stations or on demonstrations.

It is not surprising that from such circumstances a theology of liberation is born, meaning a theology that arises from the grass roots of the people and that emphasizes God's own struggle for "liberated" social structures in this world and not only personal salvation in an afterlife.[1] Countless priests, monks, nuns, Protestant pastors, and lay people have dedicated themselves completely to a life with the poor. That does not mean, however, that liberation theology has been accepted by a majority of churches. It also does not mean that through the influence of this theology the women's movement — including its specifically feminist component — has been acknowledged as necessary and important. The official church structures are too much determined by their historical ties to the ruling class. Also, Rome is now installing more conservative bishops, and among the Protestants the influence of fundamentalist sects, supported by North American evangelists, is strong. Some Protestant churches are too much involved in their own survival and their infighting over "liberalism" and "conservatism" or over power issues between individual leaders to be concerned with the needs of the most marginalized people. Nineteenth-century missionaries from North America and Europe frequently taught them a "private" Gospel and middle-class habits.

It should be mentioned that there are a few leading representatives of the Roman Catholic Church who are very courageous. For example, José Dammert Bellido, bishop of Cajamarca and president of the Peruvian Bishops' Conference, along with the archbishop of Arequipa, Fernando Vargas Ruiz de Somocurcio, declared publicly their stand against the death penalty, which President Fujimori and others would like to reintroduce.[2] Father Angel Acuña, secretary of the Vicariate of Solidarity in Huancayo, desperately pleaded in public that the state's security forces should prove they were not involved in the mysterious disap-

pearances, tortures, and murders of many students last fall in the Huancayo area, and he condemned the silence of university officials on this issue.[3] While these examples do not have an immediate bearing on the situation of women, they imply that people can be taught by church leaders to think critically about those in power. This teaching has often been lacking in the churches, and women especially were taught submission to authority.

The overall picture implies, then, that the women's movement has often been ignored or strongly criticized in a society in which the church's influence is still pervasive. It is especially the case when abortion is discussed, an issue that in a country of starving mothers and children looms much larger than in the United States. On this point people take different stands even among the representatives of liberation theology. Some groups see class differences as much more important than the oppression of women, whereas others, like the feminist centers, consider both problems inseparable and emphasize the gender issue because it has historically been the most neglected. There are complex positions between these two poles. Gustavo Gutiérrez's Instituto Bartolomé de las Casas supports studies of women's issues besides many other kinds of research and offers theoretical and practical help to lay people and theologians who work with women.[4] Gutiérrez, who is called the "father" of Latin American liberation theology, has been known for decades by people who worked with him in the Catholic student movement as fostering the leadership positions of women. That does not mean, however, that his institute is in agreement with the formulations and actions of the feminist centers.

Within this wide spectrum of relationships between women and church one factor has to be mentioned once more; without it nothing Peruvian today can be discussed realistically: Sendero Luminoso. The Shining Path has infiltrated universities, shantytowns, labor unions, and perhaps the margins of the women's movement. In spite of President Fujimori's continuing success in capturing guerilla leaders, subversive as well as military violence has not stopped. Conservative as well as liberal churches, liberation theologians as well as Evangelicals, equally oppose Sendero Luminoso. However, as long as they do not fight for justice within their own structures — including justice for women —

hungry and hopeless citizens, including many women, will accept Sendero like a bitter pill, hoping it will give them a future. The more educated women sometimes opt for the smaller MRTA guerilla movement, which started out under the inspiration of the Cuban revolution. Through the pressure of competition with Sendero Luminoso, MRTA also became increasingly violent.[5]

As indicated earlier, when a migrant woman from the Andes lives in a hut in a Lima settlement and cannot find work to feed herself and her children, she sees mainly three possibilities: prostitution, the drug trade, or the guerilla movement. The ideology of the struggle for a better world and the lofty cult atmosphere surrounding Sendero Luminoso will easily lead a woman to choose the guerillas. The movement will be for her a substitute church, and the total submission to the rule of a male leader will not be too difficult for women brought up in hierarchical, patriarchal traditions of church and state. One could even see Sendero women as making a similar choice as nuns in colonial America: The convent guaranteed the possibility of a life of the mind, freedom from the problems of marriage and children, and a dedication to high ideals. A complete separation from the mundane world and the consciousness of being initiated into a mystical order gave women, normally nonpersons, identity and self-respect — even a new name. The secrecy of Sendero life with its need of silence in many situations can remind us of the silence of the cloisters, a deliberately chosen, dedicated life. Even the uniforms that Sendero women wear in their festive prison celebrations express the emphasis on being merged into a collective where discipline and order triumph.

All this is not to say anything against monasteries, which were after all spaces of freedom and creativity for countless women. It also should not suggest that the church is in the least responsible for the perversity of Sendero Luminoso. It is to say, however, that churches, including the Protestant churches who glorified women's domesticity, might be reaping today some of their own sowing when women are unable to resist the urge to "sacrifice themselves," something the church has always required of them in daily life, and to submit absolutely to a male authority. Throughout Christian history, men were also expected to make sacrifices, but they were the "higher" kind: to give their life on the battlefield or to represent Christ's sacrifice in the mass.[6] The

churches are challenged today to grant equal dignity to both gen-
ders: to expect "lowly" service, in terms of everyday care and
nurture, of men as well as women; to allow women as well as
men to be priests and pastors, and to emphasize a commitment to
life instead of glorifying death on some battlefield. If they would
move in this direction, abusive notions of sacrifice, obedience, or
submission might be less likely. Churches could be in the fore-
front of giving women their voice, encouraging their own Bible
interpretation, their own leadership gifts, and their own critical
discernment of political power structures.

Finally, the good news is that all of this is happening here
and there. Throughout church history the church has played this
double role of constricting as well as liberating women. In Peru
as well there are Christians who are fighting the good fight like
María Elena; there are priests and nuns who accompany women's
groups on peace demonstrations that expose them to dangers
from the left and the right; there are faithful lay women in moun-
tain villages who stay with the peasants when most others have
fled.[7] That these witnesses exist is a miracle when we consider
the colonial history of Peru to which we now turn. It will show us
that Peruvian women have witnessed religious as well as politi-
cal violence for five hundred years and can derive strength from
a history of resistance.

# THE GOD OF THE SUN OR THE SON OF GOD? WOMEN WITNESSING RELIGIOUS VIOLENCE

Considering the important role the church still plays in Latin America, any groping for change in Peru has to ask what the church (the Roman Catholic Church as well as the growing Protestant churches) can provide as models or initiatives. Are there patterns of gender balance or imbalance, violence or nonviolence, dominance or democracy in Peruvian history that might challenge our theology today? What kind of Christian witness has the church proclaimed for five hundred years that might influence women's witness today?

We have to start with the fact that the theology imported from Europe, whether Catholic or Protestant, has always been a theology of "master nations" whose representatives "discovered" natives and taught them to imitate the life and faith of the First World. Colonial representatives of Spain came from a country that had just expelled the Jews from its borders, so they were not predisposed to appreciate another culture or religion. That is not to deny the fact of true "indigenization" in parts of the mission fields.[1] However, especially for the Protestant churches of the nineteenth century, European and North American influence resulted in a mission theology without roots in Peruvian soil, and representatives of the First World never were confronted with the corrective of an "Other" recognized as equal.[2]

The anthropologist Irene Silverblatt has described how in the

time before the rule of the Incas men and women had more balanced gender roles because Andean cosmology and culture were based on reciprocity and correspondence of opposites. The Incas, however, introduced changes that favored a later more general submission of women. Since Andean people lived in strong kinship relations and worshipped their ancestors, the Inca rulers masked their power politics by an innocuous kinship terminology that they extended into mythical and historical realms.[3] Thus the ruling Inca became the son of the sun, emphasized his sacred descent, and understood himself as imperial victor over many tribes and nations. The wife of the ruling Inca was the daughter of the moon and was in charge of all other women. These relationships were ritualized so that the tribute-paying tribes were more unified and more rigorously subjected to Inca-rule.[4] The Inca also had the right — like a "big brother" — to marry women to his political friends, and he sought out the most beautiful women to make them priestesses of the sun or to hold them near his temple to do expert weaving. The virginity of these women was strictly guarded. Some of them were killed in sacrificial rites. The lives of women and servants were sometimes sacrificed in order to bury them with their lord.[5]

In spite of these customs, Inca women, according to Silverblatt, still had certain rights and privileges that they lost under Spanish rule. When the Inca had to lead his army into battle, his wife often took over the government. The two complementary images in the origin myth of the Incas are the peaceful, domestic Mama Occlo and the warlike, independent Mama Huaco. Women also held local or regional offices as "governors."[6] The women who were chosen as priestesses were highly honored and played an important role in state rituals, in the articulation and interpretation of divine messages, and in the upholding of ethical values. On the one hand, they represented the Inca's power over their tribes, on the other his offer of social and economic support for their kinship groups.[7]

When the Spaniards came, domination took on very different forms: The kinship system so important to Andean people was dissolved, the concepts of private property and market economy were introduced, and the feeling of oneness with nature was replaced by an orthodox system of good and evil. The last was especially alien to Andean culture:

For the people of the highlands nothing is only good or only bad, nothing only feminine or only masculine. Everything is the one as well as the other. All things of this world contradict and complement each other.[8]

The systematic suppression of the culture and spirituality of the Andean people was answered by opposition throughout the centuries, and especially women opposed the authorities because they suffered intense hardships. According to Spanish law, a married woman was as incompetent as a minor.[9] Every legal procedure had to be authorized by the husband. Since women had always held the right to inherit land, they often opposed the new rule that gave only men the right to determine ownership. One of the most serious changes was, according to Silverblatt, the dissolution of the household unit and the diminishing cooperation of men and women. Men between eighteen and fifty who did not belong to the nobility could at any time be forced to work in mines, in primitive factories, or in personal service to the upper classes and thereby pay "tribute." That often meant leaving their families. Women were also forced to work for "tribute," for example, by spinning and weaving. Married women could be taxed double, in the kinship group of their husbands as well as their own, and children, who used to belong to the mother, were now property of the father. Often women would lose their land because the men were unable to pay their tribute out of their own property. Men also could avoid the tribute by moving into the city, leaving women, children, and the aged behind in the village where they had to struggle to pay the tribute, sometimes by endless spinning in prison-like buildings into which they were locked.[10]

Fernando Mires has pointed to an omission in most history books on the Conquest: the enforced allocation of women to the colonizers. Some forms of allocation were: (1) marriage with an Indian woman, which made it easy to appropriate land, (2) domestic service, (3) women as "gifts" to consolidate alliances between native chiefs and the Spaniards, and (4) allocation of women by force for productive or reproductive purposes. Mires also states that "patriarchy of the Muslim type, familiar to the Spaniards, was imposed in America alongside the Catholic-monogamous type of patriarchy."[11]

Spanish administrators and priests as well as the landowners whom they favored participated equally in the economic and sexual exploitation of peasant women.[12] When the kinship system was dissolved in the middle of the sixteenth century and the peasants were forced to move into nuclear settlements for more efficient control, women lost the political influence they earlier had within the kinship network. The new offices created by the Spaniards went to men and sometimes offered release from tribute.

Women lost all direct access to political or judicial authorities. Uprooting them from their original homes was in itself not only a blow to their social life, but also to their spiritual identity since American Indians everywhere do not separate their faith from their land and from the burial places of their ancestors, whose presence in the earth continues to nourish life.[13]

These drastic changes, however, were strongly and imaginatively resisted, especially by women. Many were persecuted as witches when the European witchhunt spread into the colonies. The "sins" of the witches were sometimes protest actions, like the worship of the traditional shrines (*huacas*). Some witches were actually accused of enticing the people to rebel against priests and mayors.[14] Ecclesiastical authorities seriously discussed whether witches — usually women — could fly through the air to attend nocturnal meetings in honor of some goddess. While the most infamous European theoreticians of witchcraft considered this a reality to be severely punished, Andean observers thought of these ideas as demonic delusions, not quite as dangerous as some Jewish secret wisdom, but equally to be repudiated.[15] The fact that so many more women than men were considered witches relates partly to women's traditional roles as healers, midwives, and cooks and to their association with the mysteries of menstruation, conception, birth, and sickness, all of which belonged to the realm of tainted, "lower" nature over against "higher" (male-ordered) culture. Moreover, the "witches'" creation of conjure formulas, invocations, and medical rites can be considered an appropriation of language regarded as illegitimate by male authorities.[16]

What we know about Andean cults we know mostly from the men who tried to extirpate them. Their zeal was directed mainly against the various *huacas* — objects of veneration in fields and

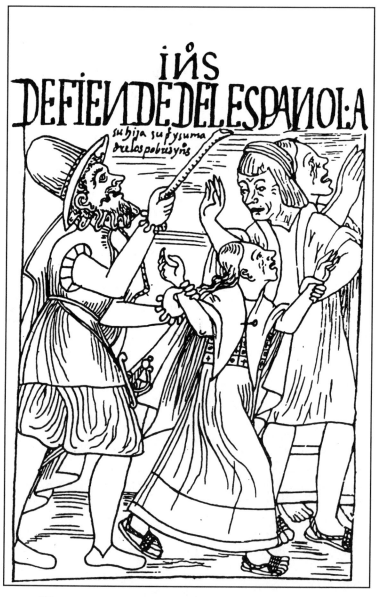

"Those poor Indians, father and mother, defend their daughter
against the Spaniard."

houses that were supposed to guarantee rich harvests and other good fortunes — and against the veneration of the ancestors. Women were frequently connected with these idolatrous objects and places. When the women could no longer pay the tribute after the men had left for the cities, they often fled into the isolation of the highland desert, where they could tend the graves of their ancestors and become priestesses of the ancient rites. Many of them were considered guardians of sacred traditions and rebels against secular and spiritual authorities. "Witchery, in this case exercised by women, was one of the factors that made the survival of certain traits of pre-colonial Andean culture possible."[17] That is exactly what the inquisition could not tolerate: "Witches" were, as Rosemary Ruether puts it, "insufficiently docile" women and hindered the erasure of ancient cultic practices.[18]

Michael Taussig has vividly portrayed how the colonial lords, researchers, priests, and tourists frequently conquered the new world literally on the back of the Indians. The ways through mountains and ravines, wild rivers, and dense jungle were often so dangerous that horses and donkeys were unable to travel them and only Indians with litters on their backs, in which the lords had to sit very quietly, managed to proceed step by step. These porters were frequently held like slaves and had to carry a hundred to two hundred pounds. Some of them were women. In 1914 a Colombian bishop observed that to be carried on the back of an Indian meant to be utterly exposed to death and nature.[19] This observation can also be a metaphor for spiritual colonization: A religion that tries to conquer the world on the back of another religion without regard to the suffering of its carrier is exposed to death and to the "natural" eruption of a spirituality of resistance. When women even more than men are forced to bear the yoke of an alien culture, their resistance is intensified. Women also have experienced colonization more concretely than men in their own bodies: through rape. The earliest illustrations of the "discovery" of America symbolized the soon to-be-conquered continent by the naked body of the native woman.[20] The church proved to be no supporter of women's rights either: It almost limited women to only two ways of life, that of the nun and that of the mother, and both kept women out of public life. In addition, priests often raped native women.

In spite of experiencing culture shock and witnessing religious

violence, Peruvian women did pass on the Christian faith from one generation to the next in their own stubborn way, resisting their marginalization or indoctrination. While accepting the faith in the Son of God, which took the place of the God of the Sun, they remained in awe of the explosive and at the same time creative and restorative power of *pachamama* (Mother Earth). Scholars of popular religion today are asking themselves what, after five hundred years of Christian teaching, Christ really means to the Andean people. Is he to them mainly a miracle worker, a saint, a martyr, a defender of the rights of the poor? Is their cult of the Virgin Mary actually covering up the cult of *pachamama* — which was forbidden as idolatry by the missionaries?[21] Whatever the answer to these questions, women, who throughout Latin America are responsible for handing on the faith to the young generation in most families and who are the main interpreters of the Bible in base communities, have always shaped their own understanding of faith.[22] There is some indication that evangelical and Pentecostal Protestantism have been more effective than the mainline churches in supporting women's daily subsistence struggle by pressing for "moral" behavior for men as well as women and by making use of women's leadership abilities.[23]

Peruvian women today can rediscover a history of women's resistance. But who is going to teach them this history, especially when they are illiterate and when churches and schools are much more interested in teaching them European and North American theology, politics, and market economy? We are still living in the shadow of the *conquistadores* and their confusion of discovery and domination, of God and gold. Just as the Spaniards in colonial times and in the following centuries practically created an "Indian" identity, so we are still unwittingly shaping "Indians" in our own image, telling them how to improve their agriculture, how to give up their superstitions, how to arm themselves or be nonviolent, or how to adjust to our concepts of God and the world.[24] It remains, therefore, a challenge to listen to Andean women's own testimonies and those of their descendants, whether they still live in the Peruvian highlands or have grown up in the settlements of the coastal cities. They deserve a hearing not because they are wiser or better than other people, but because they have been witnessing social and religious violence for centuries.

## Chapter 8

# WOMEN'S LOCAL WITNESS AND GLOBAL THEOLOGY

There is no use in establishing a catalogue of crimes committed by the Spaniards of the colonial period — even though the 1992 quincentenary seems to have lent itself to such efforts. (After all, how are we going to be judged five hundred years from now when scholars might point to the fact that in the 1990s children in the industrialized north of the globe used up forty times more of the world's resources than children in Peru, India, or various African countries?) What counts is our own witness concerning our relationship to other cultures and other theologies so the next generation will not be subjected to religious violence the way former generations were. Can we develop the tightrope act of a theology that neither falls into a rigid, Eurocentric dogmatics nor into a lukewarm universalism? Can we learn to think globally in theology by taking seriously the local roots of faith, that is, by recognizing the one God as incarnated in specific, limited cultures?

We often forget how long the development of Christian traditions took and how they received their profile only in a critical engagement with "pagan" beliefs and customs that they frequently absorbed. (The development of the celebration of Christmas is a case in point.) In concentrating on the official and institutional church history, the history of popular devotion and piety was often neglected, even though

"that piety in its slow and silent workings generates by and by a common and accepted belief." The very obvious role of Christian institutions in sustaining belief should not make us forget this other, less discernible role, which made Christians of entire peoples previously devoted to the cults

of Woden or the moon, sacred trees and pagan goddesses. It is a much harder subject, for converts did not record their thoughts and were often accused of sliding back into ancestor worship (or worse); yet it is equally worthy of analysis.[1]

In our anxiousness about losing the substance of the Christian faith through its inculturation, we forget that our Western faith is deeply inculturated. As the African Jesuit Engelbert Mveng has stated,

> The problem of the inculturation of the gospel is posed for us, first and foremost, in terms of "deculturation." The gospel must be de-westernized and restored to the peoples of the Third World.[2]

Since, however, there is no "pure," culture-free Gospel, we might work not so much toward a deculturation, but toward the intensive openness of a Western Christianity that constantly sees its limits and its need for correction in exchanges with people of other faiths and other cultures. What role does women's testimony play in this process?

Just as the Andean peasant women in colonial times, women all over the world are usually more tied to localities than men, especially because they have always been expected to nurture the children and have been kept away from hunts, wars, and business trips. Women are therefore more than men socialized to guard local, deeply rooted traditions — like the Quechua women in the Andean highlands.

Judith Herrin has described, for example, the role that local icons played for women's worship in the early Middle Ages. Infertility and sickness were healed by veneration of icons. The sacred pictures served the domestic, private meditation of women. Personal prayer and a direct relationship with the divine were preferred to the intervention of the clergy.[3] Thus the attempt by women to determine their religious life without regulation by the church and to hold on to certain traditional rites goes back far into church history.

> Since women, not by nature but on account of their socialization, are often closer to the world of everyday life and its detail, a good amount of "grounding" and concretion

enters theology through the experience of women.... To believe with all one's senses can then also mean: to recognize, clearly recover, and undisputedly acknowledge forms of devotion and faith of "others."[4]

Carol Gilligan's thesis concerning the psychological difference between male and female attitudes needs many qualifications, but is useful as a working hypothesis. In accordance with her theories, we can state that for the majority of women on this globe, there is very little temptation to think in "universal" abstracts and orthodox dogmas.[5] On account of their socialization they tend to be more open than men for everything "other." Even when women as migrants and refugees are pulled up from their roots — 80 percent of all refugees of the world are women and children and two hundred thousand "internal refugees" exist in Peru[6] — the necessity of caring for children forces them to act locally and concretely in order to survive.

Considering women's training to nurture roots and to take care of "others," and considering also their history of resistance against authority, it is not surprising that women frequently point to forgotten or even subversive traditions of their individual culture. This is especially true of non-Western women. One example is Chung Hyun-Kyung, the Korean theologian who caused intense discussion through her presentation at the World Council of Churches Conference in Canberra.[7]

Another example is the New Testament scholar Elsa Tamez, a Protestant from Mexico teaching in Costa Rica. In a recent essay Tamez did pioneer work relative to the importance of native Latin American traditions for Western theology.[8] Although she relates her thoughts to the Aztecs, her conclusions in many ways fit the history of the Inca world. Her description of spirituality before the Aztecs pertains also to the pre-Inca time: In a relatively harmonious world built on community and mutuality Andean people believed in a creator divinity who sustains life and gives food and wisdom. Other gods were personifications of the forces of nature. There is no evidence of human sacrifices in these early cultures, according to Tamez.[9] Parallel, however, to the rise of the Incas, the Aztecs appeared in Central America, and under the rule of their sun god Huitzilpochtli they acted just as warlike as the Incas in the southern Andes. In both empires the ritual sacri-

fice of humans developed. Among the Aztecs most of the victims were prisoners of war from newly conquered ethnic groups. The gracious God of life became a demanding ruler who considered killing necessary in order to sustain life and increase his power.

When the Spaniards appeared, a mass killing started that had been unimaginable earlier. Paradoxically it was justified often with the fact that the Aztecs and Incas were savage enough to sacrifice humans. Just as within the American Indian traditions a confrontation arose between the God of life and the God of death, that is, between the earlier, more peaceful cultures and the warring empires, so also, Tamez thinks, a struggle developed within Christianity: The God who keeps Abraham from killing his son, who liberates Israel from captivity and in Christ brings life and peace, becomes the God of conquest. The Spaniards bring the imperial ruler God in whose name all existing cults are eliminated and all weaker nations are subjugated. Tamez also finds that there were always some of the oppressed who resisted the custom of killing in the name of the divinity, from Maya prophets to Bartolomé de las Casas, from female prisoners of the Aztecs (or, we might conclude, the Incas), who protested their being sacrificed, to the peasant women of today who are fighting for life and justice.[10]

If the theology of the First World learns from such reflections and recognizes through the history of Latin America that it is not itself a "purified," "truer" expression of faith compared to so-called legalistic Judaism, superstitious paganism, or power-hungry Islam, but that all these negativities are found in every tradition of faith and also have to be dealt with within Christian groups, then the reality and theology of Latin America have made an important contribution.[11] We can then acknowledge that the belief in a power-hungry, legalistic God, who feeds on superstition, is present also in the midst of Christianity's past and present. We might also admit our vulnerability in using the Abraham story. Yes, Abraham is kept from killing his son, but the very suggestion that a just and loving God might order a father to kill his son shows we are not too far from Aztecs and Incas in our Holy Scriptures.

> The community must remember, like Abraham it must deal with this God, who is sometimes incomprehensible and

horrifying, and in response to whom we too may become incomprehensible and horrifying, even and especially to ourselves.[12]

The ambiguities of our own faith can then open us to those of other faiths. In recognizing the dignity and integrity of other faith traditions, we might, for example, appreciate the sensitivity with which the Quechuas praised their creator god (Wiraqocha):

> Ah Wiraqocha, the power in all that exists!
> "May man arise,
> May woman arise," (you said).
> Holy God,
> Creator
> of every awaking light.
> Who are you?
> Where are you?
> . . . . . . . . . . .
> Speak to me![13]

In the precolonial myths of the Andes, women were not seen as metaphysically impure, as origin of sin, or as essentially flawed, as was the case in the work of Christian church fathers and in Aristotelian philosophy.[14] Andean cosmology also did not have the concept of a satanic being, even though Spanish observers thought that "it was the devil who spoke in Andean oracles" and that the devil was "exceptionally active in Peru."[15] At the same time a consciousness of guilt and injustice was not lacking, and confession, e.g., by women before female priests, was customary.[16] Prayer was and is also an essential part of Andean spirituality. A Maryknoll missionary reported in 1991:

> In Peru, I found that religion and prayer, imbedded in the culture long before the first Christian missioners arrived in the Andes five hundred years ago, permeate nearly every facet of Aymara life — planting seed, harvesting potatoes, building a house. Popes now write encyclicals about reverence for the earth and its resources, a practice that the Aymara have followed in prayer and deed for centuries.[17]

What the chronicler Guamán Poma de Ayala noticed in the seventeenth century is emphasized also by present-day observers of

Latin America: that the Andean world is in many ways reminiscent of the world of the Hebrew Bible.[18] That does not mean seeing it in archaic, unchanged ways. To the contrary, some aspects of the present war situation remind us more of today's Middle Eastern struggles than of ancient Israel. The Bible is, however, being understood very directly in the Latin American context, partly because it grew out of oral traditions, and oral culture is still predominant in large parts of Latin America. Understanding the "orality" of the Andean world can give us insights into the special "literacy" of the Bible, which even illiterate peasant women can easily grasp. "Translating" the Christian message into one culture, and specifically into the lives of its women, can increase our understanding of other cultures.

Sabine McCormack states that the "veneer" of imperial Inca religion soon got lost after the fall of the Inca empire, whereas the underlying pre-Inca cults endured:

> Although policies of extirpation destroyed the cults and disrupted or changed the myths, many of the guiding religious ideas that speak through the documents recording campaigns of extirpation continue to be expressed by contemporary Andeans.[19]

It is this persistence of ancient rites up to our day that evokes the parallel to the biblical world. However, it is not an altogether patriarchal world. There are many feminine deities, and there is even evidence that Andean Christians could picture the Trinity as consisting of Jesus, Mary, and the Holy Spirit — with no "father" in sight.[20]

Summarizing, we can state that Euro–North American theology can become truly global when it dialogues with a faith as "local" as the Andean tradition. It can then face some important challenges:

1. The "global" necessity of taking women's testimonies seriously should be as evident for theology as for all other scholarly disciplines. For years now the worldwide "feminization of poverty" has become a well-known sociological term.[21] Mainstream Western theology, which cannot avoid the biblical mandate to care for "widows and orphans," has rarely taken note of the phenomenon, especially as it concerns the southern hemisphere.

Hundreds of European and North American private foundations have pioneered in a field where theology lags behind.

2. In focussing on the local and global witnesses of women, theology will give up its universalism. It will not assume that concepts like sin, sacrifice, or eternal life have the same meaning for men and women, and from this perspective it will also be more understandable that people of other cultures, men as well as women, understand such terms differently. If according to the Western-male tradition the essence of sin consists of pride, among women of all cultures sin is more likely the lack of self-esteem or the accommodation to a patriarchal system. If Western theologians ask, "Is there life after death?" women of Peru will ask, "Is there life after birth?"[22] The crucifixion of Jesus is for Western Christians often an abstract dogma, but for the mothers and wives of the tortured, raped, or murdered young people of Peru it is a daily presence. Ethics in Western theology is a rational consideration of the just interaction of human beings. For a Peruvian mother who cannot feed her children it is a creative line of action that possibly is in crass contradiction to our ethical principles.

3. Theology can learn to give up its individualism and to rediscover in women of the Third World a communal spirit that expresses the biblical understanding of community. Every soup kitchen program in Peru and every *arpillera* workshop bears witness to this spirit. These women can remind us that dogmatic projects by star theologians remain limited to an ivory tower unless they are founded on communally developed structures of faith in which even the most marginal women find their voice.

4. Theology can learn from Peruvian women that witnessing violence has to lead to an articulate witness about violence; that observation and involvement, theory and praxis, are inseparable if we want to be constructive peacemakers. Many women in Peru have shown the beginning of an indispensable cooperation between intellectuals and "workers," between feminists who work out theories about gender roles and mothers who daily push a vending cart into the city and who have to take care of several children while selling fruit and vegetables.[23] This combination of theory and praxis never happens without problems and continually has to be worked out anew between classes and ethnic groups. At this time it is especially difficult in Peru because of

the political problems involved. It is, however, not only a necessary condition of democracy, but also a necessary witness of Christians since for a faith that is really alive dogma cannot be separated from discipleship.[24]

5. Realizing how Peruvian women have witnessed religious violence for centuries because their spirituality and rites were considered "pagan," Western theology is challenged to dialogue with other religions. If we acknowledge the integrity of many aspects of Inca and pre-Inca traditions, we will learn to put in the place of a narrow christology a hermeneutic of the reign of God that corresponds to the message of Jesus of Nazareth.

> Of course, theologians have always contended that Jesus did not preach himself, but the kingdom of God.... Nobody, however, draws the final conclusions from these statements about the kingdom of God.... To live in accordance with the values of the realm of God, in other words: to honor, protect, and nurture life, is being constricted to a keeping of norms traced back to the image of a Father God and his son.[25]

Our dialogue with Jews, Muslims, and members of other faith traditions will take on new forms when we no longer preach a "Jesusology," but the reign of God. To do this in a truly global way means — to return to the words of Foucault — to give up the "tyranny of globalising discourses" and to discover ever anew the incarnation of God within the limitations of gender, culture, and geography everywhere on earth. That is the core of the message and ethics of Jesus of Nazareth.

> The second Reformation will come from neither Wittenberg nor Geneva nor Rome, but from the poor churches of the Third World.[26]

We might also say: from the poor women of the Third World.

*Part Three* ———————————————

# Women's Voices from the Third World: Literary and Theological Debates

*Chapter 9* ─────────────────────────────

# FICTION, FAITH, AND TRUTH IN LATIN AMERICAN WOMEN'S TESTIMONIES

Finding one's voice, witnessing to experience, communicating with fellow humans is an integral part of literature as well as religion. Without words, oral or written, the divine Word would not come alive. It is therefore an abridgement of human rights as well as a perversion of religion when masses of women for ages have been kept silent, uneducated, and relegated to "natural," brainless, wordless tasks of their bodies. Up to this day, millions of them are not even respected in their bodies. "Violence against women comprises at present the greatest violation of human rights throughout the earth."[1] Paula Cooey, who makes this statement, refers to the uncounted abusive practices against women throughout the world, from rape, infanticide, and neglect of females because they are not sons, to dowry death, genital mutilation, forced pregnancy, and beating of adult women by their spouses. Latin American women have borne and are still bearing their share of sexual violence. It is not surprising, then, that they are also concerned with the social violence of war. As Western women, we cannot speak for them or represent them. They themselves have to speak and make their presence felt. As Gayatri Spivak stated it,

> I am afraid of speaking too quickly in academic situations about the women — the tribal subaltern, the urban subproletariat, the unorganized peasant — to whom I have not learned to make myself acceptable other than as a concerned benevolent person who is free to come and go.[2]

In the United States, we have learned especially during the civil rights struggle in the 1960s that whites cannot speak for blacks. In terms of global relationships, Euro-Americans had to learn that they cannot determine the "development" of Third World countries, telling them what they need to have and to do. Within the churches, various mission endeavors have done a lot of harm by speaking "for" the churches in the southern part of the globe, imposing their ideas of benevolence and evangelization on them. Not being able to speak for others, however, does not mean we have no obligation toward them. We can name and tame violence in our own country and witness to the injustices inflicted upon Third World people. To quote Spivak once more:

> What I'm interested in is seeing ourselves as namers of the subaltern. If the subaltern can speak, then, thank God, the subaltern is not a subaltern any more.[3]

It is problematic, however, to call certain people "subaltern" — just because they are part of the Third World or of a marginalized group in our own country — and pretend that only we as First World people can make them speak. Daphne Patai has rightly questioned this presupposition and has shown in her own work on Brazilian women that even poor, uneducated "Third World" women can speak very eloquently.[4] What counts, then, is the *listening* to voices that have usually been ignored and our *naming* of what we have heard with the clear understanding that our own voice, our own interpretation, is necessarily mingled into our presentation of what we heard. I can neither speak *for* others nor can I present a "pure" voice of others. I can, however, speak *with* others and mingle my own witness with theirs, not completely merging both, but keeping them in dialogue, naming together with them the violence of war. If we as "intellectuals" do not even point to the sufferings and actions of the people in war-plagued countries that are rarely mentioned in our evening news, we are in danger of forgetting what we might have learned from the Vietnam War: "the complicity of the North American university in the cultural genocide (and often in the physical genocide) of other people."[5] In fact, in every major war of the industrialized world, the academy has played its part behind the scene, whether knowingly or unwittingly, for good or for ill. In an increasingly interdependent world, we have to try, then, to play that role in a

helpful and not a destructive way. One of the first steps can be our listening to voices that have too long been considered unfit to be heard in an academic discourse. While I am not dealing in this book with what are now called *testimonios* by Latin American women, I will here discuss the phenomenon because it shows parallels to many of the "voices" of women I have described in the first part and also to the theological challenges I have described in the second part. I chose the term "witness" because it covers observation as well as the act of testifying, and it is used in the ordinary sense of being an eyewitness as well as in more precise legal and theological terms. It is nearly synonymous with "testimony" and can at times overlap with the technical term *testimonio*.

For more than two decades now, Latin American literary critics have tried to define the term *testimonio*, a new genre that did not seem to fit into the traditional canon of literature, especially since it was mostly used by ethnologists and oral historians, not literary critics or fiction writers. Two of the most famous *testimonios* are Rigoberta Menchú's *I...Rigoberta Menchú* (1984) and Domitila Barrios de Chungara's *Let Me Speak!* (1987).[6] Both Rigoberta and Domitila "testify" to the terror they have lived through, and they are enabled to do so through cooperation with a First World woman. These works are neither autobiographies nor documentaries nor novels, and they stand apart from our known genres also in terms of expressing the experiences of a whole people through a spokesperson. While there are *testimonios* by men and women who express a politically conservative point of view, most are spoken by marginal people who describe their own and their people's struggle against state-sponsored oppression or who fight for survival between guerilla and military forces, and many of them are women.

This "coming to voice" in a new genre is especially important in a country in which women were for centuries excluded from certain genres like epic poetry or the sermon in colonial times. Interrogation, confession, and admonition under colonial authorities also were the privilege of men.[7] When with modernity and industrialism the novel arose as an expression of the rising middle class, it became a typically male-determined genre that had its lone heroes. The oral tradition, however, has always been associated with the lower class, women, or ethnic groups. "The novel is

associated with patriarchy, orality with subalternity," states Jean Franco.[8]

Peru has not produced a major, publicly known *testimonio* so far. It has not gone through a dictatorship as terrifying as that of Pinochet or through a time of military terror comparable to the worst years of Argentina.[9] The guerilla war started with isolated incidents only thirteen years ago and has by now come to the point where many people are afraid to speak in public or in writing about the violence that might then be turned against them — by forces from the left or the right. The well-educated *criollo* elite (born Peruvians of European descent) can write in traditional literary forms and has not experienced the whole harshness of the war. The millions of migrants use all their energy for survival. Foreigners, who usually are the interviewers or transcribers of *testimonios*, are increasingly avoiding Peru on account of the volatile political situation. Where even upper-class literature by women is still a rarity, the lack of voices from the grass roots is not surprising. There are certainly also other and less tangible reasons.

Suffice it to say, however, that the writings and the reported oral statements by women that I have described in the previous chapters have a definite *testimonial* character. Whether Micaela Bastidas testifies in court or Antonia Moreno puts her war experiences to paper; whether Aída Balta reflects the memory of a violent event in her family's history or Carmen Luz Gorriti portrays the awareness of present-day terror in the countryside and the inner turmoil of a guerilla leader — these women testify to their own experience or that of people they knew, and they insist on their own voice. They have joined the fight for the "interpretive power" that Jean Franco talks about. The same pertains to the Andean women, whether they still live in the mountains or have settled as migrants in Lima. All of the women described speak for their people. The *criollo* writers too appear to be intensely interested in contributing to a solution of the turbulent national situation while telling a story that is crafted as a work of art. All of these writings raise ethical questions — a factor frequently missing in contemporary literature — and that is, according to Jean Franco, also a trait of the *testimonios*.[10]

John Beverley has pointed out that three issues are usually discussed in the literature on *testimonios*, namely, their rela-

tionship to traditional literature, their "truth" claim, and their relationship to politics in terms of Latin American postmodernity. I will comment on the last point in the next chapter and have touched on the issue of defining "literature" earlier. The matter of "truth," however, has to be mentioned here because it is at stake in the variety of genres I have dealt with just as it is in more proper *testimonios*. The "truth" expressed by the peasant woman whose family members have disappeared or who has joined the Sendero movement may appear ideological or one-sided to us, accusing, for example, only the military or the government and discounting guerilla violence. We have to realize, however, that the speech of "witnessing" was never meant to be simply reporting facts. It is instead meant to communicate "a praxis of solidarity and liberation."[11] Besides, when the speaker is an illiterate woman, the "truth" is one-sided also because she has been deprived of an education and may therefore be limited in her possibilities of seeing a situation from multiple points of view. If she is literate, she might be a product of the dubious educational system that forces indigenous children to give up their native language, not only in school, but even in the family — often a traumatic process. "Literacy is not produced without violence."[12]

We realize, then, that the production of "classic" literary fiction on the one hand and the production of documentary journalism on the other are privileges of an educated minority and therefore just as limited in perspective as the more plainly "one-sided" oral statements of women with little education. The dichotomy of truth versus fiction lacks meaning when a text has "testimonial" quality.[13]

There is, of course, also the kind of ideology that grows out of an intensive and relatively wide-ranging education, as it is evident in Abimael Guzmán, the leader of the Sendero Luminoso movement, and many of his followers. Here the issue of factual truth verges on that of religious conviction or an atheistic fundamentalism that all the more takes on a "testimonial" quality. The cult-like discourse may then either grow out of true conviction or delusion or may be intentionally and deceptively cultivated by the leaders to create more fervent disciples.

The issue of "truth" shows a different aspect in a country that lives with the pressures of terror and hunger. Where torture and assassination are constantly feared or rumored and also experi-

enced in such stark reality that they appear "ordinary," reality and fiction, observation and fantasy begin to merge. The "magical realism" of Latin American fiction has often been commented upon. The best-known Peruvian novelist, Mario Vargas Llosa, has given a fictional interpretation of the political circumstances behind such a literary style:

> Information in this country has ceased to be objective and has become pure fantasy — in newspapers, radio, television, and in ordinary conversation. To report among us now means either to interpret reality according to our desires or fears, or to say simply what is convenient. It is an attempt to make up for our ignorance of what is going on — which in our heart of hearts we understand as irremediable and definitive. Since it is impossible to know what is really happening, we Peruvians lie, invent, dream, and take refuge in illusions. Because of these strange circumstances, Peruvian life, a life in which so few actually do read, has become literary.[14]

The surrealist blurring of truth takes place, for example, when an unofficial censorship of the press keeps the amount and seriousness of guerilla attacks from being reported or when the released prisoner is threatened to keep his or her torture secret.

However subjective all testimonies of terror and war might be, the point is that women have had to come a much longer way than men to be able to speak, to shout, to write, to stitch or paint words on banners, to exhort or accuse in public gatherings, to preach from a pulpit, to document in newspapers, or to create a film script or a play. Guerilla groups know how to take advantage of this traditional silencing of women.

Women's articulation of the way they experience reality can be as simple and as stunning as holding up the name of a disappeared loved one in a public place. Breaking the silence in this primal way of naming violence can have a liberating effect. Michael Taussig has sensed the importance of the phenomenon:

> Above all the Dirty War is a war of silencing. There is no officially declared war. No prisoners. No torture. No disappearing. Just silence consuming terror's talk for the main part, scaring people into saying nothing in public that could

be construed as critical of the Armed Forces. This is more than the production of silence. It is silencing, which is quite different. For now the not said acquires significance and a specific confusion befogs the spaces of the public sphere, which is where the action is.

It is this presence of the unsaid which makes the simplest of public-space talk arresting in this age of terror — the naming by the Mothers of the Disappeared in public spaces of the name of disappeared, together with their photographs, in collective acts acquiring the form of ritual in which what is important is not so much the facts, since they are in their way well known, but the shift in social location in which those facts are placed, filling the public void with private memory.

The point about silencing and the fear behind silencing is not to erase memory. Far from it. The point is to drive memory deep within the fastness of the individual so as to create more fear and uncertainty in which dream and reality commingle. Again and again one hears this from the mothers of the disappeared.[15]

Making people nameless and "bodiless" — as in "disappearing" them — is a way of taking power. It is therefore of great importance that women try to regain power through their bodies and their naming and shaming of violence, whether in public demonstrations or in private testimonial talking and writing. "Latin American women's testimonials bring back women's bodies and women's experience that mediates what we hear, see, feel, know."[16]

Nancy Saporta Sternbach has described how Latin American women's testimonial texts "resurrect their dead through language: they do not 'make the word flesh,' rather they 'make the flesh word,' and in so doing establish an entirely new reading of 'writing the body.' "[17]

Peruvian women have literally dug up the bones of their tortured and murdered relatives and friends, and they have re-membered them in telling about it. They do more than calling attention to acts of terror. They confront the "fictions" of left or right propaganda with the truth of faith: They threaten the authorities with resurrection, to rephrase a title by Julia Esquivel.[18]

Michael Taussig senses the reason for the impact of the Mothers of the Disappeared:

> They contest the State's attempt to channel the tremendous moral, and indeed magical, power that the dead hold over the living, especially those who die (or disappear) due to violent or mysterious circumstances. . . . They create a new public ritual whose aim is to allow the tremendous moral and magical power of the unquiet dead to flow into the public sphere, empower individuals, and challenge the would-be guardians of the Nation-State.[19]

It is at this point that for us as people of faith in the European or North American context, the voices of Peruvian women might evoke a new understanding of concepts like "resurrection," "redemption," "incarnation," or "salvation." Paula Cooey has shown that a postpatriarchal Christianity will understand such terms more in keeping with the basic message of Jesus of Nazareth than with the abstract formulations of the first great church councils or the writings of the so-called church fathers.[20] While the apostle Paul is sometimes ambiguous as to his meaning of "creation," "body," or "redemption" — see Romans 8 — he is very clear about seeing human creatures as part of the whole cosmic realm of nature that is "groaning in travail." The human body is vulnerable and perishable, but also a "temple of the Holy Spirit" (1 Corinthians 6:19). "The body is both biodegradable stuff and, if redeemed, a sacred vessel."[21]

The Hebrew Bible has a similar message: Human beings are dust and ashes, fast-fading flowers (Psalm 103:15), and yet they are "little less than God" (Psalm 8:5). God appears in the "Suffering Servant" of Isaiah 53, a battered, wounded human being, "despised and rejected," "without form or comeliness." God also appears, however, as the healer of nations, and prophets filled with divine power contribute to the establishment of justice and the gift of redemption in *this* life, on *this* earth. The rattling bones of Ezekiel 37 come alive again:

> Thus says the Lord God: "Behold, I will open your graves, and raise you from your graves, O my people. . . . And I will put my Spirit within you, and you shall live." (vv. 12 and 14)

It is the same spirit that causes Jesus to say: "Talitha cumi" — young girl, rise up, become a woman and live! (Mark 5:41). It is not by chance, then, that Peruvian Christian women struggling for the bodily "redemption" of the poorest women in their country call their group "Talitha Cumi." It is not by chance that the frail, dying body of Felícitas in Carmen Luz Gorriti's story is infused with an inexplicable power that transfers itself to those around her. The women of Yuyachkani's "Contraelviento" may be struck down by the fire power of some *caporal*, but they find the strength to sow the "maize of life." The memory of a mass killing of innocent peasants in *La boca del lobo* fills at least one young soldier with the determination to turn against traditional notions of deadly male toughness. Micaela Bastidas's body was cut and torn to pieces according to exact rules of the guardians of law, but her descendants are inspired by her courage. María Elena Moyano's body parts were blown all over her neighborhood because she dared to speak against murder, but her witness lives on in a new embodiment: in the continued struggle of Villa El Salvador and in people of many countries who re-member her life.

I was told in Peru that sometimes disappearances are more terrifying than assassinations to the peasants because there is no body to grieve over or to bury, and that such feelings often intensify the opposition of the people to the military who uses these methods. I understood this even better after reading Nancy Scheper-Hughes's moving book *Death without Weeping*, in which she describes the special significance that the body has for the people in the mountains of Brazil and the special pain inflicted on them when bodies are mutilated, lost in anonymous hospitals or morgues, or disappeared. Her words fit exactly the situation in the highlands of Peru:

> The various mundane and everyday tactics of disappearance are practiced perversely and strategically against people who view their world and express their own political goals in terms of bodily idioms and metaphors. The people of the Alto inhabit a world with a comfortable human shape, a world that is intimately embodied. . . . At their base community meetings [they] say to each other with conviction and with feeling, "Every man should be the *dono*

(owner) of his own body." Not only their politics, but their spirituality can be described as "embodied" in a popular Catholicism, with its many expressions of the carnal and of physical union with Jesus, with His mother Mary, and with the multitude of saints, more than enough for every day of the year and to guide every human purpose. There is a saint for every locale, for every activity, and for every part of the body. And the body parts of the saints, splintered into the tiniest relics, are guarded and venerated as sacred objects.[22]

Latin American people experience, however, the reality of prevailing life when the names of their dead are called out and they answer: "Presente!" They experience redemption when faith enables them to band together in community kitchens to share what saves their very bodies from extinction.

"Jesus as Mediator not Idol," is the heading of one of Paula Cooey's chapters.[23] The women of Peru, as mentioned earlier, understand the Bible very directly. Many may understand Jesus in a theologically dubious way as a miracle worker or a saint, but they are not likely to miss the power of his message in terms of a concrete partaking of his resurrection or of experiencing redemption in their own lives. They sense it in the midst of the rattling bones of Peru.

They testify to the power of the creation that is "groaning in travail" (Romans 8:22) — a pregnant feminine image — and many of them contribute to its new birth. As Elaine Scarry says, "the human being who creates on behalf of the pain in her own body may remake herself to be one who creates on behalf of the pain originating in another's body."[24] This, too, is part of redemption and reconciliation. "Wherever the body is, there the eagles will be gathered together" (Matthew 24:28): That is how Jesus described the coming of the "reign of God." The decaying "killing fields" are the space of a new creation.

# Chapter 10

## A POSTMODERN WITNESS OF WAR?

How can we take a stand against violence when we see that nothing seems to bring change except violence? Does not, on the one hand, Sendero Luminoso have a point in saying: After five hundred years of colonialism, the social structures are too rotten to be salvaged; they have to be destroyed in order to create something new? Does Sendero simply carry the old "just war" theory to its extreme by considering it better that, according to Guzmán's calculation, one million people die a violent death instead of more generations having to suffer from starvation and despair?[1] Does not, on the other hand, the military have a point in saying: Peru cannot be saved as long as groups as cruel as Sendero Luminoso undermine the social order and kill innocent people? Are not the armed forces simply reacting to an outrageous provocation and conducting a "just war" in which many have to suffer so that many more will be saved? Or are in the end the oppositions of bad Maoists versus good government forces or bad military versus good freedom fighters both outmoded concepts blinding us to the necessity of some use of violence and some grain of truth on both sides?

Such questions have been asked in other contexts of war and war research. Jean Bethke Elshtain was perhaps the first scholar in the field of "women and war" who touched on the subject of various discourses of war that could not be judged in an absolute way.

> Open to foreignness, to what the Germans call *unheimlich*, the "uncanny," together with a mood that embraces less purity, hence sees less danger in others; that practices "live and let live" — that is the intimation to which these reflections on women and war lead.... Certitudes invite the arrogance

of nationalistic excess and structure solemn, brittle identities — the tough male warrior; the pure, pacific woman — that not only keep others out, and construe them as enemies, but that preclude any inner dialogue with one's own "others."[2]

Beyond the dichotomy of just-war discourse and pacifism, Elshtain says, we have to consider "realism's acknowledgment of the dilemma of 'dirty hands.' "[3]

While such a stand seems very reasonable, the principle of "live and let live" breaks down in the killing fields of a Third World situation. Some difficult and harsh decisions might have to be made instead that throw us again in the direction of either "justifying" war or staying adamantly with nonviolence. Before we consider such decisions, however, in the light of the women's witnesses we have listened to, we might look at other postmodern views of war.

In her article "Epitaphs and Epigraphs: 'The End(s) of Man,' " Barbara Freeman attacks feminist and pacifist positions — like those of Helen Caldicott and of nuclear winter theorists — and opposes any man/war, woman/peace equations as dead ends, because representatives of such theories bring on the very thing they prophesy as danger. These people

> fail to examine two vital issues: the extent to which language in and of itself may be relied upon to function as a deterrent to the production and potential use of nuclear weapons, and the possibility that there is an atom in writing and its attendant technology that turns on and provokes an inadmissible desire: a desire for a nuclear end."[4]

While Freeman is to be commended for getting away from oppositions like "warmonger men" and "peaceful women," she grossly oversimplifies what she attacks ("humanistic feminism," essentialist women peace advocates), and her example of Marguerite Duras's *Hiroshima Mon Amour* leaves unclear how the "semiotic-erotic explosion in which body and word converge" (317) can confront either the nuclear dilemma or the gender gap. It is even less clear how such a dissolving of all borders between violence and nonviolence can be helpful in a consideration of Third World conflicts. What have we really gained when we

know that every fear harbors also a desire; that writing down a warning might actually contribute to the very phenomenon we warn against? Such considerations are intriguing, and they might keep us from foolish ideologies, but they do not keep us from the responsibility to act — including the task to write and "testify."

Literary critics of Latin American testimonial literature have considered the relationship of *testimonios* to postmodern studies. While the voices of women in this book are not what is usually known as *testimonios,* the literary criticism in this field can illuminate the problems of any kind of war narrative from the postmodern perspective.

George Yúdice has stated that testimonial writing

coincides with one of the fundamental tenets of postmodernity: the rejection of what Jean-François Lyotard...calls grand or master narratives, which function to legitimize "political or historical teleologies,...or the great 'actors' and 'subjects' of history — the nation-state, the proletariat, the party, the West, etc."[5]

Yúdice emphasizes, however, that certain *testimonios* simply exchange the traditional master narrative for a new one, e.g., patriarchal privilege might be repeated "in the guise of a Sandinista uniform" or in the form of any military *testimonio* that is actually written to control a people from the top down instead of arising from the grass roots.[6] Even when testimonial writing seems to avoid any such ideological master discourse, it might share in postmodernism's hidden Western hegemony of an aesthetic that describes the "other" without empathy, experiencing it only as its own limit. An example given by Yúdice is Joan Didion's *Salvador,* a book that describes the experience of the "ineffable," namely, "identityless corpses of utmost abjection [that] proliferate with a hallucinatory, anaesthetic reproducibility." This description "has nothing whatsoever to do with any empathy with the marginalized persons to whom violence is done." Reality "cannot be represented because language has ceased to refer." Thus the "other" is neutralized and "becomes indistinguishable from the oppressors."[7]

In contrast, Yúdice finds that, for example, Rigoberta Menchú's *testimonio* "does not fetishize otherness," but instead grows out of a communal experience and represents "a practice," an at-

tempt to bring two master discourses (Christianity and Marxism) "into the service of recognition and valuation of the marginalized."[8]

While the contrast between works like Didion's and works like Menchú's seems here overdrawn — we cannot determine Didion's lack of empathy simply by her postmodern style — Yúdice makes an important point. If in a so-called postmodern view of war and violence we defer meaning endlessly, see the "other" simply as an abject or fascinating difference, and regard the oppressor as well as the victim as mere variations of brittle, socially constructed subjectivities, we might end up with an elitism as bad as the old patriarchal model. That danger, however, does not principally invalidate a postmodern view of violence.

Foucault has persuasively argued that all political struggle and conflict is actually a war "continued by other means." He is, of course, reversing the famous quote of von Clausewitz that war is politics continued by other means. "Even when one writes the history of peace and its institutions," he says, "it is always the history of this war that one is writing."[9] Foucault has made us aware of the multiple ways in which institutions wield power through certain established discourses and of the equally diverse ways in which such structural power is opposed from the grassroots of society with a power of resistance, welling up in unpredictable ways. Foucault has not, however, drawn out the specific consequences of his theories for the history of women's exclusion from the reigning discourses and the history of women's resistance.

Jean Franco has not only filled this void, but has also related the issue to the special social location of Latin American women. She describes the history of "plotting women," like the seventeenth-century Mexican nun Sor Juana Inés de la Cruz, who struggled for interpretive power, transgressing the limited spaces to which they were restricted.[10] This struggle for interpretive power, even in a postmodern context, does not have to remain in the realm of theory only, as Franco emphasizes. Nancy Fraser has outlined the possibility of being "a politically committed, critical intellectual within the academy," and she is wondering what Foucault's political commitment actually consisted of and "how all these various struggles might be coordinated and what sort of change they might accomplish."[11] Like Franco, she relates the-

ory and political practice as they grow out of women's social location.

If, as Foucault says, modern power is "productive" rather than merely "prohibitive," and if it is operating at the lowest levels of society, then the consequences for women's "interpretive power" on the margins of society can be very important. The Mothers of the Disappeared and the *arpilleristas*, the organizers of community kitchens and the folk theater actresses can each in their own place exercise power. We can say with Foucault that there is not

one massive and primal condition of domination, a binary structure with "dominators" on one side and "dominated" on the other, but rather a multi-form production of relations of domination which are partially susceptible of integration into overall strategies.[12]

There is, then, no clear contrast between legitimate and illegitimate power. Power is a complex, ever-shifting field of relations. We can easily transfer this notion to the political situation of Peru, where the borderline between politics and war, between legitimate and illegitimate power, is fluid and hardly identifiable. But, asks Nancy Fraser, if there are no norms or claims beyond this ever-shifting struggle,

why is struggle preferable to submission? Why ought domination be resisted? Only with the introduction of normative notions of some kind could Foucault begin to answer such questions.[13]

Fraser contends that social practices are necessarily norm-governed and that norms not only constrain, but also enable us. "Clearly, what Foucault needs, and needs desperately, are normative criteria for distinguishing acceptable from unacceptable forms of power."[14]

Can we define such normative criteria? Fraser has tried to do this. She describes, for example, the politics of "needs" that are always open to various interpretations: the needs of individuals for food and shelter, the needs of parents to have child care, the needs of children to be taken care of by their parents instead of receiving child care, the needs of "the market," etc. Transferred to the Peruvian context we could say, the "need" to reintegrate

the country into the international rules of trade, the needs of the poorest for the means of survival, the need to use military force against civilians because they might be subversives — all these needs can be played against each other because they arise out of certain discourses that are not objectively verifiable. Nancy Fraser, however, does not leave matters there. She insists that we can overcome a nonchalant relativism:

> Many feminist theorists have made use of poststructuralist approaches that deny the possibility of distinguishing warranted claims from power plays. As a result there is now a significant strand of relativist sentiment within feminist ranks. At the same time, many feminists worry that relativism undermines the possibility of political commitment. . . .
>
> I claim that we *can* distinguish better from worse interpretations of people's needs. To say that needs are culturally constructed and discursively interpreted is not to say that any need interpretation is as good as any other.[15]

Fraser does not mean we can find traditional objectivist norms, but she wants to ask questions relative to any interpretive justification of needs: How inclusive or exclusive is a needs discourse? Would the social consequences of a certain perceived need disadvantage some groups of society? Does the interpretation conform to, rather than challenge, patterns of domination and submission? Does it rationalize inequality? Does it balance social needs and private "rights"? Is it democratic? In short, we have to work toward democratic change "by sorting out the emancipatory from the repressive possibilities of needs talk."[16]

How can we relate this procedure to the problem of Peruvian women's struggle against violence? If we listen to all the different voices of women from various levels of society, various political convictions, and diverse religious beliefs, it becomes clear to any common sense observer that there is much injustice on all sides. That need not imply, however, a lack of possibility for critical discernment of better or worse decisions and of actions that can make a difference, as many of the women described in the previous chapters have proven.

The next question, then, is a theological one: Can theology provide "normative" questions corresponding to those Fraser is

asking? We cannot in good conscience follow the way of fundamentalism and simply posit an "eternal truth" concerning women's involvement in war. War itself has become a thoroughly postmodern, fluid phenomenon.[17] Jean Bethke Elshtain is right in emphasizing the reality of "dirty hands," whatever our decision might be. At the same time the postmodern situation does not relieve us of the responsibility to make concrete — if often ambiguous — decisions concerning the use and the experience of violence, and to act on those decisions. "Live and let live" is not an option when thousands are dying and disappearing. So what could be our theological criteria in trying to decide on war or peace in order to shape our own witness? Can we get beyond the sheer relativism of seeing violence as depending on its context only, being sometimes more, sometimes less justified? "Constructive postmodern thought provides support for the ecology, peace, feminist, and other emancipatory movements of our time."[18] So how can we be theologically constructive?

*Chapter 11* _____

# THE BIBLICAL WITNESS FOR PEACE
# AND WOMEN'S STORIES OF WAR

Theology in every age and social location has tended to concentrate on one overriding issue, on something it considered the heart of the Christian message, be it sanctification, reconciliation, justification by faith, or liberation. In the 1960s and 1970s, when the nuclear threat seemed to overshadow all other concerns, many Christians began to see peace as the core issue for our time. While peace always had to be tied to justice, it became clear in the 1980s and 1990s that this "justice-peace" has to be understood in a more global way. Not only do we have to be concerned today about money spent on armaments versus money spent on social programs on the national level, but the overwhelming realization of hunger and hopelessness in the southern part of the globe in contrast to the riches of the north has widened our perception of what a just peace would imply worldwide. One aspect of this more comprehensive perspective is a renewed emphasis on interreligious dialogue and on the contribution that religions can make toward "justice, peace, and the integrity of creation," as the World Council of Churches has phrased it. Male theologians have often tried to discover some objective reality to which all religions could relate.[1] Women are more likely to start interreligious dialogue from a different perspective: Instead of universalizing some concept like "Ultimate Reality," they tend to share their stories with each other across national and religious borders, partly because they have long been left out of the traditional discourses of state, church, and university, partly because their experiences in daily life often lead them to prefer concrete relationships to abstract commonalities.

I wish to consider here two points concerning the relationship

of women, war, and peace — focussed on Peru — representing a challenge to theology. The first is the need for theology to concentrate on a witness for peace and nonviolence; the second is one of the forms in which this theological focus might effectively be shared today: the form of women's stories.

Why should theology concentrate on peace — a rather innocuous term that almost everybody on all sides of the political and theological spectrum professes to be in favor of? Should we talk instead of the need for nonviolence? As Susan Thistlethwaite rightly observes, in contrast to the powerlessness and "resourcelessness" that often trigger violence, nonviolence can be construed as a response of resourcefulness. "Nonviolence depends on a notion of power as pooling resources."[2]

Even so, I would rather focus here on "peace" as a concept rooted in the Hebrew *shalom* and the *eirēnē* of the New Testament: "Peace I leave with you; my peace I give to you" (John 14:27). This peace is not only the absence of war and violence; it is instead a "just peace"[3] and a unity of body and soul, the personal and the political.

The Hebrew Bible gives us a wide range of understandings of war and peace, developed over many centuries and under very different political circumstances. There is, however, a certain line of development visible from the earliest to the latest documents, from the warrior God of Exodus 15:3 to the peace vision of Micah 4:3f. In addition, the portrayal of triumphant warring is never without moral tension and contradiction by words of peace and reconciliation — even in the early books of the Bible. Here are some examples:

> Abraham's role as mediator on behalf of the wicked inhabitants of Sodom (Genesis 18:23); the purity of trust exhibited by the peaceful Jacob in a God who would save him from the grasp of the warlike Esau (Genesis 32:10–13); ... Elisha's compassion for the Arameans who had been led into Samaria (2 Kings 6:8–23); and finally, God's refusal to allow David, a man of war, to build the holy temple (1 Chronicles 28:2–3).[4]

The tribal God in the course of two millennia becomes the God of all nations whose rule of peace is to come: "And they shall beat their swords into plowshares, and their spears into pruning

hooks; nation shall not lift up sword against nation, neither shall they learn war any more" (Isaiah 2:4). Instead of trusting in kings, armies, and horses, Israel learns to trust in the divine spirit: "Not by might, nor by power, but by my spirit" (Zechariah 4:6). That this insight was not a sentimental utopia but a hard-won recognition is evidenced by the psalmists' constant awareness of enemies and the fear of enemies.

We might think that in biblical times the political circumstances were so totally different that no parallels can be drawn to situations of today. As mentioned earlier, however, the Andean world has much in common with the biblical world.[5] Parallels have also been drawn between the situation of Central American countries today and Palestine in Jesus' day. Judea was dependent on Rome as, e.g., El Salvador has been dependent on the United States:

> A willing client state relieves the imperial power of the direct responsibility of policing that region with its own troops.... Rome used client states such as Herod's brilliantly to help it maintain control over large areas yet with a minimum number of legions garrisoned permanently in the occupied territories.[6]

James W. Douglass has argued that Jesus was profoundly aware of the Roman empire's oppressive power and that his own cross was not the first one he saw, since crucifixion was used as a deterrent against rebellion. Jesus wanted to create a radically different Jewish society in which

> the nonviolent coming of God . . . would, he hoped, transform the violence of Rome, Palestine, and the world. . . . [He] sensed the connections between the violence done to the poor, the outcast, and the rebellious in a colonized first-century Judea and a violent end of the world — his world or any world in which the logic of violence is followed to the uttermost.[7]

Jean Bethke Elshtain has described how for the Greeks war was a natural state and how strife as a natural law gave occasion for manly valor and triumph. For the Romans peace was a utopia of security and tranquility, and its image was feminized, represented as a fruitful mother:

This dream of Elysium was bolstered *and* deconstructed when Christianity burst upon the antique scene. The Christian gospel proclaims peace as the highest good. Peace is a blessing not reducible to the terms of any earthly order...; nor is peace a sentimental dream of an era of perfect justice on this earth. The image of the warrior and war-god is devalorized. Suffering rather than doing harm is exalted. Peace is both interiorized and externalized, represented as an inner fruition, the peace that passes understanding, available to all through the redemptive promise of the Christian savior, and as a City of God, an unalienated world without end, amen, but a world not of this earth where the state of peace and freedom is bound to be an imperfect approximation of the ideal.[8]

Bethke Elshtain suggests, however, that in modern times peace is much more understood in terms of Kantian rationalism, continuing some aspects of the Greek and Roman understanding of a universal (male-dominated) order and an implicit denigration of (feminine) emotion. She also thinks that feminists who emphasize the peacefulness of women over against the warring of men are simply repeating the dichotomy.

I agree with her on this point, especially in view of the developments in church history that reflect the popular and philosophical trend of relegating women to the realm of peace and passivity and men to the world of political struggle and action. The human qualities that Jesus of Nazareth preached as signs of the reign of God were therefore considered "feminine." Over the centuries the churches have preached mostly to women the virtues of patience, suffering, peacemaking, service, and humility. To be "poor in spirit," to turn the other cheek, to wash feet, to love one's enemy, to forgive "seventy times seven times" — all this has not been considered "manly" in our tradition. Usually these characteristic traits that Jesus preached and lived were not understood in the right way even for women because meekness (Matthew 5:5) was taken as an ineffective, innocuous weakness (meek women had to be protected in war by "strong" men and would never be expected or allowed to "inherit the earth"); "service" was understood as the bodily and psychological care that women are expected to give to husbands, children, the elderly,

and the sick — not as the quality needed to lead a congregation, which women actually did in New Testament times, or to serve people in a political office.[9]

In Latin America, the connection of masculinity and power over others is even stronger, but it simply repeats the traditional Western pattern in more concrete forms. Roger Lancaster has shown how for Nicaragua's working class nothing is more disdained in a man than to be passive or tender. Aggressiveness is therefore trained into boys from earliest childhood on.[10]

It is the task, then, of Christian theology to rediscover the meaning of a basic concept like peace in Jesus' time without "genderizing" it, since there is no indication that Jesus ever asked of women anything different from what he asked of men. "Peace" in the New Testament is as comprehensive as *shalom* in the Hebrew Bible, connoting "health, wholeness, well-being, and harmony."[11] That Jesus could also say, "Do not think that I have come to bring peace on earth; I have not come to bring peace but a sword" (Matthew 10:34), is no contradiction. Jesus knew that peacemakers are often met with hostility that creates new divisions. The one who could turn over the tables of the money-changers in the temple and who was hated like a common criminal did not think of *shalom* or peace as a state of bliss. He did not leave us a dogma of peace, but stories of peace: stories of healing, of overcoming evil with good, of breaking down barriers between Jews and Samaritans, men and women, saints and sinners. When his male disciples were scrambling for the best places in heaven, he stated, "Whoever would be great among you must be your servant" (Mark 10:43), and he told them a parable about choosing places of honor (Luke 14:7–11).

Jesus was certainly not the only Jew of his time who realized that the virtues relegated by society to women made sense in "the reign of God." Already the Suffering Servant of Isaiah 53 had "feminine" traits. The prophets continually demanded that Israel take care of widows and orphans, and the Spirit of God was expected to be poured out on daughters as well as sons (Joel 2:28). But Jesus made this reversal of some hardened national and ecclesial traditions the core of his message. He did not mind listening to a woman's story and learning from it to the point of changing his mind, as the story of the Syro-Phoenician mother begging for the health of her daughter shows (Mark 7:25–30).

Here Jesus is not only engaged in an "interreligious dialogue," but in an "interhuman dialogue," breaking the barriers of nationality, ethnicity, religion, and gender at the same time. He is similarly "radical" in listening to the story of the Samaritan woman at the well (John 4:7–30), who in turn spreads his story of God being Spirit and not being tied to any localized type of worship. This is, so to speak, a primal type of interreligious dialogue. Jesus' disciples, however, are not interested in a story told by women; they consider it an "idle tale" (Luke 24:11).

Listening to stories by women from the Third World means going beyond interreligious dialogue to forge an interhuman dialogue that contributes to peace by not separating believers from unbelievers, art from everyday discourse, First World from Third World. It means participation in a process of reconciliation that cannot be encoded in a theological, literary, or political formula; it can only be lived and told and passed on to create new stories of reconciliation. We have earlier seen that there are stories of women's struggle for life and peace even from pre-Inca and pre-Aztec times. One of the first liberating acts initiating the whole history of Israel is the imaginative, nonviolent resistance of two Egyptian midwives against the state terror of the pharaoh (Exodus 1:15–22). Other faith traditions tell similar stories of women's role in resistance and reconciliation.[12] I have concentrated here on the Christian context because it is my tradition and that of modern-day Peru, and concepts like peace and reconciliation in our society can hardly be separated from Christian connotations.

> Just as the Hebrew concept of shalom connotes more than the absence of conflict, so reconciliation in the New Testament goes far beyond the limits of passive nonviolence. In its widest meaning, including its cosmic, social, and personal dimensions, it is synonymous with salvation, liberation, redemption, the breaking into the world of a new reality aimed at ultimate and universal peace.[13]

Western philosophy and theology have in recent years gained a new appreciation of narrative. No longer do we think that "timeless truth" has to be nonnarrative and "logical."[14] Stories not only can express truth, but can create reality. In fact, war stories have created fatal realities throughout history. Nancy Huston, in an important article published first in 1982, has

explored the intricate connections between wars and war narratives. There is, she says, "the age-old tradition which consists of transforming the events of war into stories, and then of using these stories as models or justifications for the waging of new wars."[15] The actual waging of war is heavily dependent on centuries of war literature — prose, drama and poetry, myth, saga, and song. This intense interaction goes back to long before the writing of history. Paul Fussell, in *The Great War and Modern Memory*, has described the reciprocal process by which life feeds materials to literature while literature confers form on life. Wars rely on inherited myths and create new myths.[16] Similarly, Nancy Huston asserts:

> The men who run today's military institutions have centuries and centuries of illustrious models before them; in their minds there are images of both historical and mythical heroes: Alexander the Great and Genghis Khan, for example, are scarcely less mythified than Achilles and Siegfried. ...In going off to war, men have always sought to demonstrate their ability not only to "make" history, but also to *write* it.[17]

Huston demonstrates how from the *Iliad* to the Vietnam War literature of our day "war imitates war narrative imitates war."[18] In the tales of war, women have usually played various supportive roles, like those of pretext or booty of war, of a "value" to be defended, of cheering wives or needed prostitutes, of spies, nurses, or casualties; of mothers giving birth to future heroes, of workers in munitions factories, or, finally, of bitches who belittle men who refuse to fight. Above all, women have played the role of weepers — either because of their rape (in all literal and symbolic senses of that term) or because of their bereavement: the death of a hero. Huston ends her essay by insisting that women, instead of pleading for playing more important roles in men's war tales, ought to invent new literary paradigms that reveal the senselessness of war.

Such new paradigms have to include examples that traditionally have not been considered "literary" and that come from people often ignored as nonpersons. Certainly they have to come from men as well as women. I have concentrated here on women simply because they have been silenced more often than men and

because their fast-increasing impoverishment gives them even fewer chances to make their voices heard across national and religious boundaries.

Men are poor for reasons unrelated to being male, such as lack of education or technical training, involvement in drugs or crime, or racism. Women, however, are poor because they bear children and raise them, because there is little day care, and little or no child support; poor because they are adolescent parents or because they face sexism in the workplace. For men the answer to poverty is jobs, but the solution to female poverty is far more complicated. A woman on welfare can't hold a job if there is no one to care for her children.[19]

These facts pertain to the First World, but all the more to a country like Peru. They do not always lead women to a faith in nonviolence; on the contrary, they can make them determined to change the world by armed warfare, as we have observed in Sendero women. Such women have a right, however, to tell their stories the way male military heroes have told them for ages. History will show which stories will prevail: the stories of war or of peace. We know that both can create reality, but some reality is destructive.

While for the faith community human stories of peace will always be related to the biblical story of reconciliation between God and human beings — indeed between God and the whole creation — not all stories are "created equal." The difference lies in the life lived as it expresses itself in the story. Where stories — whether fictional or documentary — are not inextricably tied to life and to a lived *shalom*, they create a pseudo-reality, a language event without impact on our bodily existence, or they express a destructive pattern of reality. Only divine power is able to make life and story merge completely — as Jews and Christians see it happening in stories of the Bible — but human narratives can mirror this divine wholeness and can enact it, thereby co-creating a life of reconciliation.

What are, then, our criteria for judging the "truth" of a story? To come back to Nancy Fraser's argument of the previous chapter, we can now ask some normative questions in theological terms, not only relating to stories, but to all discourses of war

and peace. In every case we have to consider the *Sitz im Leben*, the concrete life-setting of a discourse. It is, for example, not irrelevant to a portrayal of violence whether it originates among Peruvian or South African or Russian people. We cannot, however, endlessly relativize situations of war and peace, and we have to ask the normative questions: whether in its particular situation a certain discourse is merely an intellectual exercise or is connected to an individual or communal praxis; whether it does reach people at a gut level but is bound to increase violence and hatred; whether it expresses *shalom* for every person or simply makes a privileged minority feel good because it can stay away from what it considers violence; and finally, whether it demands the same rights and responsibilities for men as for women, for "friends" as for "enemies."

Such questions need not lead to an avoidance of "militance" in the best sense. Subverting a military or a terrorist discourse does not mean being content with innocuous stories of peace and harmony, of nurture and spiritual fulfillment. On the contrary: It may sharpen our anger and intensify our commitment as well as our patterns of speech. The old stereotypes of the feminine, its relationship to the unconscious and the emotional, can here be rehabilitated to bring a sense of passion to our politics of peace.[20] "Would that you were cold or hot!" says the Book of Revelation. "So, because you are lukewarm, and neither cold nor hot, I will spew you out of my mouth" (3:15f.).

Jean Bethke Elshtain is right when she warns us of the old trap: peacemaker women versus warmaking men. However, she hardly tells us where we are going to go after we have deconstructed this dichotomy. Since women are still underrepresented in politics and overrepresented among the poor, the illiterate, and the refugees, can we turn their socially constructed distance from the waging of wars into something creative? Instead of having them "catch up" with men, for example, by permitting them into combat units of the military, can they develop preventive approaches to war that turn their socially enforced outsider status in the world of politics into a strategic asset? The Mothers of the Disappeared have done so effectively. Every nation needs, however, a wide range of women's witnesses of war to bring a gender balance to the discussion about ways to peace. This is what Peruvian women are offering to us. Their words are neither wiser

nor better than those of men, but it is their inalienable right to be heard and taken into account. Any political system that keeps one group or another silent is bound to become sooner or later a structure of warmongers trying to keep rebellions down.

Did the Bible itself, however, often keep women from telling their stories? We can readily admit that the answer has to be ambiguous. If women were supposed to be silent in church (1 Corinthians 14:34), they were even more expected to be silent in public life and were extremely limited in contributing to the peace of society. Nevertheless, this is a problem that was not introduced by Jesus, but by the apostle Paul and other Christian leaders of his time who struggled (however imperfectly) for the survival of the church in a patriarchal society. Jesus could describe his own witness for peace — which had a wide-ranging political effect — in such feminine terms as the activity of a hen gathering her chicks (Luke 13:34) and could liken the reign of God to the leavening that a woman uses in bread making (Luke 13:21).

I cannot talk here about the biblical "witness for peace" without mentioning the contemporary movement that bears this name. The organization Witness for Peace has become internationally known for its courageous work on behalf of the Central American people. It is hard to underestimate what its participants have achieved by doing two things: telling stories about Central America and, as people of faith, acting on the truth they perceived in these stories, sometimes literally laying their lives on the line. Ed Griffin-Nolan has described the history of the movement from 1983 to 1991.[21] As Jim Wallis writes in the foreword, the basic idea first seemed to be foolish, but

> almost eight years later, four thousand people have traveled to Nicaragua with Witness for Peace. They have prayed, stood with the grieving, documented atrocities, recorded stories, attended funerals, harvested coffee and beans — and have returned to the United States to talk about what they have seen and heard. . . .
>
> Witness for Peace stands as one part of a movement of resistance that altered U.S. policy and, many believe, may well have prevented a U.S. invasion of Nicaragua. Witness

for Peace takes its place in the long history of nonviolent action for peace.[22]

Today, in 1993, Witness for Peace is helping Guatemalan refugees to return to their homes. It continues its presence in Nicaragua and has expanded its work into Haiti. "Dozens of communities in Latin America, the Middle East, and Africa have contacted Witness requesting a supportive presence."[23] Recently, in 1993, such an inquiry came from China.

Witness for Peace is not an organization of women only, and it does not merely tell the stories of women — although they play a powerful part in its work. The organization is mentioned here because it shows how we as people from a "privileged" country might shape our own witness for peace if we pass on the stories of a country like Peru, especially the often forgotten stories of women, and "enact" the biblical witness for peace. In this way we might pay more attention to the causes of war instead of concentrating only on what to do when war has actually broken out — as it gradually did in Peru.

War is not merely an activity; it is a system. It is a system supported by economic and political assumptions and by structures that drive us toward conflict, which is then resolved by chosen methods of violence....

Perhaps it is time to explore the meaning of a "nonviolent army," of which Gandhi dreamed. Trained and disciplined — but unarmed — people could be deployed in sufficient numbers to make a strategic difference in many situations of conflict; but only if they were prepared to make sacrifices and suffer casualties just as soldiers are.[24]

With respect to Peru a witness for peace does not mean an exclusive focus on United States policy in Latin America, although this type of witness remains very important if the "drug war" continues and the human rights violations are ignored.[25] Different persons shape different witnesses. I would like to conclude this chapter with one more story by a Peruvian woman, in this case a "witness of war" dealing with some of the "lost" children of the country.

Liselotte Schrader is the daughter of Peruvian-German parents. She grew up near Lima, but received an education as

a preschool teacher in Germany. She and her mother had the long-range goal of helping abandoned and orphaned Peruvian children who were victims of the war situation in the country, but they did not have the resources to build a major institution. An advertisement in a German newspaper brought a response from Internationaler Verband Westfälischer Kinderdörfer, a nongovernmental German organization that was already sponsoring two "children's villages," one in Ghana and one in India. They were willing to have Liselotte build a similar place in Peru.

The Peruvian government donated a large tract of land to the project, about twenty-five minutes by car from Lima, in Cieneguilla. The place was, however, nothing but a barren, stony mountain desert, with only a little river at its fringe. After seemingly endless bureaucratic and other difficulties, construction began in 1989. Four years later the desert has been made to bloom: The first four houses are completed, each providing a family setting for a Peruvian couple and eight to ten children of whom not more than two are their own and the rest foster children. There are terraces with innumerable fruit trees, rows of vegetables, and flowers adapted to the hot, dry climate. Cows and chickens contribute to the beginning of a self-sustaining agriculture. A community building provides a nursery that includes children of neighboring peasants. Workshops for carpentry, car repair, and printing are in the making so that the children later can learn a trade. A trained teacher and a young Peruvian Methodist couple (both husband and wife are recent graduates of seminary) live with the Schrader family (Liselotte, her parents, and her brother) and with the foster families to work with the children. A psychiatrist visits regularly to help the foster parents understand the children's traumas. The overall plan calls for 15 houses and 120 children.

Liselotte recalls some of the children's stories: Charlie, one-and-a-half years old, was so severely undernourished that he will suffer from diarrhea for years, but after repeated treatments he already appears to be a happy child. One boy saw his father shot by guerillas in front of his eyes, and his mother is too sick to take care of her son. Another was badly beaten in one of the state orphanages. Many come with open sores that need intense medical attention. Some do not know whether the violence that uprooted them from their homes was caused by the military or by gueril-

las, and some are afraid to be "recruited." "We did not want to take any child over ten or twelve years," Liselotte said,

because the age span between the oldest and the youngest would be too great. One thirteen-year-old orphaned boy, however, was in danger of being recruited by the guerillas, so the neighbors begged me to take him in, and I did. In general we have more boys than girls because they are more likely to be abandoned by parents who can no longer feed them. They are expected to be able to fend for themselves in the city, whereas girls need protection from abuse in the street, are needed to help in the household, and are more easily than boys taken in by richer families who would like to train them as maids.[26]

Women like Liselotte Schrader have no political program except the vision to train a future generation for peace. Her Aldea Infantil/Westfalia Kinderdorf is a witness of more than words. Here *criollo* street children from Lima and mestizo or Quechua peasant children from the mountains learn to get along. They are trained not only to respect each other, but also nature: The agriculture is based on sound ecological principles. They attend weekly a Roman Catholic mass and a Methodist Bible study and find no contradiction therein.

In a recent newsletter of the organization Terre des Hommes, which works with street children in Peru, the psychological condition of war-damaged Peruvian children is described:

Severe grief and hot anger are mixed. The children would like to kill those who abandoned them or who have caused their plight, but they cannot hate those whom they love without feeling guilt and anxiety. There is, however, a way out: In playing certain games, fantasy and reality are mixed. The war orphans who escaped death play regularly *cachaco* (policeman or soldier) or *terruco* (terrorist or guerilla), who are killing each other.... In playing the children kill and are killed without dying. Thus they cope with the fear of death and find an outlet for their aggressions.[27]

These are the children who will learn to live in peace in Liselotte Schrader's Aldea Infantil. So far neither guerillas nor the military have interfered with the village, although both are

nearby. They probably have observed that the people working with the children have built up the place by the sweat of their brow and have gained the respect and cooperation of their peasant neighbors.

Thinking back to the women's testimonies described in the first part of this book, it is apparent that they range from fiction, poetry, and simple narrative to sophisticated journalism, academic essay, song, play, film, or demonstration message. Women's witnesses of war come in many different shapes, and not all of them turn out to be witnesses for peace. Without their multiplicity and variety, however, we cannot see the whole picture of the terrors of war and the presuppositions of peace. We have to weigh the stories, including those that seek to bring about change by violence, and ask some "normative" questions: What is the "lived life" behind this witness? What are the "works" that testify to a radical truth? — in the sense of John 5:36 where Jesus refers to his "works" as bearing witness to the divine power at work through him. It is important to listen to witnesses who simply relate what they have heard and seen, but even more important to pay attention to those that seem to manifest a prophetic truth in a concrete praxis. Of course, we can never "prove" that a witness is true or false, genuine or pretentious. In biblical terms, it is actually the Holy Spirit that testifies to the truth of certain "works" (John 15:24–27),[28] but in this very Spirit in our conscience we can be co-witnesses.

# CONCLUSION

During the writing of this book much has changed in Peru. Sendero Luminoso has experienced very serious blows, but it is not impossible that it will recover its strength.[1] President Fujimori, after simply dismissing the Congress and setting aside the Constitution in April of 1992, has victoriously survived an election that was boycotted by the major political parties. He has a new Congress to work with, but one of their first acts was to ratify his presidential powers, and there is no true opposition party to keep him in check. While Fujimori to some extent succeeded in reinserting Peru into the international economic community, the poor are poorer than ever because health care, housing, education, food, and gasoline had to be cut or taxed severely in order to pay the foreign debt. Drug trafficking is as lively as ever, and nobody knows what the economy would look like without drug money. Human rights abuses by guerillas and the military continue. Moreover, as one observer suggests, "the recent increase in Peru's death squads has almost certainly been ordered by the military."[2] Politics is increasingly becoming militarized.

It is estimated that approximately 60 percent of the population is living in extreme poverty. "People's desperation drives them to violent reactions."[3] It is common now among poor families to eat only once a day, and the quality of the meals is alarmingly low. The consumption of milk is practically nonexistent in the most impoverished sectors. Meat is no longer affordable for the majority of the population. After the "Fujishock" (Fujimori's adjustment program of 1990), the number of communal kitchens organized by women in Lima alone had grown to 7,200, involving about 250,000 women.[4] Today, however, these communal organizations are seriously hindered in their work by the

guerillas, and — paradoxically — the government has accused some of them of being sympathizers of Sendero. For the past five years, Peru has been cited by the United Nations Working Group on Enforced or Involuntary Disappearances as the country where the greatest number of disappearances has been recorded. Fujimori has introduced legislation to improve the human rights situation, but at the same time he has accused Amnesty International and other human rights groups of "being the useful fools of the terrorists" and hiding their crimes.[5]

What is there to hope? The greatest hope lies in the people who keep their dignity, their relentless persistence in trying to survive, and their intense desire to know their situation and to speak about it. That is especially evident in the women because they come out of a history of being kept silent.

As one woman from a very poor settlement of Lima phrased it: "The life we live here is actually no life at all. If we always keep silent, then we stay dead all our life long, because not only the people buried in the cemetery are dead: no, we are too."[6]

The women mentioned in this book have broken the silence. They have named violence in the sense of articulating and identifying it in order to free themselves from its deadly grip. This type of addressing an evil might remind us of the way Jesus is said to have driven out demons by "naming," addressing, and challenging them.[7] These women have done so in narrative, poetic or symbolic form. Besides calling attention to their voices, I also wanted to look at the historical and contemporary reasons for women's predicament. "Feminist scholarship is correctly committed to recovering women's silenced voices, but it must also look critically at all the varied methods for silencing them."[8] We have seen that the silencing happened throughout a long historical process. While the imperialism of the Incas played a part in it, the Spanish church and state contributed more intensely to keeping women out of public discourse.

There were always, however, witnesses calling attention to injustices, and many of them were women. It is not our task to decide whether a woman acts from a secular or a religious motivation. I found it important, however, to ask what any Peruvian woman's witness on violence and war might contribute to literature and theology in the United States and Europe, and I see the following challenges — first in terms of *literature:*

1. *The term "literature" has to be more comprehensive than it is usually understood in Western cultures.* When we study contemporary Latin American women's literature, we cannot limit ourselves to the traditional genres. This is certainly not a new insight, but I had to discover the particular Peruvian aspects of the issue. There are various studies available on the Peruvian women's movement, but hardly anything on Peruvian women's literature.[9] I have interpreted the term "literature" in this book very broadly, because I find we cannot even begin to understand either "literature" or "violence and war" in a country like Peru unless we listen to every kind of available articulation or meaningful communication before we determine how much of it is "art." Countless Peruvian women might have been able to write a first-class novel, poem, or drama if anybody had ever paid attention to their first public statement, their ability to act in a play, their well-formulated witness in court, or their inability to put pen to paper unless they were granted some free hours in the daily war of their lives.

2. *The speaking subject in women's writing is different from that of the average "author" in the First World because it is more likely to have the character of a witness.* In the wide spectrum of Peruvian women's voices speaking out about war and violence, from Quechua migrants to fiction writers, there is a common factor. Sara Castro-Klarén has described it for those who write, but we could even relate it to those who *speak* in public: "To write is to witness."[10] Even the words of women mentioned here that are not written down in a book, but shouted, stitched, visualized in a film, acted out in a folk theater, or painted on a banner, have been uttered to bear testimony to violence and war. Our postmodern concern with the instability of the speaking subject pales in significance when we listen, for example, to the experiences of María Elena Moyano or of the women tortured and raped in prisons. As Sara Castro-Klarén says,

> No matter how disturbing the crisis of representation in the West, the lived experience of these women — survivors of hunger, forced labor, rape, illiteracy, political persecution, unimaginable poverty, exile, incarceration, and torture — encapsulates and employs an undeniable sense of the real and the immediate.[11]

3. *The subject matter of literature is likely to involve documentary as well as ethical concerns more directly than does North American or European literature.* When we study the "literature" of Peruvian women — in the widest sense of the term — we find a strong engagement with, and critique of, the Peruvian reality. I was not able to discuss in this book the large body of women's poetry because — except for the new writer Carmen Luz Gorriti — no Peruvian woman poet I am aware of has dealt specifically with war and social violence.[12] However, psychological and "private" violence against women is definitely a topic in much of women's poetry.[13]

In general, then, Peruvian women's literary witness of war challenges us to widen our perspective of the forms, authors, and subject matter of literature.

What are the *theological* challenges confronting us in the war witness of Peruvian women?

1. *The interreligious dialogue that did not take place in colonial times between Spaniards and indigenous Peruvians can be learned today between the First and the Third World, between fundamentalist Protestants and liberal Roman Catholics, between academic theology and popular religion. It can start with women's own stories.* We cannot expect feuding political groups to make peace as long as religious factions continue to be more interested in their institutional survival and power than in the welfare of all. Since women have largely been kept out of high positions in church and state, they can turn their enforced limitations into a strength by linking people and issues at the grassroots level and paying attention to indigenous beliefs. Churches can be challenged to preach the reign of God, not a "Jesusology" that contradicts Jesus' own teachings. Since women are still the main nurturers and educators, they might lead the way in matters of an inculturation of the Christian faith that guards cultural integrity without compromising our faith or our reason.

2. *In view of the injustices done to Andean women in the name of a Christian culture, churches will have to examine their current attitude toward women and give them their rightful place.* They will increasingly ask themselves whether the "sacrifices" women are asked to make in daily life are those that men have usually refused to make, and whether peace is ever possible as long as half of all human beings are deprived of certain rights — even within the

church — and God is portrayed in male terms only, supporting an ideology of domination. As long as the churches in Peru — which are largely directed by North American and European ideology and practice — do not grant women a space in which they can use their gifts as intensively as men, women will easily opt for violent groups that do grant them power — in a perverse way.

3. *Theology and church can learn from the women of another culture that terms like "sin," "pride," "love," and "justice" cannot be universally defined, but have different meanings for men and women, the rich and the poor, Peruvians and North Americans.* The feminization of poverty has brought about a discourse and an ethic that in some cases stands in contradiction to our comfortable theological conceptions. We have to give up what Foucault calls the "tyranny of globalising discourses"[14] and find the divine truth in many different embodiments.

In short, the churches' doctrine, practice, and language can be revitalized by a dialogue with women in countries like Peru. The Christian faith has had a literally "tremendous" influence in Latin America, but the indelible mark of the churches on society is today resented by many of the more educated women. It is striking to find out, for example, that the majority of the known Peruvian women poets consider themselves atheists or as completely estranged from the church, even though some of them express a high regard for the Bible or the image of Christ and most of them have been educated in convent schools.[15] This development cannot be traced solely to the Peruvian Roman Catholic Church or the small Protestant churches in Peru. It has its roots also in the mission theology and church practice of Europe and North America and therefore holds up a mirror to our own faith tradition that is in need of revision.

There are, finally, also challenges posed to literature as well as theology by the fact that some women speak up *for* war and theoretically and practically support strategic violence in order to further social change:

*Even if we unequivocally oppose statements and actions of women in organizations committed to armed violence — as I think we must — we have to discern our own involvement in structural violence and in the linguistic doublespeak of war and have to consider the Peruvian government's violence that ties into the internationally sanctioned trade of money and arms. "Those structures that benefit us most*

are frequently the ones that work the greatest violence against others."[16] We only have to read Eduardo Galeano's *Open Veins of Latin America* to realize that in terms of business investments, "hunger wages in Latin America help finance high salaries in the United States and Europe." "In our day the people of Peru produce fishmeal, very rich in protein, for the cattle of the United States and Europe, but proteins are conspicuously absent from the diet of most Peruvians."[17] Whenever U.S. military advisers help to eradicate a few acres of coca plants to reduce the menace of drugs in the U.S., they may also destroy the livelihood of peasant families who have no other income and for whom the coca plant has been sacred for centuries. We may enjoy the low price of coffee or an alpaca sweater, not thinking of the Peruvian starvation wages making such prices possible. "Perhaps in our era apathy is the unforgivable sin."[18] Such apathy is an ethical challenge for church and theology and a linguistic challenge for literary scholars since we have ignored the deceptiveness of terms like "Third World," "low-intensity warfare," "drug war," the "necessities of the market," or lack of "development."

The same linguistic scrutiny has to be applied to the rhetoric of Sendero Luminoso, whose talk about "solidarity," "power to the people," and "world revolution" sounds hollow in view of its atrocities. Carlos Iván Degregori has pointed to the deceptively religious language of Abimael Guzmán, who sees himself (almost like a reincarnated Buddha) as the fourth incarnation of world communism — after Marx, Lenin, and Mao — and talks about the party being "the salt of the earth" or the people having to "cleanse their souls" because "many are called, but few are chosen."[19] No less deceptive are the language and actions of the Peruvian government when it denies that the armed forces systematically violate human rights and when it even promotes an army general who participated in a cover-up of army involvement in a famous massacre.[20]

The challenge, then, for scholars and people of faith in the U.S. and Europe is to weigh every testimony and to shape our own witness in view of the Peruvian voices and the biblical witness for peace, which continues to be explored in scholarship.[21] None of us owns the truth, and confession — in the sense of telling our own story as well as realizing our own shortcomings — will have to be part of the witness. "In testimony words

open up life, life opens up words, but always in relation to the visions produced by the fusion of narration and confession."[22]

How can women make a difference? Christian feminists are well aware that churches have on the one hand played a dismal role in silencing women and have on the other hand provided a space for women to "come to speech" wherever individuals or communities encouraged their speaking or whenever they simply realized that "not one story or statement is transmitted in which Jesus demands the cultural patriarchal adaptation and submission of women."[23] Peasant women have always been especially silent, whether from the solitude of the plains or from social and political repression. It is one of the great tasks of the churches in Peru to assist these women in breaking their silence, including that of the millions who have become migrants and cannot formulate and voice their needs in the cities.[24]

A word has to be added about women from other countries living in Peru. There are to this day a great number of foreign women belonging to religious orders and some foreign Protestant missionaries who have helped Peruvian women in courageous ways to find a voice and an identity. Whatever damage Christian missionaries have done since colonial rule, they also have at times struggled beside the Peruvian people in true solidarity. The German writer Christel Voss-Goldstein gives an example of such present-day work by describing two German Catholic lay women who led a rural Peruvian congregation. On a retreat they encouraged these illiterate peasant women to ask themselves some questions including: "Why am I not able to read? Is it somebody's fault?" "In what ways do I suffer from the fact that I cannot read?" "Does God love me less because I am illiterate?" Then the women listed for each other what they can do — which turned out to be everything that most women do, except reading and writing. So their new empowering slogan was, "*Atyyku* — we can!" They gradually learned to take responsibility in their congregations and communities.[25]

Most of the help provided by First World women is ambiguous. We cannot simply speak and do "for others."[26] We also, however, cannot forget about them. The process of mutualizing instead of patronizing is a constant challenge.[27] Since Sendero has been threatening foreign workers, those that remain in Peru are courageous and committed and sometimes can hardly be dis-

tinguished from Peruvians when they work together in human rights groups, women's center programs, or churches. They are part of the resistance against violence.

The Mexican writer Elena Poniatowska has stated, "We write in order to bear testimony.... We write like the men who write their name on prison walls.... Perhaps this has nothing to do with literature." Poniatowska considers writing "a complete act of insurrection."[28] Remembering the thousands of pieces in which María Elena Moyano's body was spread like seeds over the ground of her community, we can help a nonviolent insurrection to grow, knowing that the forces of violence are "threatened with resurrection."[29] The words of women will not let injustice be buried forever. There will always be "a woman singing in the midst of chaos."[30]

# NOTES

## Part One
## Peruvian Women's Testimonies about War

*Introduction: Witnessing War as a Gringa in Peru*

1. All translations from the Spanish and the German are mine unless otherwise indicated.

2. I will use the common term "Third World" throughout the book even though it is an inadequate expression for nations that comprise two-thirds of the world and that contain indigenous people who were there "first."

3. Gretchen Morgenson, "Dreams in a Bottle: How Fragrance Fortunes Are Won and Lost," *Harper's Bazaar*, November 1992, 172.

4. Paul Ricoeur, "The Hermeneutics of Testimony," in Paul Ricoeur, *Essays on Biblical Interpretation*, ed. Lewis S. Mudge (Philadelphia: Fortress Press, 1980), 119–54. I would like to thank Leif Vaage for calling my attention to this article and for suggesting the term "testimony" as uniting my literary and theological reflections.

5. Ibid., 131.

6. *Oxford English Dictionary*, 2nd ed., s.v. "witness."

7. *Criollos* are native Peruvians of European (mostly Spanish) descent. "Whites" are, strictly speaking, only the European and North American immigrants.

8. Robin Kirk (with contributions by others), *Untold Terror: Violence against Women in Peru's Armed Conflict* (New York: Americas Watch and the Women's Rights Project, Divisions of Human Rights Watch, 1992), 1.

9. See Paul A. W. Wallace, *White Roots of Peace* (Philadelphia: University of Pennsylvania Press, 1946), 6f.

10. Joseph Epes Brown, *The Spiritual Legacy of the American Indian* (New York: Crossroad, 1987), x.

11. I will later explain this point with reference to Irene Silverblatt's study *Moon, Sun, and Witches: Gender Ideologies and Class in Inca and Colonial Peru* (Princeton, N.J.: Princeton University Press, 1987).

12. See Virginia Ramey Mollenkott, "An Evangelical Perspective on Interreligious Dialogue," in *Women of Faith in Dialogue,* ed. Virginia Ramey Mollenkott (New York: Crossroad, 1988), 61–73. This essay points to a sound biblical basis for an "inclusive" theology that is open to all other faiths.

13. Quoted from *Maryknoll: Magazine of the Catholic Foreign Mission Society,* February 1992, 12.

14. See "Peru One Year Later: Report of an International Ecumenical Delegation to Peru — September 30–October 7, 1991" (Geneva: World Council of Churches, February 1992), 5f. This report still refers to twenty-two thousand deaths, including one thousand children, but more recent reports usually figure at least twenty-six and sometimes over twenty-seven thousand victims. See "Basic Facts on Peru," p. xvii above.

15. Claudia Salazar, "A Third World Woman's Text: Between the Politics of Criticism and Cultural Politics," in *Women's Words: The Feminist Practice of Oral History,* ed. Sherna Berger Gluck and Daphne Patai (New York: Routledge, 1991), 98.

16. Daphne Patai, "U.S. Academics and Third World Women: Is Ethical Research Possible?" in *Women's Words: The Feminist Practice of Oral History,* ed. Sherna Berger Gluck and Daphne Patai (New York: Routledge, 1991), 137–53; and Daphne Patai, "Ethical Problems of Personal Narratives, or, Who Should Eat the Last Piece of Cake?" *International Journal of Oral History* 8, no. 1 (1987): 5–27.

17. See Bell Gale Chevigny and Gari Laguardia, eds., *Reinventing the Americas: Comparative Studies of Literature of the United States and Spanish America* (Cambridge: Cambridge University Press, 1986.

18. Daphne Patai, "Constructing a Self: A Brazilian Life Story," *Feminist Studies* 14 (Spring 1988): 149. See also Carol Christ's definition of "narrative" as pertaining to "all articulations of experience that have a narrative element, including fiction, poetry, song, autobiography, biography, and talking with friends" (Carol P. Christ, *Diving Deep and Surfacing: Women Writers on Spiritual Quest* [Boston: Beacon Press, 1980], 1).

19. That "war" in the private sphere of the home and "real" war cannot be separated has been emphasized by Lynne Hanley, *Writing War: Fiction, Gender, and Memory* (Amherst: University of Massachusetts Press, 1991). That governments can be "terrorists" is vividly described in Robin Morgan, *The Demon Lover: On the Sexuality of Terrorism* (New York: W. W. Norton, 1989), 124–53. See also Nancy Scheper-Hughes, *Death without Weeping: The Violence of Everyday Life in Brazil* (Berkeley: University of California Press, 1992), 220, on "state terrorism."

20. See Jean Franco, "Beyond Ethnocentrism: Gender, Power, and the Third-World Intelligentsia," in *Marxism and the Interpretation of Culture,*

ed. Cary Nelson and Lawrence Grossberg (Urbana: University of Illinois Press, 1988), 507.

21. See Silverblatt, *Moon, Sun, and Witches,* 160–96. I will deal with the persecution of presumed witches later. On the whole, the syndrome in Latin America was probably similar to that of Puritan Massachusetts: It was a way of "terrorizing older and insufficiently docile women," as Rosemary Radford Ruether phrased it. See her *Sexism and God-Talk* (Boston: Beacon Press, 1983), 171.

22. María Emma Mannarelli, "La conquista de la palabra," *VIVA* 3, no. 8 (November/December 1986): 21.

23. See Christel Voss-Goldstein and Horst Goldstein, eds., *Schwestern über Kontinente. Aufbruch der Frauen: Theologie der Befreiung in Lateinamerika und feministische Theologie hierzulande* (Düsseldorf: Patmos, 1991), 68.

24. See Elizabeth A. Say, *Evidence on Her Own Behalf: Women's Narrative as Theological Voice* (Savage, Md.: Rowman & Littlefield, 1990), 6.

25. These observations by Rosario Castellanos are reported in Mineke Schipper, ed., *Unheard Words: Women and Literature in Africa, the Arab World, Asia, the Caribbean, and Latin America* (London: Allison & Busby, 1985), 232.

26. Associated Press Report, *Herald-Sun* (Durham, N.C.), August 29, 1993.

A "Special Topics Forum" at the American Academy of Religion conference in Kansas City, November 1991, dealt with "Wars of Religion: Present and Forthcoming." The program announcement said that there is a "growing tendency of modern political conflicts to assume a religious character." "The situation has been further exacerbated by the rise of fundamentalist movements in Christianity, Islam, Judaism, and Hinduism, as well as in other faiths." See AAR/SBL Annual Meeting Program, Kansas City 1991, 100.

27. The point has been made especially by Gustavo Gorriti Ellenbogen, *Sendero: Historia de la guerra milenaria en el Perú* (Lima: Editorial Apoyo, 1990).

28. I can give here only a small sample of the available literature that touches on the aspects mentioned above: Cynthia Enloe, *Does Khaki Become You? The Militarization of Women's Lives* (Boston: South End Press, 1983); Helen M. Cooper et al., eds., *Arms and the Woman: War, Gender, and Literary Representation* (Chapel Hill: University of North Carolina Press, 1989); Margaret R. Higonnet et al., eds., *Behind the Lines: Gender and the Two World Wars* (New Haven: Yale University Press, 1987); Jean Bethke Elshtain, *Women and War* (New York: Basic Books, 1987); Adrienne Harris and Ynestra King, eds., *Rocking the Ship of State: Toward a Feminist Peace Politics* (Boulder: Westview Press, 1989).

29. There are, of course, exceptions: Margaret Randall, e.g., has written *Christians in the Nicaraguan Revolution* (Vancouver: New Star Books,

1983). Julia Esquivel's moving poems about Guatemala's sufferings have become famous: *Threatened with Resurrection: Prayers and Poems from an Exiled Guatemalan* (Elgin, Ill.: Brethren Press, 1982). Renny Golden has given us powerful testimonies from El Salvador in *The Hour of the Poor, the Hour of Women: Salvadoran Women Speak* (New York: Crossroad/Continuum, 1991). I have written a German article, "Die friedfertige Frau? Theologische Perspektiven zum Thema Frauen, Krieg und Frieden," *Evangelische Theologie* 47 (January/February 1987): 60–82; translated and condensed as "La mujer, la guerra y la paz," *Selecciones de teología* 27 (October–December 1988): 317–31, and as "Peacemaker Woman? Theological Perspectives on Women, War, and Peace," *Reformed World* 41 (June 1990): 41–56. Jean Bethke Elshtain's *Women and War* touches on some theological issues, and there are a number of books on the subject of "women and peace" from a religious point of view. Discussing Western women's peace efforts, however, is different from asking some hard questions about the church's role in women's ambiguous or enthusiastic support of past wars, their participation in the military today, and the role of women in the wars of the Third World. Only when we have worked through these complex issues can we see clearly what our role as peacemakers might be today.

30. *Women in Peru: Voices from a Decade,* published in 1986 by the Ecumenical Committee on the Andes (ECO-ANDES), 198 Broadway #302, New York, NY 10038.

31. The subtitle of Say, *Evidence on Her Own Behalf: Women's Narrative as Theological Voice.*

32. Although I am not of the Methodist tradition, I have long been in agreement with the time-honored Methodist principle of the "quadrilateral": the combination of Scripture, tradition, experience, and reason. See *The Book of Discipline of the Methodist Church* (Nashville: United Methodist Publishing House, 1988), 82–86. There are, of course, great differences in the way one orders and defines these four elements.

33. Ricoeur, "The Hermeneutics of Testimony," 146.

34. About *sophia* (wisdom) in Hebrew literature and in the words of Jesus, see Elisabeth Schüssler Fiorenza, *In Memory of Her: A Feminist Theological Reconstruction of Christian Origins* (New York: Crossroad, 1983); and Susan Cady, Marian Ronan, and Hal Taussig, eds., *Wisdom's Feast: Sophia in Study and Celebration* (San Francisco: Harper & Row, 1989).

## Chapter 1: Early Witnesses

1. Bell Gale Chevigny, "The Lives and Fictions of American Women," in *Reinventing the Americas: Comparative Studies of Literature of the United States and Spanish America,* ed. Bell Gale Chevigny and Gari Laguardia (Cambridge: Cambridge University Press, 1986), 139.

2. For the estimated figures of Indian deaths, see, e.g., Gustavo Gutiérrez, *Dios o el oro en las Indias: Siglo XVI* (Lima: Instituto Bartolomé de las Casas, 1989), 10. The estimates for the pre-Columbian Indian population in both Americas vary widely, from 8,400,000 to more than 100,000,000. Gutiérrez opts for a middle position, around 57,300,000. There is widespread agreement, however, on the figure of American Indians still living around 1570 in "Spanish America": around 8,907,150. The Peruvian population fell from an estimated 9,000,000 in 1520 to 1,000,000 in 1570. See Ofelia Ortega, "Latin American Women: A History of Rebellion," *Echoes* (World Council of Churches) 1 (1992): 15: "At the time of the discovery, the Indian population of America numbered some 80 million, and by the end of the 16th century their numbers were down to 10 million."

About the change in women's status, see Sara Beatriz Guardia, *Mujeres peruanas: El otro lado de la historia* (Lima: Tempus Editores, 1986).

3. See Penny Dransart, "Women and Ritual Conflict in Inka [sic] Society," in *Images of Women in Peace and War: Cross-Cultural and Historical Perspectives*, ed. Sharon McDonald, Pat Holden, and Shirley Ardener (Madison: University of Wisconsin Press, 1988), 66–77.

4. See Franklin Pease G.Y., "Notas sobre literatura incaica," *Historia y Cultura: Revista del Museo Nacional de Historia* 16 (1983): 95–112. See also Rolena Adorno, ed., *From Oral to Written Expression: Native Andean Chronicles of the Early Colonial Period* (Syracuse, N.Y.: Maxwell School of Citizenship and Public Affairs, Syracuse University, 1982).

5. Pease, "Notas sobre literatura incaica," 98.

6. See Rolena Adorno, *Guamán Poma: Writing and Resistance in Colonial Peru* (Austin: University of Texas Press, 1986).

7. Guardia, *Mujeres peruanas*, 42.

8. Ibid.

9. Ibid.

10. *Colección documental del bicentenario de la revolución emancipadora de Tupac Amaru*, vol. 4/2 (Lima 1981), 79; letter of December 6, 1780.

11. Ibid., 43.

12. See the reports about the executions, e.g., in *Colección documental*, vol. 4/2, 78, and vol. 3/1, 514. About many other courageous women like Micaela Bastidas whom Peruvian historians have rediscovered and about the innumerable uprisings against the colonial overlords in which women were actively involved, see several essays in *Mujer y Sociedad* 34 (December 1989): 16–25. Of special interest is the article by Herrmann Haman Carillo, "Participación de la mujer peruana en apoyo de las operaciones militares," 16–19. Ortega, "Latin American Women," 16, has a list of rebelling women of the eighteenth century in various Latin American countries.

13. See Miguel Maticorena Estrada, *Colección documental*, vol. 3/1, xviif.

14. *Colección documental,* vol. 4/2, 15.

15. The second question is answered positively, of course, by sympathizers of guerilla groups. See, e.g., Carol Andreas, "Women at War," *NACLA Report on the Americas* 24, no. 4 (December–January 1990/91): 23–27 containing an interview with Luis Arce Borja, exiled editor of the newspaper *El Diario* and spokesperson for the Shining Path guerillas). The third question gets an affirmative answer in Robin Morgan, *The Demon Lover: On the Sexuality of Terrorism* (New York: W. W. Norton, 1989). I will refer to both publications again later.

16. Antonia Moreno de Cáceres, *Recuerdos de la Campaña de la Breña: Memorias,* ed. Hortensia Cáceres (Lima: Editorial Milla Batres, S.A., 1974). Page numbers in parenthesis in the text hereafter will refer to this edition.

17. See Susana Zapata, "Las rabonas," *Mujer y Sociedad* 6, no. 11 (July 1986): 30f.

18. Ibid. See also Flora Tristán, *Peregrinaciones de una paria* (Lima: Moncloa-Campodónico Editores, 1971), 234.

19. The female police force of Peru, established in 1956, was the first in Latin America. See *La República,* May 3, 1989, 17.

## Chapter 2: Women Writers of the Twentieth Century

1. Jean Franco, *Plotting Women: Gender and Representation in Mexico* (New York: Columbia University Press, 1989), xv and xiv.

2. About the general situation of women writers in Peru, see the essay by Cecilia Bustamante, "La escritora y la sociedad," presented at the University of Ottawa on May 21, 1978, and available from CENDOC-Mujer, La Mar 170, Lima 18, Peru. See also by the same author some interview statements on Peruvian literature in Roland Forgues, ed., *Palabra viva,* vol. 4: *Las poetas se desnudan* (Lima: Editorial El Quijote, 1991), 114–17.

About Clorinda Matto de Turner, see, for example, Alberto Tauro, *Clorinda Matto de Turner y la novela indigenista* (Lima: Universidad Nacional de San Marcos, 1976) and Francisco Carillo, *Clorinda Matto de Turner y su indigenismo literario* (Lima: Ediciones de la Biblioteca Universitaria, 1967). Matto de Turner was a staunch supporter of General Cáceres; see above pp. 24–30).

3. One example of a male writer portraying a guerilla is Luis Nieto Degregori, *La joven que subió al cielo* (Lima: El Zorro de Abajo Ediciones, 1988). The important recent novel by Miguel Gutiérrez, *La violencia del tiempo* (1992), deals with the revolutionary spirit in Peruvian history and its relationship to racial and ethnic identity. See a review of the book and an interview with the author by Abraham Siles Vallejos in *Quehacer* (May–June 1992): 100–110.

4. Page numbers in parenthesis hereafter refer to Aída Balta, *El legado de Caín* (Lima: Editorial El Quijote, 1987).

5. Balta alludes here to the death of the poet Javier Heraud in the battle of Port Maldonado.

6. "Aída Balta, Segunda vuelta," review by G.E.F., *Caretas* (October 12, 1987): 62.

7. Aída Balta's first novel is *Sodoma, Santos y Gomorra* (Lima: Editorial El Quijote, 1986).

8. I am referring to an interview with Aída Balta, October 21, 1992. An extensive review of the novel by the French critic Roland Forgues commends Balta for alternating first- and third-person narrative and then "fusing" them in the second person when she relates the suicide of Suriel. Roland Forgues, "Aída Balta y la reconquista del paraíso," *El Comercio,* March 21, 1993.

9. Two excellent analyses of the development of the Shining Path movement are Carlos Iván Degregori, *El surgimiento de Sendero Luminoso: Ayacucho 1969–1979* (Lima: Instituto de Estudios Peruanos, 1990), and Gustavo Gorriti Ellenbogen, *Sendero: Historia de la guerra milenaria en el Perú* (Lima: Editorial Apoyo, 1990). Other recent statements affirm the reality that Balta describes: Sendero gets most converts from high-school-age students; it is originally not tied into Andean traditions, but into an international Maoism; Sendero leader Abimael Guzmán started out as an admirer of Castro; racism makes more Sendero converts than poverty, etc. See interviews by Mariella Balbi with Raúl Gonzales, Manuel Granados, and David Scott Palmer, *La República,* October 24, 1989, 6f., and May 24, 1987, 34.

10. Gonzalo Portocarrero and Elisabeth Acha, *Violencia estructural en el Perú: Sociología* (Lima: Asociación Peruana de Estudios e Investigación para la Paz, 1990).

11. See ibid., 74, 77, 82.

12. It is certainly to be hoped that *El legado de Caín* will be translated into English.

13. Roland Forgues, "Aída Balta y la reconquista del paraíso," *El Comercio,* March 21, 1993.

14. The story is to be found in the volume *Memorias clandestinas (Cuentos): Primer Concurso de Cuento "Magda Portal," Convocado por el Centro de la Mujer Peruana Flora Tristán* (Lima: Ediciones Flora Tristán, 1990): 75–81. It is also reprinted in *VIVA* 18 (June 1990): 61–63. The same journal issue contains an interview with the author, 56f.

15. The Peruvian sociologist Carolina Carlessi has written an article on the intricate relationship between domestic and political violence. She quotes the Peruvian historian Alberto Flores Galindo as even relating torture and the abusive treatment of maids. As he sees it, "Torture does not cause a scandal in Peru because it is not confined to the prison. It reaches also into homes and families." See Carolina Carlessi, "Pen-

sando el hogar," *El Zorro de Abajo* 4 (March 1986): 33–35, and Galindo's article to which she refers, "Pensando el horror," in *El Zorro de Abajo* 2 (September/October 1985): 36–38.

16. Gorriti gave me four unpublished poems and the story "Victoria Poseída" in October 1992. With the money she received as a prize for the story "El legado" she has privately published a first small volume of poetry.

17. David William Foster, "Latin American Documentary Narrative," *PMLA* 99 (January 1984): 53.

18. A partial list of articles and interviews by Mariella Balbi published in *La República* and used for my discussion are from the following dates: May 24, 1987, and December 29, 1989 (conversations with "senderologists" Raúl Gonzales, Manuel Granados, and Gustavo Gorriti); December 8, 1987 (Mothers of the Disappeared); April 24, 1988 (interview with Raúl Gonzales); June 27, 1988 (the war situation in Ayacucho); August 1, 1988 (roundtable discussion with retired general Sinesio Jarama, the priest Hubert Lancier, and the sociologist Raúl Gonzales); October 10, 1988 (Vaso de Leche program); December 4 and 6, 1988 (the right-wing paramilitary group Comando Rodrigo Franco); February 2, 1989 (attack on a mayor); March 5, 1989 ("democratic" elections in the midst of violence); April 9, 1989 (failed antisubversive strategy); January 29, 1989 (interview with the rector of the University of Ayacucho); March 14, 1989 (interview with Professor Julio Cotler); May 28, 1989 (interview with Juan Granda about Sendero strategies); October 24, 1989 (interviews in the U.S. with Sendero sympathizers and with David Scott Palmer); June 4, 1989 (interview with Rector Morote of Ayacucho); June 20, 1989 (interview with the head of a committee to investigate crimes of a paramilitary group); June 13, 1989 (interviews with the heads of the leading political parties); September 27, 1992 (about women in Sendero).

19. *VIVA* 5, no. 18 (June 1990): 6–8, and 5, no. 19 (December 1990): 10–13.

20. *La República*, July 13, 1989, 11, reports on a prize won by Mariella Balbi from the Sociedad Interamericana de Prensa for her articles on the human rights situation. The Banco de Crédito has given her an award for her reports on the "Peruvian reality." See *La República*, July 27, 1989.

21. See the Amnesty International report on the murder in *Amnesty Action* (July/August 1989), 2.

22. See *La República*, June 2, 1989, 2, and June 3, 1989, 3.

23. The paper had criticized the "covenant" between the U.S. and the Fujimori government to give Peru military aid in the drug war. The type of plastic bomb used is available only to the military and the police, raising the suspicion that this murder was not committed by any subversive group.

24. Balbi told me about this anonymous telephone threat when I interviewed her on May 22, 1989. The government gave her special protection after the threat.

25. See *La República*, September 9, 1992, about the journalists Magno Sosa and José Ramírez. The article also mentions Gustavo Gorriti's arrest after the *autogolpe* (self-inflicted coup) of Fujimori. Since Gorriti is internationally known as an expert on the Sendero movement (see note 9 in this chapter), he was set free after several days. See also the journal *Caretas*, September 10, 1992, 23, about Magno Sosa. As of this writing (March 1993) Sosa has been released and is living in Venezuela.

26. *La República*, May 24, 1987, 33–35. The government referred to is that of Alan García, whose socialist rule started with much hope and ended in a morass of corruption.

27. *La República*, August 1, 1988, 19.

28. *La República*, June 13, 1989, i–viii.

29. *La República*, June 20, 1989, 11.

30. *La República*, May 28, 1989, 10–12.

31. *La República*, October 24, 1989, 3–6, describes Balbi's interviews in the United States. To my knowledge, the first comprehensive article about Sendero's international connections appeared in the *New York Times Magazine* on May 24, 1992; but only after Guzmán's capture in September 1992 did these facts become generally known, especially because the Fujimori government made an effort to brand the so-called ambassadors of Sendero as international outlaws.

32. *La República*, October 24, 1989, 7–8.

33. This report in the journal *Oiga* (December 3, 1990) is mentioned in *Presencias*, the newsletter of CENDOC-Mujer, a documentation center in Lima (December 1990/January 1991): 2.

34. "Tevemás entrevista a Mariella Balbi," *El Comercio*, September 2, 1991.

35. In a partly humorous mini-interview published in the journal *Caretas* (September 24, 1992), 55, Balbi answers the question whether she believes in God with: "I do not feel the need to believe."

36. Ibid.

37. See Gonzalo Portocarrero and Elisabeth Acha, *Violencia estructural en el Perú: Sociología* (Lima: Asociación Peruana de Estudios e Investigación para la Paz, 1990), and Margarita Giesecke, Carmen Checa, and Alberto Giesecke, *Violencia estructural en el Perú: Historias de vida* (Lima: Asociación Peruana de Estudios e Investigaciones para la Paz, 1990).

38. Piedad Pareja Pflücker, *Terrorismo y sindicalismo en Ayacucho (1980)* (Lima: Empresa Editora Ital Perú, 1981). Pflücker had written two previous works: *Anarquismo y sindicalismo en el Perú (1905–1929)* (1978) and *Aprismo y sindicalismo en el Perú (1943–1948)* (1980). She later coauthored with Eric Torres Montes, *Municipios y terrorismo: Impacto de la violencia*

*subversiva en los gobiernos locales* (Lima: Centro de Estudios Peruanos, 1989).
39. Pareja Pflücker, *Terrorismo y sindicalismo*, 18.
40. Ibid., 22.
41. Ibid., 173.
42. Pareja Pflücker and Torres Montes, *Municipios y terrorismo*, 74.

## Chapter 3: Witnessing in Different Forms

1. I am using the term "American Indian" because it is an acceptable designation among native tribes in the U.S., although they prefer to have their specific tribe named wherever possible. In Peru the term *indio* definitely has discriminatory overtones, and "indigenous" or "Andean" are often the preferred terms. However, the former also has the connotation of "poor," and the latter does not fit for people who have lived in the coastal capital for decades. I think, then, that the use of "American Indian" or even simply "Indian" should not be ruled out in the context of my topic. In a debate on the state of indigenous groups after five hundred years of European presence, Jaime Urrutia, an anthropologist, states that in Peru the social class designations are mixed with ethnic categories, and, given the fact of racism, nobody likes to use "indigenous" as a self-designation. See *La República*, October 6, 1992. See also Orin Starn, "Missing the Revolution: Anthropologists and the War in Peru," *Cultural Anthropology* 6, no. 1 (February 1991): 70, on the terms "Indian," "cholo," and "mestizo," as "partly overlapping positions on a continuum."

2. Robin Kirk, *The Decade of Chaqwa: Peru's Internal Refugees* (Washington, D.C.: U.S. Committee for Refugees, 1991), 20f., 3.

3. Ibid., 28f.

4. Ibid., 35.

5. Linda Rupert et al., *Women in Peru: Voices from a Decade* (New York: Ecumenical Committee on the Andes [ECO-ANDES], April 1986), 21f.

6. Ibid., 21.

7. Rosa María Alfaro, "Comunicar entre violencias: Una estrategia de paz," in Narda Henríquez and Rosa María Alfaro, eds., *Mujeres, violencia, y derechos humanos* (Lima: Abraxas Editorial, 1991), 48. This volume contains the papers of the conference.

8. Ibid., 169.

9. The original materials of the seminar and workshop "Mujer, violencia, y derechos humanos, Lima, February 27 and 28, 1989, were made available to me by the librarian of the feminist center Flora Tristán in Lima in the spring of 1989. Francisca's *testimonio* is slightly condensed in the book, and I am mentioning some details found only in the typescript.

10. *Mujeres, violencia y derechos humanos*, 171.

11. Ibid., 45.

12. See, e.g., the report about Peru in 1992 by the Proyecto de Desarollo Integral of Lima, published December 1992. The newspaper *La República* for several weeks in the fall of 1992 carried articles about people who should not have appeared on the list and letters to the editor from individuals who tried to prove that, far from being Sendero sympathizers, they had been threatened by Sendero. The cause of the confusion is partly that computer disks with hundreds of names were found in Abimael Guzmán's house, but nobody knows whether the list included suspected enemies of Sendero, potential friends, or simply grassroots leaders who were to be targeted and watched.

13. The 1991 interview is recorded in *Informativo*, newsletter of the Grupo de Apoyo Peruano, New York, nos. 12–13 (double edition), 21f. The comment to Balbi is found in *La República*, December 8, 1987), 13.

14. See Regina Harrison, *Signs, Songs, and Memory in the Andes: Translating Quechua Language and Culture* (Austin: University of Texas Press, 1989), 135–37.

15. Ibid., 137–39.

16. Ibid., 137.

17. I have the following information on Juana Lidia from a brochure accompanying a cassette of her songs. The booklet was written in German by Rainer Huhle for the Peru-Group of Nürnberg, Germany, and for SERPAJ (Servicio de Paz y Justicia), a nongovernmental organization working in Ayacucho to help victims of violence. The cassette and the brochure, "Juana Lidia Argumedo: Lieder vom Leben und Überleben in Ayacucho," can be ordered from Gaby Franger, Frauen in der Einen Welt, Eichendorffstrasse 20, 90491 Nürnberg, Germany. The text gives extensive information on the background and character of this music.

18. Ibid., 17.

19. The *huayno* is the best-known form of Andean music. A few slowly sung stanzas are followed by a *fuga* of one or more faster stanzas and a marked ending. It is mainly a mestizo form with European influences. Instruments of the *huayno* are usually violin, harp, and charango (a small guitar), or, in the case of Juana Lidia's cassette, violin, mandolin, and accordion. The voices are often falsetto and sound "Chinese" to Westerners. I have translated the two songs given here from the German translation of the Quechua.

20. Tambo is a small town in the province of La Mar, Department of Ayacucho, and the birthplace of Juana Lidia.

21. A well-known folklore band from Ayacucho, Grupo Trilce, considers its name a combination of *triste* and *dulce* and sees this mood as typical of Andean music. Trilce music can be ordered from Frauen in der Einen Welt, Eichendorffstrasse 20, 90491 Nürnberg, Germany. The word *trilce* was originally coined by the Peruvian poet César Vallejo. Rainer Huhle has emphasized that the *huaynos* are less direct and more

generally plaintive (also occasionally ironic or satiric) because they express the passive resistance of the mestizos after the active resistance had been broken during the first centuries of colonization. The more general mood of sadness and of pride in a great cultural tradition turns the *huaynos* written by individual singers more easily into folk songs and thereby contributes to the power of survival. See "Juana Lidia Argumedo," pp. 31f.

22. See note 10, p. 213 about the different types of *rondas*.

23. Not all tribes are satisfied with President Fujimori. When he declared (before the November 1992 elections for a new Congress) that only new groups with at least one hundred thousand signatures would be represented, fifty people from different tribes in the Amazonian areas came in colorful costumes to the capital to tell Fujimori that they needed representation even if in their widely dispersed villages they could not possibly collect the required amount of signatures. No previous government had considered their rights and needs. Fujimori suggested they should join the party he supported. See *La República*, September 10, 1992.

24. See the interview with Rostworowski in *El Comercio*, September 13, 1992.

25. Orin Starn, "Missing the Revolution," emphasizes the fluidity of Andean culture and its merger with modernity. He also mentions the curious fact that sometimes the Andean heritage "becomes redeployed by popular organizations" (86). Grassroots organizations make the peasants aware of their partly lost cultural traditions.

26. Carol Andreas, "Women at War," *NACLA Report on the Americas*, 24, no. 4 (December 1990/January 1991), 21.

27. Ibid., 27.

28. Carlos Iván Degregori, *El surgimiento de Sendero Luminoso: Ayacucho 1969–1979* (Lima: Instituto de Estudios Peruanos, 1990), 206ff.

29. *El Diario* (Lima), May 1, 1990, 15. I owe the reference to this article and many valuable items of information on the women of Sendero to conversations with and essays by Robin Kirk. See her articles "Women of the Shining Path," *Image*, March 22, 1992, 15–21, and "Women Warriors at Core of Peruvian Rebellion," *San Francisco Chronicle*, April 1, 1991, 1f.

30. Ingrid Bettin, *Seele aus Stein und Taube: Begegnung mit Peru* (Wuppertal: Peter Hammer Verlag, 1989).

31. *Presencias* (CENDOC-Mujer) 8 (May 1991), refers to an article in *El Comercio*, May 29, 1991, about judicial procedures against Arredondo, and the newspaper *Expreso* reported on March 28, 1992, about her latest prison sentence.

32. Bettin, *Seele aus Stein und Taube*, 27.

33. Ibid., 182.

34. Ibid., 183.

35. Ibid., 31. It should be mentioned that Arguedas was married to Arredondo, his second wife, for only two-and-a-half years before he took his own life in 1969. It is a very dubious claim of Sybila that he would have supported Sendero Luminoso's violent tactics.

36. Ibid., 79.

37. Andreas, "Women at War," 22.

38. Julia Vicuña, "Las mujeres en Sendero," *VIVA* 4, no. 16 (September 1989), 8.

39. Ibid., 8f. Emphasis is mine. See also *El Diario*, March 14, 1988, quoted in *La República*, September 16, 1992. Laura Zambrano had later been freed from prison and disappeared, spreading the rumor that she had gone abroad, but on September 12, 1992, she was captured together with Guzmán and is now in prison for life. She is supposed to have been the coordinator of the most violent attacks in Lima.

40. Ibid., 9.

41. Gonzalo Portocarrero and Elisabeth Acha, *Violencia estructural en el Perú: Sociología* (Lima: Asociación Peruana de Estudios e Investigación para la Paz, 1990), 13f.

42. Ibid., 79f.

43. Ibid., 80.

44. See Bettin, *Seele aus Stein und Taube*, 168f., and also Houston A. Baker, Jr., *Long Black Song: Essays in Black American Literature and Culture* (Charlottesville: University Press of Virginia, 1972), 46. I have discussed black apocalypticism in my book *Women, Ethnics, and Exotics: Images of Power in Mid-Nineteenth-Century American Fiction* (Knoxville: University of Tennessee Press, 1983), 152f. See also the apocalyptic and messianic perspective of the Tupac Amaru revolt of 1780 as described in *Colección documental del bicentenario de la revolución emancipadora de Tupac Amaru,* vol. 3/1: *Los procesos a Tupac Amaru y sus compañeros* (Lima, 1981), xvii–xxii.

45. Rosemary Radford Ruether, *Gaia and God: An Ecofeminist Theology of Earth Healing* (San Francisco: Harper, 1992), 81, 83.

46. Andreas, "Women at War," 25.

47. *La República*, September 19, 1992.

48. Julie Phillips in a review of Luisa Valenzuela's work. See *The Women's Review of Books* 9, nos. 10–11 (July 1992): 20.

49. The BBC in 1990 produced a video about Peru and about the election campaign of Mario Vargas Llosa. Yuyachkani plays an important role in this film, and their attempt to rediscover Peru's Andean heritage stands in ironic contrast to statements by Vargas Llosa that the indigenous people of Peru have to become modernized. The video is available in English from Yuyachkani, Tacna 363 (Magdalena), Lima, Peru.

A recent interview with the women of Yuyachkani in the *Women's Review of Books* 10 (July 1993): 10–11, emphasizes their "search for a 'feminine' perspective on everything that goes on." The introduc-

tion calls Yuyachkani "one of Latin America's most important theatre groups" ("As Necessary as Bread: Susan Homar Interviews the Women of Yuyachkani").

50. See María Rostworowski, "La aguerrida Mama Huaco," *Mujer y Sociedad* 6, no. 11 (July 1986): 22–24.

51. No printed edition is available so far. I was able to get the text in Spanish typescript in May of 1989 in Lima from Yuyachkani members. Other plays by the group, however, are printed, e.g., *Allpa Rayku: Una experiencia de teatro popular* (Lima: Perúgraph Editores, 1983), and a children's play, *Un día en perfecta paz* (Lima: Rumi Maqui Editores, 1989). The article/interview mentioned in note 49 above describes among other Yuyachkani plays their recent *No me toquen ese vals (Don't Play That Waltz for Me.)*

52. This is a famous Andean myth that is described, like other background material of "Contraelviento," in Alejandro Ortiz Rescaniere, *De adaneva a incarrí: Una visión indígena del Perú* (Lima: Retablo de Papel Ediciones, 1973).

53. Many of the characters and incidents go back to the Fiesta de Candelaria in Puno, in the highlands of Peru.

54. The *amaru* (Quechua for snake) symbolizes the Andean people (the oppressed) — note that the name Tupac Amaru contains the same word — and the bull stands for Spain (the oppressor).

55. I learned these details from Ana Correa, one of the earliest members of the group, whom I interviewed on May 12, 1989, and on September 15, 1992. She plays the role of Colla in "Contraelviento."

56. Ana Correa mentioned that this "living on" of father and daughters is to her like the living spirit of Salvador Allende who still influences Chile.

57. Rescaniere, *De adaneva a incarrí*, 127.

58. Ibid., 128–62.

59. The film *La boca del lobo* is available with English subtitles from CINEVISTA, 353 West 39th Street, New York, NY 10018, Tel. (212) 947-4373, Telefax (212) 947-0644.

60. Personal letter from Giovanna Pollarolo of September 29, 1989. Pollarolo is the wife of the film director Francisco Lombardi. She teaches at the Pontificia Universidad Católica in Lima. Two poetry publications of hers are *Huerto de los olivos* and *Entre mujeres solas*. A more recent film script she wrote with Augusto Cabada is *Caídos del Cielo* (1990), also directed by Lombardi. This film compares the lives of people from three different social classes of Lima and also deals with the problem of violence.

61. See the interview with Giovanna Pollarolo, conducted by Miguel Díaz Reyes, in *La República*, second week of December 1988, 6f., and the interview with Francisco Lombardi, conducted by Mariella Balbi, *La República*, November 27, 1988, 13f.

62. See the interview in Roland Forgues, *Palabra viva*, vol. 4: *Las poetas se desnudan* (Lima: Editorial El Quijote, 1991), 222.

63. Ricardo González Vigil, "Giavonna Pollarolo, desde la desolación," *El Comercio*, September 22, 1991.

64. See Marjorie Agosín, *Scraps of Life — Chilean Arpilleras: Chilean Women and the Pinochet Dictatorship* (Toronto: Williams-Wallace, 1987), especially 79–81, "The Arpillera as Political Protest," and 61–65, "The Arpilleras of the Vicarate Workshops and Government Policy toward Them."

65. Gaby Franger, *Arpilleras: Cuadros que hablan: Vida cotidiana y organización de mujeres* (Lima: Betaprint Ediciones, 1988), 73.

66. Marina Haro, "La guerra del hambre," in *Vivir la reconciliación–hacer la paz: Estrategias de mujeres contra la opresión*. Congreso Internacional de Mujeres en Nuremberg (Wendelstein, Germany: Cicero Publishing, 1992), 138.

67. Ibid., 142.

68. The circumstances are described in Franger, *Arpilleras*, 106–9.

69. Robin Kirk, *Untold Terror: Violence against Women in Peru's Armed Conflict* (New York: Human Rights Watch, 1992); available from Human Rights Watch, 485 Fifth Ave., New York, NY 10017.

70. Ibid., 1.

71. Ibid., 3.

72. The legal team at the Flora Tristán feminist center in Lima holds detailed files about proposed new legislation and gives information about the complex struggle of women's groups to influence political decision-making. The new penal code took effect in 1992. It states that "simple rape" (without weapons) should be punished with three to six years in prison.

73. Kirk, *Untold Terror*, 11.

74. Ibid., 36.

75. As of April 1991, 55 percent of the population lived under effective military rule. See Jo Marie Burt and Aldo Panfichi, *Peru: Caught in the Crossfire* (Jefferson City, Mo.: Peru Peace Network/USA, 1992), 28.

76. Kirk, *Untold Terror*, 19.

77. Aída García Naranjo, "Somos creadoras de vida, no úteros reproductores de violencia," *VIVA* 5, no. 19 (December 1990): 43.

78. Ibid., 41f.

79. Ibid., 42.

80. Helen Orvig, personal letter of March 25, 1992, scarcely six weeks after the assassination.

81. *Si*, February 24, 1992, 24.

82. *Ojo*, February 17, 1992, 13.

83. *Revista Ideéle* 4, no. 35 (March 1992): 4.

84. *Expreso*, February 18, 1992, 2.

85. *La República*, February 18, 1992, 7.

86. *Ojo*, February 17, 1992, 12.
87. *La República*, February 16, 1992, 16.
88. Ibid.
89. *El Diario*, March 1, 1992, 8.
90. *La República*, February 16, 1992, 16.
91. "Organización popular es la alternativa al terror," *El Peruano*, February 17, 1992.
92. *Revista Ideéle* 4, no. 35 (March 1992): 4.
93. Margarita Giesecke, Carmen Checa, and Alberto Giesecke, *Violencia estructural en el Perú: Historias de vida* (Lima: Asociación Peruana de Estudios e Investigación para la Paz, 1990), 61–69.
94. Ibid., 61f.
95. Ibid., 64.
96. Ibid., 68.
97. *La República*, February 18, 1992, 2–4.

*Chapter 4: The Sexuality of Terrorism, Religious Teaching, and Women's Silence*

1. Robin Morgan, *The Demon Lover: On the Sexuality of Terrorism* (New York: W. W. Norton, 1989).
2. Robin Kirk, *The Decade of Chaqwa: Peru's Internal Refugees* (Washington, D.C.: U.S. Committee for Refugees, 1991), 31 and 34.
3. See the article by Cecilia Medina, "Women's Rights as Human Rights: Latin American Countries and the Organization of American States (OAS)," in *Women, Feminist Identity, and Society in the 1980's: Selected Papers*, ed. Myriam Díaz-Diocaretz and Iris M. Zavala (Amsterdam/Philadelphia: John Benjamin Publ. Co., 1985), 63–79. While the article does not take into account the present legal situation in which both parents are equally responsible for the education of the children, it describes the status of legislation before July 1984 when Peru was still one of five Latin American countries in which the marriage contract demanded that the woman care for the couple's children and "supervise" domestic work (68). Many other legal inequalities between men and women are analyzed in the article. Customs do not die immediately when legislation changes.
4. Edmundo Léon y Léon and Oscar Aliaga-Abanto, "Peru: Furrows of Peace in a Bloodstained Land," in *Relentless Persistence: Nonviolent Action in Latin America*, ed. Philip McManus and Gerald Schlabach (Philadelphia: New Society Publishers, 1991), 141.
5. Laura E. Donaldson, *Decolonizing Feminisms: Race, Gender, and Empire Building* (Chapel Hill: University of North Carolina Press, 1992), 33.

6. Morgan, *The Demon Lover*, 336. In a radio program of "The People's Pharmacy" by Joe and Terry Graedon in Durham, North Carolina, on February 13, 1993, a Duke University endocrinologist stated that there is not yet any definite scientific evidence about biological gender difference as it influences identity and behavior, but that some recent studies indicate a possible difference in brain structure.

7. Morgan, *The Demon Lover*, 325.

8. Ibid., 78.

9. Ruth Leger Sivard, *World Military and Social Expenditures 1991* (Washington, D.C.: World Priorities, 1991), 5.

10. Noam Chomsky, "'At This Time in History, Nothing Is Independent,' Interview with Noam Chomsky," *Latinamerica Press*, February 25, 1993, 4.

11. See the excerpts of a WOLA Policy Brief published for Congress, "Going to the Source: Results and Prospects for the War on Drugs in the Andes," *Latin America Update* 16, no. 1 (May–August 1991), 3, and the excellent article by Peter R. Andreas et al., "Dead-End Drug Wars," *Foreign Policy* (Winter 1991–92): 106–28, stating, e.g., that "after more than a decade of U.S. efforts to reduce the cocaine supply, more cocaine is produced in more places than ever before" (107). The authors call it a "foolish and costly obsession" to try solving the nation's drug problem in the distant jungles of South America when so many addicts in the U.S. who seek help are turned away from treatment centers for lack of space (128).

12. Inés Coronado Tinoco, *Causas sociales de la delincuencia femenina por tráfico de drogas* (Lima: Editorial Gráfica del Perú, 1989).

13. Ibid., 118.

14. Edward S. Herman and Gerry O'Sullivan, *The Terrorism Industry: The Experts and Institutions That Shape Our View of Terror* (New York: Pantheon Books, 1989), xii.

15. See Carolina Carlessi, *La culpa como factor desmovilizador de los grupos de mujeres*, Serie Cuadernos Feminismo no. 1 (Lima: Lilith Ediciones, 1983); and Rosa Dominga Trapasso, "Religion...mujer y ciclo vital," *VIVA* 5, no. 17 (January 1990): 19–24.

16. Rosa Málaga, "Educadas para poner la otra mejilla," *VIVA* 5, no. 17 (January 1990): 25–27.

17. I realize that there are also charismatic-evangelical groups that are much more critical of the status quo and more progressive regarding women's issues than the average fundamentalist church.

18. Elsa Tamez is a Protestant theologian from Mexico teaching in Costa Rica. Her publications include: *Bible of the Oppressed* (Maryknoll, N.Y.: Orbis Books, 1982); *Against Machismo: Interviews by Elsa Tamez* (New York: Meyer Stone/Crossroad, 1987), and *Through Her Eyes: Women's Theology from Latin America*, ed. Elsa Tamez (Maryknoll, N.Y.: Orbis Books, 1989).

19. See Irene Silverblatt, *Moon, Sun, and Witches: Gender Ideologies and Class in Inca and Colonial Peru* (Princeton, N.J.: Princeton University Press, 1987), xix: "Ruling groups manipulated the ambivalence of gender images to buttress their political control." Pp. 87–90 describe "Chosen Women as Political Pawns."

20. About Inca warfare, see Penny Dransart, "Women and Ritual Conflict in Inka [sic] Society," in *Images of Women in Peace and War: Cross-Cultural and Historical Perspectives*, ed. Sharon McDonald, Pat Holden, and Shirley Ardener (Madison: University of Wisconsin Press, 1988).

21. James Higgins, *A History of Peruvian Literature* (Liverpool: Francis Cairns, 1987), 9.

22. Dransart, "Women and Ritual Conflict," 73.

23. Bell Gale Chevigny, "The Lives and Fictions of American Women," in *Reinventing the Americas: Comparative Studies of Literature of the United States and Spanish America*, ed. Bell Gale Chevigny and Gari Laguardia (Cambridge: Cambridge University Press, 1986), 140.

## Part Two:
## The Women's Movement of Peru
## and the Theology of the First World

*Chapter 5: The Genealogy of the Peruvian Women's Movement*

1. Michel Foucault, *Power/Knowledge: Selected Interviews and Other Writings 1972–1977* (New York: Pantheon Books, 1980), 83.

2. Here and in the following I am relying mainly on Virginia Vargas, "The Women's Movement in Peru: Streams, Spaces, and Knots," unpublished manuscript, 1990, published in Spanish as a chapter of Vargas's book *Como cambiar el mundo sin perdernos: El movimiento de mujeres en el Perú y América Latina* (Lima: Ediciones Flora Tristán, 1992), 15–83. Vargas has repeatedly worked at the Institute for Social Research in The Hague and presented there a shorter form of this paper in English. In Spanish she has published also *El aporte de la rebeldía de las mujeres* (Lima: Ediciones Flora Tristán, 1989), and numerous articles.

3. See Magda Portal, *Flora Tristán, Precursora* (Lima: Editorial La Equidad, 1983), 24.

4. Sara Beatriz Guardia, *Mujeres peruanas: El otro lado de la historia* (Lima: Tempus Editores, 1986), 54f., and Carlos Neuhaus Rizo Patrón, *Pancha Gamarra la Mariscala* (Lima: Francisco Moncloa Editores, S.A., 1967), 39–50. A *cholo* is an Indian or a person from the province.

5. Donald E. Worcester, *Bolívar* (Boston: Little, Brown, and Co., 1977), 174, 221f.

6. The documentation center CENDOC-Mujer has edited a monthly newsletter, *Presencias*, listing these articles. However, as of March 1992,

this publication was terminated. The center is now trying to establish a database on women's issues as they are appearing in the media.

7. Vargas, "The Women's Movement in Peru," 28.

8. In 1984 the first civic house where battered women can lodge a formal complaint was opened in Lima. See *VIVA* 4, no. 16 (September 1989): 36.

9. The best analysis of women in Villa El Salvador is Cecilia Blondet M., *Las mujeres y el poder: Una historia de Villa El Salvador* (Lima: Instituto de Estudios Peruanos, 1991). The book also contains helpful statistics. For example, there were four thousand self-help kitchens in and around Lima in 1990, and three thousand similar kitchens that were directly supported by the government (ibid., 120).

10. There are two kinds of *rondas*. The one represents armed self-help groups of peasants who unite in order to punish thieves or wife-beaters or protect villagers from guerilla attacks. They exercise a kind of local judicial authority. The second kind are *rondas* that have been forcibly armed by the government in order to support the army's antisubversive strategies, but they are seen by critics as intensifying the level of violence in the countryside. Recently some self-help *rondas* have voluntarily submitted themselves to protection by, and cooperation with, the military. Women are active in all groups, but only in very small numbers.

11. Ana María Portugal, "Bertha Gonzales: Tenaz labor por las mujeres," *VIVA* 4, no. 16 (September 1989): 11–13.

12. Base communities are often hard to distinguish from Bible study groups or other lay groups within a parish (*parroquia*). The Brazilian theologian Ivone Gebara is even contending that so-called base communities exist mainly in the minds of Western intellectuals. She prefers to speak of the church of the poor. See Ivone Gebara, "Basisgemeinden-Modell ohne Zukunft," *Junge Kirche* 54 (June/July 1993): 360–62; trans. from *Sem Fronteiras* (September 1992),

13. Vargas, "The Women's Movement," 17.

14. This remark and the following comments are to be found in the minutes of the meeting, kept by members of CALANDRIA, a nongovernmental organization concerned with social communication (Address: Morales Alpaca 193 [Pueblo Libre], Lima, Peru).

*Chapter 6: The Churches' Role in Women's*
*Confrontation with Violence*

1. As an introduction to Latin American liberation theology, see, for example, Phillip Berryman, *Liberation Theology: The Essential Facts about the Revolutionary Movement in Latin America and Beyond* (New York: Pantheon Books, 1978), and the first basic text: Gustavo Gutiérrez, *A*

*Theology of Liberation: History, Politics, and Salvation* (Maryknoll, N.Y.: Orbis Books, 1973; first published in Spanish, 1971). See also Robert McAfee Brown, *Liberation Theology: An Introductory Guide* (Louisville: Westminster/John Knox, 1993).

2. See *La República*, September 14 and October 21, 1992. Also Gustavo Gutiérrez spoke publicly against the death penalty.

3. Ibid., October 18, 1992.

4. The institute published, for example, the book by Carmen Lora, Cecilia Barnachea, and Fryné Santisteban, *Mujer, víctima de opresión, portadora de liberación* (Lima: Instituto Bartolomé de las Casas, 1987), and the essay by Consuelo de Prado, "I Sense God in Another Way," reprinted in *Through Her Eyes: Women's Theology from Latin America*, ed. Elsa Tamez (Maryknoll, N.Y.: Orbis Books, 1989), 140–49. Carmen Lora also published "Nuevos sujetos: Mujeres y política," *Páginas* 108 (April 1991): 38–48. In addition the issue contains articles by other women on poverty in today's Peru. *Páginas* 117 (September 1992) contains an article by Consuelo de Prado y Amparo Huamán, "La mujer en la comunidad eclesial," and one by Catalina Romero on "Democracia en América Latina." Romero is in charge of research for the institute and was formerly its director. The publication *Signos*, which like *Páginas* is sponsored by the institute, frequently publishes articles by and about women. See also the volume *La nueva evangelización: Reflexiones, experiencias y testimonios desde el Perú* (Lima: Instituto Bartolomé de Las Casas, 1992).

5. According to one Amnesty International statistic (July 1992), Sendero in the year 1991 killed 1,314 people and the MRTA 139, while in the same time span 300 disappeared and 60 were illegally executed. See *El Comercio*, July 10, 1992. On January 9, 1993, 500 MRTA troops occupied the city of Moyobomba for five hours and attacked police stations with machine-guns, grenades, and rockets. See the February 3, 1993, newsletter of the Peru Peace Network, P.O. Box 1433, Jefferson City, MO 65102. About MRTA violence see also Jo-Marie Burt and Aldo Panfichi, *Peru: Caught in the Crossfire* (Jefferson City, Mo.: Peru Peace Network/USA, 1992), 26.

6. I have explained this aspect of church history more thoroughly in my article "Peacemaker Woman? Theological Perspectives on Women, War, and Peace," *Reformed World* 41 (June 1990): 41–56. Only as I was completing the research on this book I became aware of Nancy Jay's study, *Throughout Your Generations Forever: Sacrifice, Religion, and Paternity* (Chicago: University of Chicago Press, 1992). It is to my knowledge the first thorough examination of the gendered aspects of sacrifice, not only in so-called primitive religions, but also in contemporary Christianity.

7. The Maryknoll order, for example, is doing outstanding work in Peru.

## Chapter 7: The God of the Sun or the Son of God?
## Women Witnessing Religious Violence

1. Lamin Sanneh in *Translating the Message: The Missionary Impact on Culture* (Maryknoll, N.Y.: Orbis Books, 1989) has pointed to the necessary "translation" of the faith into the culture of a mission country as part of the essence of Christianity. Some early missionaries to the Andes were pioneers, for example, in learning Quechua and translating missionary texts into Quechua.

2. Tzvetan Todorov, *The Conquest of America: The Question of the Other* (New York: Harper & Row, 1984), gives a good picture of the invaders' inability to regard the "Other" as valuable. See also Frauke Gewecke, *Wie die neue Welt in die alte kam* (Stuttgart: Klett-Cotta, 1986), 273–92.

3. Irene Silverblatt, *Moon, Sun, and Witches: Gender Ideologies and Class in Inca and Colonial Peru* (Princeton, N.J.: Princeton University Press, 1987). Silverblatt seems to assume that the Incas consciously masked their actual power play, but the matter might be more complex. When, for example, in 1993 a maid (*muchacha*) in Lima is patronizingly called a "daughter of the house" even though she is being exploited, the attitude might be naively honest and simply narrow-minded, because it is grounded in centuries of state and church ideology concerning the servant role of women or popular assumptions about the "laziness" of another race. It is not always a deliberate strategy. (See Grace Esther Young, "The Myth of Being 'Like a Daughter,'" *Latin American Perspectives* 54, vol. 14, no. 3 (Summer 1987): 365–80. Silverblatt's stance is, however, justified in terms of early colonial history writing, which considered the Incas' claim of divine descent a political ruse; but these colonial observers did not realize or admit how much the church as well exploited religion for political purposes. See Sabine MacCormack, *Religion in the Andes: Vision and Imagination in Early Colonial Peru* (Princeton, N.J.: Princeton University Press, 1991), 399 and 402.

4. Silverblatt, *Moon, Sun, and Witches*, 44–47.

5. Ibid., 81–101. When a father gave up his daughter to be sacrificed by the Inca, he was sometimes rewarded with a political office! (ibid., 95). See also María Rostworowski, "La mujer en la época prehispánica," *Documento de Trabajo* no. 17, 3rd ed. (Lima: Instituto de Estudios Peruanos, 1988), 10. Besides young women, children between four and twelve years, "beautiful and without any flaws," were sacrificed in pairs, boys and girls, by being buried alive. They may have received a drink beforehand that put them to sleep. Their places of burial became sacred grounds. See also MacCormack, *Religion in the Andes*, 104.

6. Rostworowski, "La mujer," 12f., and by the same author, "La aguerrida Mama Huaco," *Mujer y Sociedad* 6, no. 11 (July 1986): 22–24.

7. The Quechua word for "kinship group" (*ayllu*) is hard to translate because it also designates the land on which the group lives, and it

can indicate a political or genealogical unit (Silverblatt, *Moon, Sun, and Witches*, 217–25).

8. Ingrid Bettin, *Seele aus Stein und Taube: Begegnung mit Peru* (Wuppertal: Peter Hammer Verlag, 1989), 167.

9. In a lecture at Duke University, March 6, 1992, Silverblatt stated that according to Spanish law the testimony of one Spaniard was equal to that of two Indian men or three Indian women.

10. These circumstances are documented, e.g., by Felipe Guamán Poma de Ayala, who had a Spanish father and an Andean mother. He wrote his *Nueva corónica y buen gobierno* (1615) specifically for King Philip III of Spain. His combination of text and vivid drawings makes this work one of the most important sources about colonial Peru. An interpretation of his work is Rolena Adorno, *Guamán Poma: Writing and Resistance in Colonial Peru* (Austin: University of Texas Press, 1986).

11. Fernando Mires, *En nombre de la cruz* (San José: Costa Rica: DEI, 1989), 18f., as quoted in the excellent article by Ofelia Ortega, "Latin American Women: A History of Rebellion," *Echoes* (World Council of Churches) 1 (1992): 18.

12. Silverblatt, *Moon, Sun, and Witches*, 134–47, and figures 8 and 10; Adorno, *Guamán Poma*, figures 17 and 18.

13. See George E. Tinker, "Native Americans and the Land: 'The End of Living and the Beginning of Survival,'" in *Lift Every Voice: Constructing Christian Theologies from the Underside*, ed. Susan Brooks Thistlethwaite and Mary Potter Engle (New York: Harper & Row, 1990), 141–51.

14. Silverblatt, *Moon, Sun, and Witches*, 160–96.

15. See MacCormack, *Religion in the Andes*, 36–39.

16. See María Emma Mannarelli, *Inquisición y mujeres: Las hechiceras en el Perú durante el siglo XVII* (Lima: CENDOC-Mujer, 1987): 7, 12.

17. Ibid., 13.

18. Rosemary Radford Ruether, *Sexism and God-Talk: Toward a Feminist Theology* (Boston: Beacon Press, 1983), 171.

19. Michael Taussig, *Shamanism, Colonialism, and the Wild Man: A Study in Terror and Healing* (Chicago: University of Chicago Press, 1987), 317.

20. See the picture by Stradanus, representing Amerigo Vespucci arriving on the shores of America, carrying a banner with a cross in one hand and an astronomical instrument in the other, greeting a well-rounded naked woman rising from a hammock. The picture has been interpreted in Susan R. Dixon, "Points of View: The Art of Encounter," in *View from the Shore: American Indian Perspectives on the Quincentenary, Northeast Indian Quarterly* (Fall 1990): 88f. A theological interpretation can be found in Ana María Bidegain, "Women and the Theology of Liberation," in *Through Her Eyes: Women's Theology from Latin America* (Maryknoll, N.Y.: Orbis Books 1989), 15–18.

21. José Luis González Martínez, ed., *La religión popular en el Perú* (Cusco: Instituto de Pastoral Andina, 1984), 93, 113f.

22. See Christel Voss-Goldstein and Horst Goldstein, *Schwestern über Kontinente. Aufbruch der Frauen: Theologie der Befreiung in Lateinamerika und feministische Theologie hierzulande* (Düsseldorf: Patmos, 1991), 68, 97.

23. See David Stoll, *Is Latin America Turning Protestant? The Politics of Evangelical Growth* (Berkeley: University of California Press, 1990), 13 and 318f.

24. Silverblatt's lecture mentioned in note 9 described the shaping of "Indian" identity by the Spaniards and the resulting Andean nativist movement, which appeared anti-Spanish while actually merging Andean and Spanish ways. See also MacCormack, *Religion in the Andes*, 181f.

## Chapter 8: Women's Local Witness and Global Theology

1. Judith Herrin, *The Formation of Christendom* (Princeton, N.J.: Princeton University Press, 1987), 12f.; the first sentence of the paragraph is a quote from Edmund Bishop.

2. Engelbert Mveng, "A Cultural Perspective," in *Doing Theology in a Divided World*, ed. Virginia Fabella and Sergio Torres (Maryknoll, N.Y.: Orbis Books, 1985), 74.

3. Herrin, *Formation of Christendom*, 309. A German article shows that even in the area of religious literary art a Roman woman of late antiquity merged "pagan" and Christian traditions. See Anne Jensen, "Faltonia Betitia Proba: Eine Kirchenlehrerin der Spätantike," in *Mit allen Sinnen glauben: Feministische Theologie unterwegs*, ed. Herlinde Pissarek-Hudelist and Luise Schottroff (Gütersloh: Gerd Mohn, 1991), 84–94.

4. Herlinde Pissarek-Hudelist, "Eine 'Schwester im Glauben,' " in *Mit allen Sinnen glauben*, 24.

5. Carol Gilligan, *In a Different Voice: Psychological Theory and Women's Development* (Cambridge, Mass.: Harvard University Press, 1982). Gilligan unfortunately has not dealt in this book with women of color. The debate about gender identity or differentiation is still in flux. See, e.g., Susan Bordo, "Feminism, Postmodernism, and Gender Scepticism," in *Feminism/Postmodernism*, ed. Linda J. Nicholson (New York: Routledge, 1990). A German contribution discusses the discursive construction of female identity through a model of female "martyrdom" or sacrifice: Hilge Landweer, *Das Märtyrerinnenmodell: Zur diskursiven Erzeugung weiblicher Identität* (Pfaffenweiler: Centaurus, 1990). I want to stress that I see the remaining psychological differences between the genders as produced by an unjust socialization; but we have to take advantage of the present-day situation and use it for a good purpose. Concerning the possibility of a biologically based difference, see my note 6 on p. 211.

6. Joni Seager and Ann Olson, *Women in the World: An International Atlas* (New York: Simon & Schuster, 1986), 27, and Robin Kirk, *The*

*Decade of Chaqwa: Peru's Internal Refugees* (Washington, D.C.: U.S. Committee for Refugees, 1991), 20f., 34.

7. See an edited form of her address and six responses to it in *Christianity and Crisis* 51, nos. 10/11 (July 15, 1991): 220–32.

8. Elsa Tamez, "Quetzalcóatl y el dios cristiano: Alianza y lucha de Dioses," *Vida y Pensamiento* (San José, Costa Rica) 11, no. 1 (1991), 31–54.

9. We know, of course, very little of these cultures, and there is always the danger of romanticizing the distant past. However, Bartolomé de las Casas also assumed that human sacrifice was introduced by the Incas, not earlier. See Sabine MacCormack, *Religion in the Andes: Vision and Imagination in Early Colonial Peru* (Princeton, N.J.: Princeton University Press, 1991), 223.

10. Ibid., 23, and Elsa Tamez, "Introduction: The Power of the Naked," in *Through Her Eyes: Women's Theology from Latin America*, ed. Elsa Tamez (Maryknoll, N.Y.: Orbis Books, 1989), 8–11.

11. Similar contributions are being made by Asians and Africans. My mentioning side by side Judaism, "paganism," and other religions does not imply that they are all in a similar relationship to Christianity; Christianity relates to Judaism in a completely different way.

12. W. Dow Edgerton, *The Passion of Interpretation* (Louisville: Westminster/John Knox, 1992), 92.

13. José María Arguedas, *Poesía Quechua* (Buenos Aires: Editorial Universitaria de Buenos Aires, 1966), 11, 14.

14. I have dealt with these issues in detail in my article "Peacemaker Woman? Theological Perspectives on Women, War, and Peace," *Reformed World* 41 (June 1990): 41–56.

15. McCormack, *Religion in the Andes*, 7.

16. Silverblatt, *Moon, Sun, and Witches*, 156f., 173.

17. James Madden, M.M., "Dancing in God's Presence," *Maryknoll: Magazine of the Catholic Foreign Mission Society* 85, no. 10 (October 1991): 18.

18. Christel Voss-Goldstein and Horst Goldstein, *Schwestern über Kontinente: Theologie der Befreiung in Lateinamerika und feministische Theologie hierzulande* (Düsseldorf: Patmos, 1991), 100.

19. MacCormack, *Religion in the Andes*, 13.

20. Ibid., 275.

21. The expression was first used by Diana Pearce of the Catholic University of America. See Pamela D. Couture, *Blessed Are the Poor? Women's Poverty, Family Policy, and Practical Theology* (Nashville: Abingdon, 1991), 38.

22. Clarke Campbell-Evans drew this comparison in a presentation at Duke University, October 15, 1991.

23. The work of Peruvian middle-class feminists with women of the settlements around Lima has been described in detail by a Danish woman, Christina Hee Pedersen, in her book *Nunca antes me habían*

*enseñado eso: Capacitación feminista: Metodología/comunicación/impacto* (Lima: Lilith Ediciones, 1988). It is a sensitive exploration of the mutual prejudices in working together between social classes and the possibilities of bridging the gap patiently and creatively.

24. See Frederick Herzog, *God-Walk: Liberation Shaping Dogmatics* (Maryknoll, N.Y.: Orbis Books, 1988), xi–xiv et passim.

25. Voss-Goldstein and Goldstein, *Schwestern über Kontinente,* 71.

26. Johann Baptist Metz, "Standing at the End of the Eurocentric Era of Christianity: A Catholic View," in *Doing Theology in a Divided World,* ed. Virginia Fabella and Sergio Torres (Maryknoll, N.Y.: Orbis Books, 1985), 86.

## Part Three:
## Women's Voices from the Third World:
## Literary and Theological Debates

*Chapter 9: Fiction, Faith, and Truth*
*in Latin American Women's Testimonies*

1. Paula Cooey, "The Redemption of the Body: Post-Patriarchal Reconstruction of Inherited Christian Doctrine," in *After Patriarchy: Feminist Transformations of the World Religions,* ed. Paula Cooey, William R. Eakin, and Jay B. McDaniel (Maryknoll, N.Y.: Orbis Books, 1991), 111.

2. Gayatri Spivak, *The Post-Colonial Critic: Interviews Strategies, Dialogues,* ed. Sarah Harasym (New York: Routledge, 1990), 70. On pp. 141f. of the same work Spivak defines what she means by the term "subaltern."

3. Ibid., 158.

4. Daphne Patai, "Who's Calling Whom 'Subaltern'?" *Women and Language* 11, no. 2 (Winter 1988): 23–26.

5. John Beverley, "Introducción," *Revista de Crítica Literaria Latinoamericana* 18, no. 36 (second semester 1992): 8.

6. Elisabeth Burgos-Debray, ed., *I... Rigoberta Menchú: An Indian Woman in Guatemala* (London: Verso Editions, 1984), and Domitila Barrios de Chungara with Moema Viezzer, *Let me Speak: Testimony of Domitila, a Woman of the Bolivian Mines* (New York: Monthly Review Press, 1987; first published in Spanish in 1977).

7. Jean Franco, "Si me permiten hablar: La lucha por el poder interpretativo," *Revista de Crítica Literaria Latinoamericana* 18, no. 36 (second semester 1992): 110f.

8. Ibid., 114.

9. See, for example, an essay by Ariel Dorfman on the relationship of political repression and the outpouring of *testimonios:* "Código político

y código literario: El género testimonio en Chile hoy," in *Testimonio y Literatura*, ed. René Jara and Hernán Vidal (Minneapolis: Prisma Books, 1986), 170f.

10. Ibid., 114.

11. Beverley, "Introducción," 15, and Paul Ricoeur, "The Hermeneutics of Testimony," in Paul Ricoeur, *Essays on Biblical Interpretation*, ed. Lewis S. Mudge (Philadelphia: Fortress Press, 1980), 127.

12. Walter Mignolo, "Literacy and Colonization: The New World Experience," in *1492–1992: Re/Discovering Colonial Writing*, ed. René Jara and Nicholas Spadaccini (Minneapolis: Prisma Institute, 1989), 67, translated by and quoted from Beverley, "Introducción," 12.

13. Beverley, "Introducción," 15.

14. Mario Vargas Llosa, *The Real Life of Alejandro Mayta* (New York: Vintage, 1986), 246, quoted from Nancy Scheper-Hughes, *Death without Weeping: The Violence of Everyday Life in Brazil* (Berkeley: University of California Press, 1992), 229.

15. Michael Taussig, *The Nervous System* (New York: Routledge, 1992), 26f.

16. Laura P. Rice-Sayre, "Witnessing History: Diplomacy versus Testimony," in *Testimonio y Literatura*, ed. René Jara and Hernán Vidal (Minneapolis: Prisma Books, 1986), 68.

17. Nancy Saporta Sternbach, "Re-Membering the Dead: Latin American Women's 'Testimonial' Discourse," *Latin American Perspectives* 18, no. 3 (Summer 1991): 94.

18. Julia Esquivel, *Threatened with Resurrection: Prayers and Poems from an Exiled Guatemalan* (Elgin, Ill.: Brethren Press, 1982).

19. Taussig, *The Nervous System*, 48.

20. Cooey, "The Redemption of the Body," 112–30.

21. Ibid., 115.

22. Scheper-Hughes, *Death without Weeping*, 231.

23. Cooey, Eakin, and McDaniel, eds., *After Patriarchy*, 120.

24. Elaine Scarry, *The Body in Pain: The Making and Unmaking of the World* (New York: Oxford University Press, 1985), 324.

## Chapter 10: A Postmodern Witness of War?

1. On the traditional "just war" theory and a contemporary critique of it, see John Howard Yoder, *When War Is Unjust: Being Honest in Just War Thinking* (Minneapolis: Augsburg, 1984).

2. Jean Bethke Elshtain, *Women and War* (New York: Basic Books, 1987), 261.

3. Ibid., 252.

4. Barbara Freeman "Epitaphs and Epigraphs: 'The End(s) of Man,' " in *Arms and the Woman: War, Gender, and Literary Representation*, ed.

Helen M. Cooper, Adrienne Ausländer Munich, and Susan Merrill Squier (Chapel Hill: University of North Carolina Press, 1989), 313.

5. George Yúdice, "Testimonio and Postmodernism," in *Latin American Perspectives* 18, no. 3 (Summer 1991): 16. (Yúdice is here quoting Fredric Jameson's introduction to Jean François Lyotard, ed., *The Postmodern Condition: A Report on Knowledge* [Minneapolis: University of Minnesota Press, 1984]).

6. Ibid., 17f.

7. Ibid., 23–25.

8. Ibid., 28f.

9. Michel Foucault, *Power/Knowledge: Selected Interviews and Other Writings 1972–1977* (New York: Pantheon Books, 1980), 90f.

10. Jean Franco, *Plotting Women: Gender and Representation in Mexico* (New York: Columbia University Press, 1989), 23–54.

11. Nancy Fraser, *Unruly Practices: Power, Discourse, and Gender in Contemporary Social Theory* (Minneapolis: University of Minnesota Press, 1989), 2.

12. Foucault, *Power/Knowledge*, 142.

13. Fraser, *Unruly Practices*, 29.

14. Ibid., 33.

15. Ibid., 181.

16. Ibid., 183.

17. See Miriam Cooke, "WO-man, Retelling the War Myth," in Miriam Cooke and Angela Woollacott, eds., *Gendering War Talk* (Princeton, N.J.: Princeton University Press, 1993), 177–204.

18. David Ray Griffin, *Sacred Interconnections: Postmodern Spirituality, Political Economy, and Art* (Albany: State University of New York Press, 1990), xi.

*Chapter 11: The Biblical Witness for Peace and Women's Stories of War*

1. See Maura O'Neill, *Women Speaking, Women Listening: Women in Interreligious Dialogue* (Maryknoll, N.Y.: Orbis Books, 1990), 17.

2. Susan Thistlethwaite, *Sex, Race, and God: Christian Feminism in Black and White* (New York: Crossroad, 1989), 132f. Thistlethwaite mentions the frequent misunderstanding of nonviolence as something passive and quotes Catherine Reid as saying that Gandhi's *satyagraha* (truth force) is more adequate (132).

3. See Susan Thistlethwaite, ed., *A Just Peace Church* (New York: United Church Press, 1986), and Glen H. Stassen, *Just Peacemaking: Transforming Initiatives for Justice and Peace* (Louisville: Westminster/ John Knox, 1992).

4. Leonard Grob, "Pursuing Peace: Shalom in the Jewish Tradition," in *Education for Peace: Testimonies from World Religions*, ed. Haim Gordon and Leonard Grob (Maryknoll, N.Y.: Orbis Books, 1987), 32.

5. See above p. 150f.

6. James W. Douglass, *The Nonviolent Coming of God* (Maryknoll, N.Y.: Orbis Books, 1991), 12.

7. Ibid., 15.

8. Jean Bethke Elshtain, "The Problem with Peace," in *Women, Militarism & War: Essays in History, Politics, and Social Theory*, ed. Jean Bethke Elshtain, and Sheila Tobias (Savage, Md.: Rowman & Littlefield, 1990), 257.

9. I have discussed the "genderizing" of Jesus' commands more thoroughly in terms of exegesis and church history in "Peacemaker Woman?"

10. Roger N. Lancaster, *Life Is Hard: Machismo, Danger, and the Intimacy of Power in Nicaragua* (Berkeley: University of California Press, 1992). Lancaster thinks that Nicaraguan men try to prove their masculinity by spouse beating and by sexual activity with various women as well as with physically passive homosexuals (ibid., 235–78).

11. Paul L. Hammer, *The Gift of Shalom* (Philadelphia: United Church Press, 1976), 11.

12. See the articles in Virginia Ramey Mollenkott, ed., *Women of Faith in Dialogue* (New York: Crossroad, 1988).

13. Timothy George, "A Radically Christian Witness for Peace," in *Education for Peace: Testimonies from World Religions*, ed. Haim Gordon and Leonard Grob (Maryknoll, N.Y.: Orbis Books, 1987), 65.

14. See Don Cupitt, *What Is a Story?* (London: SCM Press, 1991). See also Robert McAfee Brown, *Persuade Us to Rejoice: The Liberating Power of Fiction* (Louisville: Westminster/John Knox, 1992).

15. Nancy Huston, "Tales of War and Tears of Women," *Women's Studies International Forum* 5, nos. 3/4 (1982), reprinted in Judith Stiehm, ed., *Women and Men's Wars* (New York: Pergamon Press, 1983), 271.

16. Paul Fussell, *The Great War and Modern Memory* (New York: Oxford University Press, 1975), ix.

17. Huston, "Tales of War and Tears of Women," 272.

18. Ibid., 273.

19. Mimi Alperin, "The Feminization of Poverty," in *Women of Faith in Dialogue,* ed. Virginia Ramey Mollenkott, 172.

20. Adrienne Harris has formulated these ideas with respect to a different understanding of *écriture feminine* in her excellent article "Bringing Artemis to Life: A Plea for Militance and Aggression in Feminist Peace Politics," in *Rocking the Ship of State: Toward a Feminist Peace Politics*, ed. Adrienne Harris and Ynestra King (Boulder: Westview Press, 1989), 93–113.

21. Ed Griffin-Nolan, *Witness for Peace: A Story of Resistance* (Louisville: Westminster/John Knox, 1991).

22. Ibid., 10.

23. Ibid., 226.

24. Jim Wallis, "The Challenge of Nonviolence," *Sojourners* 22, no. 3 (April 1993), 4f.

25. The Peru Peace Network, among other groups, is doing an excellent job of monitoring U.S. policy toward Peru and in general publicizing current events in the country. Address: Peru Peace Network-USA, P.O. Box 1433, Jefferson City, MO 65102.

26. Personal conversation with Liselotte Schrader at the Children's Village, September 27, 1992.

27. The article is an abbreviated reprint of an essay in the Peruvian publication *área chica*. Terre des Hommes can be reached at Ruppenkampstrasse 11a, 45 Osnabrück, Germany.

28. Paul Ricoeur, "The Hermeneutics of Testimony," in Paul Ricoeur, *Essays on Biblical Interpretation*, ed. Lewis S. Mudge (Philadelphia: Fortress Press, 1980), 139. Ricoeur also points out the difference between the term "testimony" in the Gospel of Luke, pointing to things seen and heard, and in the Gospel of John, emphasizing a manifestation of Christ and a confession of the truth witnessed (136–39).

## Conclusion

1. See Ernest W. Ranly, "Letter from Peru: Shaky Reforms," *Christian Century* 110, no. 7 (March 3, 1993): 229. Ranly quotes Gustavo Gorriti as saying Sendero has been set back to where it was in 1986.

2. Ibid., 231.

3. Oscar Aliaga-Abanto, "Peru: Poverty and Violence in a Critical Context," report on a conference of the Peru Peace Network/USA, St. Louis, Missouri, January 1992, 6.

4. Ibid., 13.

5. Ibid., 12. See also Jo Marie Burt and Aldo Panfichi, *Peru: Caught in the Crossfire* (Jefferson City, Mo.: Peru Peace Network, 1992), 30.

6. A woman named "Jacoba S." is quoted in this way by Erika Straubinger, *Zwischen Unterdrückung und Befreiung: Zur Situation der Frauen in Gesellschaft und Kirche Perus. Geschichtlicher Rückblick und Gegenwartsanalyse* (Frankfurt am Main: Peter Lang, 1992), 277.

7. Mark 1:23–28; 5:2–13; 9:20–29. Rosanna Panizo called my attention to this aspect of "naming."

8. Nancy Jay, *Throughout Your Generations Forever: Sacrifice, Religion, and Paternity* (Chicago: University of Chicago Press, 1992), 150.

9. On Peruvian women in general and their historical and contemporary life from a Christian (Roman Catholic) perspective, see the very comprehensive work in German by Erika Straubinger, cited in note 6. The book provides a wealth of information, and the second volume also contains valuable statistics on Peruvian women. On literature by women the work of the feminist centers is the best source of information at this time. See, e.g., the short story contest mentioned above on p. 37.

On poetry by women see the book edited by Roland Forgues, *Palabra viva*, vol. 4: *Las poetas se desnudan* (Lima: Editorial El Quijote, 1991).

10. Sara Castro-Klarén, introduction to *Women's Writing in Latin America: An Anthology*, ed. Sara Castro-Klarén, Silvia Molloy, and Beatriz Sarlo (Boulder: Westview Press, 1991), 19.

11. Ibid., 22.

12. There are, of course, individual poems that I have not mentioned because I had no intention of being comprehensive, but simply wanted to offer examples. A socially engaged poet is, for example, Carolina Ocampo, whose poems "La paloma de la paz está en guerra" and "Corriendo para alcanzar el tren" deal with the violence of life in Peru. See Forgues, *Palabra viva*, 272.

13. I am thinking, for example, of Carmen Ollé's poetry in her *Noches de Adrenalina* and of her "poetic novel," *¿Por qué hacen tanto ruido?* (Lima: Ediciones Flora Tristán, 1992); and of Giovanna Pollarolo's poetry mentioned above in note 60 on p. 208.

14. See above p. 121. As I am concluding my manuscript, I realize that a recent book will be helpful for future research about the impact of Latin American women on theology: María Pilar Aquino, *Nuestro clamor por la vida: Teología latino-americana desde la perspectiva de la mujer* (San José, Costa Rica: Editorial DEI, 1992).

15. See the interviews with twenty-one women poets in Forgues, *Palabra viva*. Remarks on religious beliefs are to be found, e.g., on pp. 87, 98, 127, 135, 190, 219, 275, 292.

16. Robert McAfee Brown, *Religion and Violence*, 2nd ed. (Philadelphia: Westminster Press, 1987), 37.

17. Eduardo Galeano, *The Open Veins of Latin America: Five Centuries of the Pillage of a Continent* (New York: Monthly Review Press, 1973), 227 and 301. While Galeano's statements go back to the early 1970s when the fishmeal trade was much stronger, the situation is basically still the same.

18. Brown, *Religion and Violence*, 38.

19. Degregori made these remarks in a lecture at Duke University, November 19, 1992.

20. See Burt and Panfichi, eds., *Peru: Caught in the Crossfire*, 30f.

21. See, e.g., Susan Niditch, *War in the Hebrew Bible: A Study in the Ethics of Violence* (New York: Oxford University Press, 1993), a work that points to the seeds of an "ideology of nonparticipation" in war (e.g., in 2 Chronicles 20) and thereby to "a late biblical tradition groping toward peace" (149). "Biblical" is here referring to the Hebrew Bible. See also Perry B. Yoder and Willard M. Swartley, eds., *The Meaning of Peace: Biblical Studies* (Louisville: Westminster/John Knox, 1992) and Ulrich Mauser, *The Gospel of Peace: A Scriptural Message* (Louisville: Westminster/John Knox, 1992). As my book goes to press, I am reading the page proofs of Lisa Sowle Cahill, *Love Your Enemies* (courtesy of

Augsburg Fortress Publishers), a thorough historical and biblical study. I agree with Cahill's distinction between just-war proponents as emphasizing rules and theory and pacifists as being tied to a living of community.

22. Rebecca S. Chopp, *The Power to Speak: Feminism, Language, God* (New York: Crossroad, 1989), 61. Chopp is here reflecting on Paul Ricoeur, "The Hermeneutics of Testimony," in Paul Ricoeur, *Essays on Biblical Interpretation,* ed. Lewis S. Mudge (Philadelphia: Fortress Press, 1980), 119–54.

23. Elisabeth Schüssler Fiorenza, *In Memory of Her: A Feminist Theological Reconstruction of Christian Origins* (New York: Crossroad, 1983), 52f.

24. Lourdes Arizpe has described this phenomenon relative to Mexico in her article "Peasant Women and Silence," in *Women's Writing in Latin America: An Anthology,* ed. Sara Castro-Klarén, Sylvia Molloy, and Beatriz Sarlo (Boulder: Westview Press, 1991), 333–38. I realize that female silence can also be a form of resistance or a "cultural self-defense mechanism." See "Indigenous Women and Community Resistance: History and Memory," in *Women and Social Change in Latin America,* ed. Elizabeth Jelin (London: Zed Books, 1990), 178.

25. Christel Voss-Goldstein and Horst Goldstein, eds., *Schwestern über Kontinente. Aufbruch der Frauen: Theologie der Befreiung in Lateinamerika und feministische Theologie hierzulande* (Düsseldorf: Patmos, 1991), 49f.

26. The problem has been well defined by Linda Alcoff in her article "The Problem of Speaking for Others," *Cultural Critique* 20 (Winter 1991/92): 5–32.

27. Frederick Herzog has written about the need for "mutualization" instead of the often superficial "globalization," and he has worked out a long-term project of mutual research and support between Duke Divinity School and the Comunidad Bíblico Teológica in Lima. The project includes cooperation between the Methodist churches in North Carolina and Peru. See Frederick Herzog, "Tradición Común Shaping Christian Theology: Mutualization in Theological Education," Report to the Association of Theological Schools, 1993.

28. Quoted in Castro-Klarén, introduction to *Women's Writing in Latin America,* 22.

29. Title of a book of poetry by the Guatemalan poet Julia Esquivel: *Threatened with Resurrection: Prayers and Poems from an Exiled Guatemalan* (Elgin, Ill.: Brethren Press, 1982).

30. See the title of a volume of poetry by Rosina Valcárcel, *Una mujer canta en medio del caos* (Lima: Colección Amarilis, 1991).

# BIBLIOGRAPHY

(*Most newspaper articles are listed only in the Notes.*)

Adorno, Rolena. *From Oral to Written Expression: Native Andean Chronicles of the Early Colonial Period.* Syracuse, N.Y.: Maxwell School of Citizenship and Public Affairs, Syracuse University, 1982.
————. *Guamán Poma: Writing and Resistance in Colonial Peru.* Austin: University of Texas Press, 1986.
Alcoff, Linda. "The Problem of Speaking for Others." *Cultural Critique* 20 (Winter 1991/92): 5–32.
Alfaro, Rosa María. "Comunicar entre violencias: Una estrategia de paz." In *Mujeres, violencia, y derechos humanos,* edited by Narda Henríquez and Rosa María Alfaro, 45–72. Lima: Abraxas Editorial, 1991.
Aliaga-Abanto, Oscar. "Peru: Poverty and Violence in a Critical Context." Report of a conference of the Peru Peace Network/USA. St. Louis, January 1992.
Alperin, Mimi. "The Feminization of Poverty." In *Women of Faith in Dialogue,* edited by Virginia Ramey Mollenkott, 170–76. New York: Crossroad, 1988.
Andreas, Carol. "Women at War." *NACLA Report on the Americas* 24, no. 4 (December/January 1990/91): 23–27.
Andreas, Peter R. "Dead-End Drug Wars." *Foreign Policy* (Winter 1991–1992): 106–28.
Arendt, Hannah. *On Violence.* New York: Harcourt Brace, 1970.
Arguedas, José María. *Poesía Quechua.* Buenos Aires: Editorial Universitaria de Buenos Aires, 1966.
Arizpe, Lourdes. "Peasant Women and Silence." In *Women's Writing in Latin America,* edited by Sara Castro-Klarén, Sylvia Molloy, and Beatriz Sarlo, 333–38. Boulder: Westview Press, 1991.
Balbi, Mariella. "Machismo vs. Mechismo." *VIVA* 18 (June 1990): 6–8.
————. "Gloria Helfer: Asumó el poder como un servicio." *VIVA* 19 (December 1990): 10–13.
Balta, Aída. *Sodoma, Santos y Gomorra.* Lima: Editorial El Quijote, 1986.
————. *El legado de Caín.* Lima: Editorial El Quijote, 1987.

Bastian, Jean Pierre. *Breve historia del Protestantismo en América Latina.* Mexico City: Casa Unida de Publicaciones, 1986.

Berryman, Phillip. *Liberation Theology: The Essential Facts about the Revolutionary Movement in Latin America and Beyond.* New York: Pantheon Books, 1978.

Bettin, Ingrid. *Seele aus Stein und Taube: Begegnung mit Peru.* Wuppertal: Peter Hammer, 1989.

Beverley, John. "Introducción." *Revista de Crítica Literaria Latinoamericana* 18, no. 36 (second semester 1992): 7–18.

Bidegain, Ana María. "Women and the Theology of Liberation." In *Through Her Eyes: Women's Theology from Latin America,* edited by Elsa Tamez, 15–36. Maryknoll, N.Y.: Orbis Books, 1989.

————. "Mujer y poder en la iglesia." In *La mujer en el imaginario mítico-religioso de las sociedades indias y mestizas,* edited by Milagros Palma, 97–120. Quito: Ediciones Abya-Yala, 1990.

Blondet M., Cecilia. *Las mujeres y el poder: Una historia de Villa El Salvador.* Lima: Instituto de Estudios Peruanos, 1991.

Bordo, Susan. "Feminism, Postmodernism, and Gender Scepticism." In *Feminism/Postmodernism,* edited by Linda J. Nicholson, 133–56. New York: Routledge, 1990.

Brown, Joseph Epes. *The Spiritual Legacy of the American Indian.* New York: Crossroad, 1987.

Brown, Robert McAfee. *Religion and Violence.* 2nd ed. Philadelphia: Westminster, 1987.

————. *Persuade Us to Rejoice: The Liberating Power of Fiction.* Louisville: Westminster/John Knox, 1992.

————. *Liberation Theology: An Introductory Guide.* Louisville: Westminster/John Knox, 1993.

Brownmiller, Susan. *Against Our Will: Men, Women, and Rape.* New York: Simon & Schuster, 1975.

Burt, Jo Marie, and Aldo Panfichi. *Peru: Caught in the Crossfire.* Jefferson City, Mo.: Peru Peace Network/USA, 1992.

Bustamante, Cecilia. "La escritora y la sociedad." Paper presented at the University of Ottawa on May 21, 1978. Available from CENDOC-Mujer, La Mar 170, Lima 18, Peru.

————. Interview by Roland Forgues. In *Palabra viva,* vol. 4: *Las poetas se desnudan,* edited by Roland Forgues, 105–17. Lima: Editorial El Quijote, 1991.

Cady, Susan, Marian Ronan, and Hal Taussig, eds. *Wisdom's Feast: Sophia in Study and Celebration.* San Francisco: Harper & Row, 1989.

Cahill, Lisa Sowle. *Love Your Enemies: Discipleship, Pacifism, and Just War Theory.* Minneapolis: Augsburg-Fortress, 1993.

Carillo, Francisco. *Clorinda Matto de Turner y su indigenismo literario.* Lima: Ediciones de la Biblioteca Universitaria, 1967.

Carillo, Herrmann Haman. See Haman Carillo, Herrmann.

Carlessi, Carolina. *La culpa como factor desmovilizador de los grupos de mujeres*. Serie Cuadernos Feminismo no. 1. Lima: Lilith Ediciones, 1983.

———. "Pensando el hogar." *El Zorro de Abajo* 4 (March 1986): 33–35.

Carr, Anne, and Elisabeth Schüssler Fiorenza, eds. *Motherhood: Experience, Institution, Theology. Concilium* 206 (Special Column), 1989.

———, and Elisabeth Schüssler Fiorenza, eds. *The Special Nature of Women? Concilium*, December 1991.

Castro-Klarén, Sara. "Introduction" to *Women's Writing in Latin America: An Anthology*, edited by Sara Castro-Klarén, Sylvia Molloy, and Beatriz Sarlo, 3–26. Boulder: Westview Press, 1991.

Castro-Klarén, Sara, Sylvia Molloy, and Beatriz Sarlo, eds. *Women's Writing in Latin America: An Anthology*. Boulder: Westview Press, 1991.

CENDOC-Mujer. *Presencias* (monthly listing of articles on women's issues). Published 1990–1992. Available from CENDOC-Mujer, La Mar 170, Lima 18, Peru.

———. "El movimiento popular de mujeres como respuesta a la crisis." *Paquete informativo* no. 2. Lima, 1992 (see address above).

Chevigny, Bell Gale. "The Lives and Fictions of American Women." In *Reinventing the Americas: Comparative Studies of Literature of the United States and Spanish America*, edited by Bell Gale Chevigny and Gary Laguardia, 139–57. Cambridge: Cambridge University Press, 1986.

Chevigny, Bell Gale, and Gari Laguardia, eds. *Reinventing the Americas: Comparative Studies of Literature of the United States and Spanish America*. Cambridge: Cambridge University Press, 1986.

Chomsky, Noam. "'At This Time in History Nothing Is Independent': Interview with Noam Chomsky." *Latinamerica Press* (February 25, 1993): 4.

Chopp, Rebecca. *The Power to Speak: Feminism, Language, God*. New York: Crossroad, 1989.

Christ, Carol. *Diving Deep and Surfacing: Women Writers on Spiritual Quest*. Boston: Beacon, 1980.

*Colección documental del bicentenario de la revolución emancipadora de Tupac Amaru*. Vol. 2/1: *La rebelión de Tupac Amaru: Antecedentes*. Vol. 3/1 and vol. 4/2: *Los procesos a Tupac Amaru y sus compañeros*. Lima: Comisión nacional del Sesquicentenario de la Independencia del Perú, 1970 and 1981.

Cooey, Paula M., William R. Eakin, and Jay B. McDaniel, eds. *After Patriarchy: Feminist Transformations of the World Religions*. Maryknoll, N.Y.: Orbis Books, 1991.

Cooey, Paula. "The Redemption of the Body: Post-patriarchal Reconstruction of Inherited Christian Doctrine." In *After Patriarchy: Feminist Transformations of the World Religions*, edited by Paula Cooey, William R. Eakin, and Jay B. McDaniel, 106–130. Maryknoll, N.Y.: Orbis Books, 1991.

Cooke, Miriam, and Angela Woollacott, eds., *Gendering War Talk*. Princeton, N.J.: Princeton University Press, 1993.

Cooper, Helen M., Adrienne A. Munich, and Susan M. Squier, eds. *Arms and the Woman: Gender and Literary Representation*. Chapel Hill: University of North Carolina Press, 1989.

Coronado Tinoco, Inés. *Causas sociales de la delincuencia femenina por tráfico de drogas*. Lima: Editorial Gráfica del Perú, 1989.

Couture, Pamela D. *Blessed Are the Poor? Women's Poverty, Family Policy, and Practical Theology*. Nashville: Abingdon, 1991.

Cupitt, Don. *What Is a Story?* London: SCM Press, 1991.

D'Costa, Gavin. *Christian Uniqueness Reconsidered: The Myth of a Pluralistic Theology of Religions*. Maryknoll, N.Y.: Orbis Books, 1990.

Degregori, Carlos Iván. *El surgimiento de Sendero Luminoso: Ayacucho 1969–1979*. Lima: Instituto de Estudios Peruanos, 1990.

Dixon, Susan R. "Points of View: The Art of Encounter." In *View from the Shore: American Indian Perspectives on the Quincentenary. Northeast Indian Quarterly* 7, no. 3 (Fall 1990): 88–93.

Dominga Trapasso, Rosa. "Religión...mujer y ciclo vital." *VIVA* 17 (January 1990): 19–24.

Donaldson, Laura. *Decolonizing Feminisms: Race, Gender, and Empire Building*. Chapel Hill: University of North Carolina Press, 1992.

Dorfman, Ariel. "Código político y código literario: El género testimonio en Chile hoy." In *Testimonio y Literatura*, edited by René Jara and Hernán Vidal, 170–234. Minneapolis: Institute for the Study of Ideologies and Literature, 1986.

Douglass, James W. *The Nonviolent Coming of God*. Maryknoll, N.Y.: Orbis Books, 1991.

Dransart, Penny. "Women and Ritual Conflict in Inka [sic] Society." In *Images of Women in Peace and War: Crosscultural and Historical Perspectives*, 66–77. Madison: University of Wisconsin Press, 1988.

ECO-ANDES. "Women in Peru: Voices from a Decade." New York: Ecumenical Committee on the Andes (198 Broadway, New York, NY 10038), 1986.

Edgerton, W. Dow. *The Passion of Interpretation*. Louisville: Westminster/John Knox, 1992.

Elshtain, Jean Bethke. *Women and War*. New York: Basic Books, 1987.

———. "The Problem with Peace." In *Women, Militarism & War: Essays in History, Politics, and Social Theory*, edited by Jean Bethke Elshtain and Sheila Tobias, 255–66. Savage, Md.: Rowman & Littlefield, 1990.

Enloe, Cynthia. *Does Khaki Become You? The Militarization of Women's Lives*. Boston: South End Press, 1983.

———. *Bananas, Beaches, and Bases: Making Feminist Sense of International Politics*. Berkeley: University of California Press, 1990.

Esquivel, Julia. *Threatened with Resurrection: Prayers and Poems from an Exiled Guatemalan*. Elgin, Ill.: Brethren Press, 1982.

———. *Florecerás Guatemala*. Mexico City: Ediciones CUPSA, 1989.

Fabella, Virginia, and Sergio Torres, eds. *Doing Theology in a Divided World.* Maryknoll, N.Y.: Orbis Books, 1985.

Fisher, Lillian Estelle. *The Last Inca Revolt 1780–1783.* Norman: University of Oklahoma Press, 1966.

Flores Galindo, Alberto. "Pensando el horror." *El Zorro de Abajo* 2 (September/October 1985): 36–38.

Forgues, Roland. "Aída Balta y la reconquista del paraíso." Review of *El legado de Caín,* by Aída Balta. *El Comercio,* March 21, 1993.

———. *Palabra viva.* Vol. 4: *Las poetas se desnudan.* Lima: Editorial El Quijote, 1991.

Foster, David William. "Latin American Documentary Narrative." *PMLA* 99 (January 1984): 41–55.

Foucault, Michel. *Power/Knowledge: Selected Interviews and Other Writings, 1972–1977.* New York: Pantheon books, 1980.

"Francisca." "Ya no se puede seguir andando." *Testimonio* in Narda Henríquez and Rosa María Alfaro, eds., *Mujeres, violencia y derechos humanos,* 169–73. Lima: Abraxas Editorial, 1991.

Franco, Jean. "Beyond Ethnocentrism: Gender, Power, and the Third World Intelligentsia." In *Marxism and the Interpretation of Culture,* edited by Cary Nelson and Lawrence Grossberg, 503–15. Urbana and Chicago: University of Illinois Press, 1988.

———. *Plotting Women: Gender and Representation in Mexico.* New York: Columbia University Press, 1989.

———. "Si me permiten hablar: La lucha por el poder interpretativo." *Revista de Crítica Literaria Latinoamericana* 18, no. 36 (second semester 1992): 109–16.

Franger, Gaby. *Cuadros que hablan: Vida cotidiana y organización de mujeres.* Lima: Betaprint Ediciones, 1988.

Fraser, Nancy. *Unruly Practices: Power, Discourse, and Gender in Contemporary Social Theory.* Minneapolis: University of Minnesota Press, 1989.

Freeman, Barbara. "Epitaphs and Epigraphs: 'The End(s) of Man.'" In *Arms and the Woman: Gender and Literary Representation,* edited by Helen M. Cooper, Adrienne A. Munich, and Susan M. Squier, 303–22. Chapel Hill: University of North Carolina Press, 1989.

Fussell, Paul. *The Great War and Modern Memory.* New York: Oxford University Press, 1975.

Galeano, Eduardo. *The Open Veins of Latin America: Five Centuries of the Pillage of a Continent.* New York: Monthly Review Press, 1973.

García Naranjo, Aída. "Somos creadoras de vida, no úteros reproductores de violencia." *VIVA* 19 (December 1990): 42f.

G. E. F. "Aída Balta, segunda vuelta." Review of *El legado de Caín,* by Aída Balta. *Caretas* (October 1987): 62.

Gebara, Ivone. "Basisgemeinden-Modell ohne Zukunft." *Junge Kirche* 54 (June/July 1993): 360–62. Translated from *Sem Fronteiras,* September 1992.

George, Timothy. "A Radically Christian Witness for Peace." In *Education for Peace: Testimonies from World Religions*, edited by Haim Gordon and Leonard Grob, 62–76. Maryknoll, N.Y.: Orbis Books, 1987.

Gewecke, Frauke. *Wie die neue Welt in die alte kam.* Stuttgart: Klett-Cotta, 1986.

Giesecke, Margarita, Carmen Checa, and Alberto Giesecke. *Violencia estructural en el Perú: Historias de vida.* Lima: Asociación Peruana de Estudios e Investigaciones para la Paz, 1990.

Gilligan, Carol. *In a Different Voice: Psychological Theory and Women's Development.* Cambridge, Mass.: Harvard University Press, 1982.

Golden, Renny. *The Hour of the Poor, the Hour of Women: Salvadoran Women Speak.* New York: Crossroad/Continuum, 1991.

González Martínez, José Luis. *La religión popular en el Perú.* Cusco: Instituto de Pastoral Andina, 1984.

Gordon, Haim, and Leonard Grob, eds. *Education for Peace: Testimonies from World Religions.* Maryknoll, N.Y.: Orbis Books, 1987.

Gorriti, Carmen Luz. "El legado: Una historia de Huancayo." In *Memorias clandestinas (Cuentos): Primer Concurso de Cuento "Magda Portal," Convocado por el Centro de la Mujer Peruana Flora Tristán*, 75–81. Lima: Ediciones Flora Tristán, 1990.

Gorriti Ellenbogen, Gustavo. *Sendero: Historia de la guerra milenaria en el Perú.* Lima: Editorial Apoyo, 1990.

Griffin, David Ray. *Sacred Connections: Postmodern Spirituality, Political Economy, and Art.* Albany: State University of New York Press, 1990.

Griffin, Susan. *A Chorus of Stones: The Private Life of War.* New York: Doubleday, 1992.

Griffin-Nolan, Ed. *Witness for Peace: A Story of Resistance.* Louisville: Westminster/John Knox, 1991.

Grob, Leonard. "Pursuing Peace: Shalom in the Jewish Tradition." In *Education for Peace: Testimonies from World Religions*, edited by Haim Gordon and Leonard Grob, 30–44. Maryknoll, N.Y.: Orbis Books, 1987.

Guamán Poma de Ayala, Felipe. *Letter to a King: A Peruvian Chief's Account of Life under the Incas and under Spanish Rule.* New York: Dutton, 1978.

———. *Nueva crónica y buen gobierno.* 1st ed. Madrid: Historia 16, 1987 (published first around 1615).

Guardia, Sara Beatriz. *Mujeres peruanas: El otro lado de la historia.* Lima: Tempus Editores, 1986.

Gutiérrez, Gustavo. *A Theology of Liberation: History, Politics, and Salvation.* Maryknoll, N.Y.: Orbis Books, 1973 (first published in Spanish in 1971).

———. *Dios o el oro en las Indias: Siglo XVI.* Lima: Instituto Bartolomé de las Casas, 1989.

———. *Las Casas: In Search of the Poor of Jesus Christ.* Maryknoll, N.Y.: Orbis Books, 1993.

Haman Carillo, Herrmann. "Participación de la mujer peruana en apoyo de las operaciones militares." *Mujer y Sociedad* 34 (December 1989): 16–19.

Hammer, Paul. *The Gift of Shalom.* Philadelphia: United Church Press, 1976.

Hanley, Lynne. *Writing War: Fiction, Gender, and Memory.* Amherst: University of Massachusetts Press, 1991.

Harlow, Barbara. *Resistance Literature.* New York: Methuen, 1987.

Haro, Marina. "La guerra del hambre." In *Vivir la reconciliación — hacer la paz: Estrategias de mujeres contra la opresión,* edited by Elisabeth Benzing, Esteban Cuya, and Gaby Franger, 138–42. Wendelstein, Germany: Cicero Publishing, 1992.

Harris, Adrienne, and Ynestra King, eds. *Rocking the Ship of State: Toward a Feminist Peace Politics.* Boulder: Westview Press, 1989.

————. "Bringing Artemis to Life: A Plea for Militance and Aggression in Feminist Peace Politics." In *Rocking the Ship of State: Toward a Feminist Peace Politics,* edited by Adrienne Harris and Ynestra King, 93–113. Boulder: Westview Press, 1989.

Harrison, Regina. *Signs, Songs, and Memory in the Andes: Translating Quechua Language and Culture.* Austin: University of Texas Press, 1989.

Henríquez, Narda, and Rosa María Alfaro, eds. *Mujeres, violencia y derechos humanos.* Lima: Abraxas Editorial, 1991.

Herman, Edward S., and Gerry O'Sullivan. *The Terrorism Industry: The Experts and Institutions That Shape Our View of Terror.* New York: Pantheon Books, 1989.

Herrin, Judith. *The Formation of Christendom.* Princeton, N.J.: Princeton University Press, 1987.

Herzog, Frederick. *God-Walk: Liberation Shaping Dogmatics.* Maryknoll, N.Y.: Orbis Books, 1988.

————. "Tradición Común Shaping Christian Theology: Mutualization in Theological Education." Report to the Association of Theological Schools, 1993.

Herzog, Kristin. *Women, Ethnics, and Exotics: Images of Power in Mid-Nineteenth-Century American Fiction.* Knoxville: University of Tennessee Press, 1983.

————. "Die friedfertige Frau? Theologische Perspektiven zum Thema Frauen, Krieg und Frieden." *Evangelische Theologie* 47 (January/February 1987): 60–82.

————. "La mujer, la guerra y la paz." *Selecciones de Teología* 27 (October–December 1988): 317–31 (translation of previous title without notes).

————. "Peacemaker Woman? Theological Perspectives on Women, War, and Peace." *Reformed World* 41 (June 1990): 41–56 (translation of "Die friedfertige Frau?" without notes).

Higgins, James. *A History of Peruvian Literature.* Liverpool: Francis Cairns Publications, 1987.

Higonnet, Margaret R., et al., eds. *Behind the Lines: Gender and the Two World Wars*. New Haven: Yale University Press, 1987.

Huston, Nancy. "Tales of War and Tears of Women." In *Women and Men's Wars*, edited by Judith Stiehm, 271–82. New York: Pergamon Press, 1983.

Jaggar, Alison M., and Susan R. Bordo, eds. *Gender/Body/Knowledge: Feminist Constructions of Being and Knowing*. New Brunswick and London: Rutgers University Press, 1989.

Jay, Nancy. *Throughout Your Generations Forever: Sacrifice, Religion, and Paternity*. Chicago: University of Chicago Press, 1992.

Jara, René, and Hernán Vidal, eds. *Testimonio y Literatura*. Minneapolis: Institute for the Study of Ideologies and Literature, 1986.

Jelin, Elizabeth, ed. *Women and Social Change in Latin America*. London: Zed Books, 1990.

Jensen, Anne. "Faltonia Betitia Proba: Eine Kirchenlehrerin der Spätantike." In *Mit allen Sinnen glauben: Feministische Theologie unterwegs*, edited by Herlinde Pissarek-Hudelist and Luise Schottroff, 84–94. Gütersloh: Gerd Mohn, 1991.

Kirk, Robin. *The Decade of Chaqwa: Peru's Internal Refugees*. Washington, D.C.: U.S. Committee for Refugees, 1991.

————. "Women Warriors at Core of Peruvian Rebellion." *San Francisco Chronicle*, April 1, 1991, 1f.

————. *Untold Terror: Violence against Women in Peru's Armed Conflict*. New York: Americas Watch and the Women's Rights Project, Divisions of Human Rights Watch, 1992.

————. "Women of the Shining Path." *Image* (March 22, 1992): 15–21.

Kraemer, Ross Shepard. *Her Share of the Blessings: Women's Religions among Pagans, Jews, and Christians in the Greco-Roman World*. New York: Oxford University Press, 1992.

Lancaster, Roger N. *Life Is Hard: Machismo, Danger, and the Intimacy of Power in Nicaragua*. Berkeley: University of California Press, 1992.

Landweer, Hilge. *Das Märtyrerinnenmodell: Zur diskursiven Erzeugung weiblicher Identität*. Pfaffenweiler: Centaurus, 1990.

Léon y Léon, Edmundo, and Oscar Aliaga-Abanto, "Peru: Furrows of Peace in a Bloodstained Land." In *Relentless Persistence: Nonviolent Action in Latin America*, edited by Philip McManus and Gerald Schlabach, 136–51. Philadelphia: New Society Publishers, 1991.

Lora, Carmen. "Nuevos sujetos: Mujeres y política." *Páginas* 108 (April 1991): 38–48.

Lora, Carmen, Cecilia Barnachea, and Fryné Santisteban. *Mujer: Víctima de opresión, portadora de liberación*. Lima: Instituto Bartolomé de las Casas, 1987.

MacCormack, Sabine. *Religion in the Andes: Vision and Imagination in Early Colonial Peru*. Princeton, N.J.: Princeton University Press, 1991.

McManus, Philip, and Gerald Schlabach, eds. *Relentless Persistence: Nonviolent Action in Latin America*. Philadelphia: New Society Publishers, 1991.

Madden, James. "Dancing in God's Presence." *Maryknoll: Magazine of the Catholic Foreign Mission Society* 85, no. 10 (October 1991): 16–20.

Málaga, Rosa. "Educadas para poner la otra mejilla." *VIVA* 17 (January 1990): 25–27.

Mannarelli, María Emma. "La conquista de la palabra." *VIVA* 8 (November/December 1986): 21–23.

————. *Inquisición y mujeres: Las hechiceras en el Perú durante el siglo XVII.* Lima: CENDOC-Mujer, 1987.

Martin, David. *Tongues of Fire: The Explosion of Protestantism in Latin America.* Oxford, England; Cambridge, Mass.: Basil Blackwell, 1990.

Maticorena Estrada, Miguel. "Prólogo." In *Colección documental del bicentenario de la revolución emancipadora de Tupac Amaru.* Vol. 3/1, xiv–xxi. Lima: Comisión nacional del Sesquicentenario de la Independencia del Perú, 1981.

Mauser, Ulrich. *The Gospel of Peace: A Scriptural Message.* Louisville: Westminster/John Knox, 1992.

Medina, Cecilia. "Women's Rights as Human Rights: Latin American Countries and the Organization of American States (OAS)." In *Women, Feminist Identity, and Society in the 1980's: Selected Papers,* edited by Myriam Díaz-Diocaretz and Iris M. Zavala, 63–79. Amsterdam/Philadelphia: John Benjamin Publ. Co., 1985.

*Memorias clandestinas (Cuentos): Primer Concurso de Cuento "Magda Portal," Convocado por el Centro de la Mujer Peruana Flora Tristán.* Lima: Ediciones Flora Tristán, 1990.

Menchú, Rigoberta. *I... Rigoberta Menchú: An Indian Woman in Guatemala,* edited by Elisabeth Burgos-Debray. London: Verso Editions, 1984.

Metz, Johann Baptist. "Standing at the End of the Eurocentric Era of Christianity: A Catholic View." In *Doing Theology in a Divided World,* edited by Virginia Fabella and Sergio Torres. Maryknoll, N.Y.: Orbis Books, 1985.

Mignolo, Walter. "Literacy and Colonization: The New World Experience." In *1492–1992: Re/Discovering Colonial Writing,* edited by René Jara and Nicholas Spadaccini. Minneapolis: Prisma Institute, 1989.

Mires, Fernando. *En nombre de la cruz.* San José, Costa Rica: Editorial DEI, 1989.

Mollenkott, Virginia Ramey, ed. *Women of Faith in Dialogue.* New York: Crossroad, 1988.

————. "An Evangelical Perspective on Interreligious Dialogue." In *Women of Faith in Dialogue,* edited by Virginia Ramey Mollenkott, 61–73. New York: Crossroad, 1988.

Moreno de Cáceres, Antonia. *Recuerdos de la campaña de la Breña: Memorias.* Edited by Hortensia Cáceres. Lima: Editorial Milla Batres, 1974.

Moreno Rejón, Francisco, comp. *La nueva evangelización: Reflexiones, experiencias y testimonios desde el Perú.* Lima: Instituto Bartolomé de las Casas, 1992.

Morgan, Robin. *The Demon Lover: On the Sexuality of Terrorism.* New York: W. W. Norton, 1989.

Mveng, Engelbert. "A Cultural Perspective." In *Doing Theology in a Divided World,* edited by Virginia Fabella and Sergio Torres. Maryknoll, N.Y.: Orbis Books, 1985.

Neuhaus Rizo Patrón, Carlos. *Pancha Gamarra la Mariscala.* Lima: Francisco Moncloa Editores, 1967.

Niditch, Susan. *War in the Hebrew Bible: A Study in the Ethics of Violence.* New York: Oxford University Press, 1993.

Nieto Degregori, Luis. *La joven que subió al cielo.* Lima: El Zorro de Abajo Ediciones, 1988.

O'Neill, Maura. *Women Speaking, Women Listening: Women in Interreligious Dialogue.* Maryknoll, N.Y.: Orbis Books, 1990.

Ortega, Ofelia. "Latin American Women: A History of Rebellion." *Echoes* (World Council of Churches) 1 (November 1992): 15–20.

Ortiz Rescaniere, Alejandro. *De adaneva a incarrí: Una visión indígena del Perú.* Lima: Retablo de Papel Ediciones, 1973.

Palma, Milagros, ed. *Simbólica de la femineidad: La mujer en el imaginario mítico-religioso de las sociedades indias y mestizas.* Quito: Ediciones Abya-Yala, 1990.

————. "Malinche: El malinchismo o el lado femenino de la sociedad mestiza." In *Simbólica de la femineidad: La mujer en el imaginario mítico-religioso de las sociedades indias y mestizas,* edited by Milagros Palma, 13–38. Quito: Ediciones Abya-Yala, 1990.

Palmer, David. *The Shining Path of Peru.* New York: St. Martin's Press, 1992.

Panizo, Rosanna. "Donde está la paz de este mundo?" *Revista Ulaje Comparte* 3, 1 (1986): 10–12.

————. "Violencia: Un punto en discusión." *Revista Ulaje Comparte* 4, 4 (1987): 4–6.

Patai, Daphne. "Ethical Problems of Personal Narratives, or, Who Should Eat the Last Piece of Cake?" *International Journal of Oral History* 8, no. 1 (1987): 5–27.

————. "Constructing a Self: A Brazilian Life Story." *Feminist Studies* 14 (Spring 1988): 143–66.

————. *Brazilian Women Speak: Contemporary Life Stories.* New Brunswick, N.J.: Rutgers University Press, 1988.

————. "Who's Calling Whom 'Subaltern'?" *Women and Language* 11, no. 2 (Winter 1988): 23–26.

————. "U.S. Academics and Third World Women: Is Ethical Research Possible?" In *Women's Words: The Feminist Practice of Oral History,* edited by Sherna Berger Gluck and Daphne Patai, 137–53. New York: Routledge, 1991.

Pease G.Y., Franklin. "Notas sobre literatura incaica." *Historia y Cultura: Revista del Museo Nacional de Historia* 16 (1983): 95–112.

Pedersen, Christina Hee. *Nunca antes me habían enseñado eso: Capacitación feminista. Metodología/comunicación/impacto.* Edited by Carolina Carlessi. Lima: Lilith Ediciones, 1988.

Pflücker, Piedad Pareja. *Terrorismo y sindicalismo en Ayacucho (1980).* Lima: Empresa Editora Ital Perú, 1981.

Pflücker, Piedad Pareja, and Eric Torres Montes. *Municipios y terrorismo: Impacto de la violencia subversiva en los gobiernos locales.* Lima: Centro de Estudios Peruanos, 1989.

Pilar Aquino, María. *Nuestro clamor por la vida: Teología latino-americana desde la perspectiva de la mujer.* San José, Costa Rica: Editorial DEI, 1992.

Pissarek-Hudelist, Herlinde, and Luise Schottroff, eds. *Mit allen Sinnen glauben: Feministische Theologie unterwegs.* Gütersloh: Gerd Mohn, 1991.

Poole, Deborah, and Gerardo Rénique. *Peru: Time of Fear.* London: Latin American Bureau, 1992.

Pissarek-Hudelist, Herlinde. "Eine 'Schwester im Glauben.'" In *Mit allen Sinnen glauben: Feministische Theologie unterwegs,* edited by Herlinde Pissarek-Hudelist and Luise Schottroff, 18–25. Gütersloh: Gerd Mohn, 1991.

Portal, Magda. *Flora Tristán: Precursora.* Lima: Editorial La Equidad, 1983.

Portocarrero, Gonzalo, and Elisabeth Acha. *Violencia estructural en el Perú: Sociología.* Lima: Asociación Peruana de Estudios e Investigación para la Paz, 1990.

Portugal, Ana María. "Bertha Gonzales: Tenaz labor por las mujeres." *VIVA* 16 (September 1989): 11–13.

de Prado, Consuelo. "I Sense God in Another Way." In *Through Her Eyes: Women's Theology from Latin America,* edited by Elsa Tamez, 140–49. Maryknoll, N.Y.: Orbis Books, 1989.

———, and Amparo Huamán. "La mujer en la comunidad eclesial." *Páginas* 117 (September 1992): 102–10.

Ranly, Ernest W. "Letter from Peru: Shaky Reforms." *Christian Century* 110, no. 7 (March 3, 1993): 229–31.

Rice-Sayre, Laura P. "Witnessing History: Diplomacy versus Testimony." In *Testimonio y Literatura,* edited by René Jara and Hernán Vidal. Minneapolis: Institute for the Study of Ideologies and Literature, 1986.

Ricoeur, Paul. "The Hermeneutics of Testimony." In *Paul Ricoeur, Essays on Biblical Interpretation,* edited by Lewis S. Mudge, 119–54. Philadelphia: Fortress Press, 1980.

Romero, Catalina. "The Peruvian Church: Change and Continuity." In *The Progressive Church in Latin America,* edited by Scott Mainwaring and Alexander Wilde, 253–75. Notre Dame: University of Notre Dame Press, 1990.

———. "Democracia en América Latina." *Páginas* 117 (September 1992): 42–49.

Rostworowski, María. "La aguerrida Mama Huaco." *Mujer y Sociedad 6*, no. 11 (July 1986): 22–24.

———. *La mujer en la época prehispánica*. Documento de Trabajo no. 17. 3rd. ed. Lima: Instituto de Estudios Peruanos, 1988.

Ruether, Rosemary Radford. *Sexism and God-Talk*. Boston: Beacon, 1983.

———. *Gaia and God: An Ecofeminist Theology of Earth Healing*. New York: HarperCollins, 1992.

Rupert, Linda, et al. *Women in Peru: Voices from a Decade*. New York: Ecumenical Committee on the Andes (ECO-ANDES), 1986.

Sala, Mariella. "Atreverme a ser yo: Entrevista a Carmen Luz Gorriti." *VIVA* 18 (June 1990): 56f.

Salazar, Claudia. "A Third World Woman's Text: Between the Politics of Criticism and Cultural Politics." In *Women's Words: The Feminist Practice of Oral History*, edited by Sherna Berger Gluck and Daphne Patai, 93–106. New York: Routledge, 1991.

Sanneh, Lamin. *Translating the Message: The Missionary Impact on Culture*. Maryknoll, N.Y.: Orbis Books, 1989.

Say, Elizabeth A. *Evidence on Her Own Behalf: Women's Narrative as Theological Voice*. Savage, Md.: Rowman & Littlefield, 1990.

Scarry, Elaine. *The Body in Pain: The Making and Unmaking of the World*. New York, Oxford: Oxford University Press, 1985.

Scheper-Hughes, Nancy. *Death without Weeping: The Violence of Everyday Life in Brazil*. Berkeley: University of California Press, 1992.

Schipper, Mineke, ed. *Unheard Words: Women and Literature in Africa, the Arab World, Asia, the Caribbean, and Latin America*. London and New York: Allison & Busby, 1985.

Schottroff, Luise. "Nonviolence and the Love of One's Enemies." In *Essays on the Love Commandment*, trans. R. H. Fuller and I. Fuller. Philadelphia: Fortress Press, 1978.

Schüssler Fiorenza, Elisabeth. *In Memory of Her: A Feminist Theological Reconstruction of Christian Origins*. New York: Crossroad, 1983.

Seager, Joni, and Ann Olson. *Women in the World: An International Atlas*. New York: Simon & Schuster, 1986.

Servicio de Paz y Justicia (SERPAJ Ayacucho) and Perugruppe Nürnberg, eds. *Juana Lidia Argumedo: Lieder vom Leben und Überleben in Ayacucho*. Text by Rainer Huhle. Lima, 1987.

Siles Vallejos, Abraham. " 'La violencia del tiempo': Una memorable novela de Miguel Gutiérrez." *Quehacer* (May–June 1992): 100–110.

Silverblatt, Irene. *Moon, Sun, and Witches: Gender Ideology and Class in Inca and Colonial Peru*. Princeton, N.J.: Princeton University Press, 1987.

Sivard, Ruth Leger. *Women... A World Survey*. Washington, D.C.: World Priorities, 1985.

———. *World Military and Social Expenditures*. Washington, D.C.: World Priorities, 1991.

Sölle, Dorothee. *Thinking about God: An Introduction to Theology.* London: SCM Press; Philadelphia: Trinity Press International, 1990.

Spivak, Gayatri Chakravorty. *The Post-Colonial Critic: Interviews, Strategies, Dialogues,* edited by Sarah Harasym. New York: Routledge, 1990.

Starn, Orin. "Missing the Revolution: Anthropologists and the War in Peru." *Cultural Anthropology* 6, no. 1 (February 1991): 63–91.

Stern, Steve J. *Resistance, Rebellion, and Consciousness in the Andean Peasant World, 18th to 20th Centuries.* Madison: University of Wisconsin Press, 1987.

Sternbach, Nancy Saporta. "Re-membering the Dead: Latin American Women's 'Testimonial' Discourse." *Latin American Perspectives* 18, no. 3 (Summer 1991): 91–102.

Stoll, David. *Is Latin America Turning Protestant? The Politics of Evangelical Growth.* Berkeley: University of California Press, 1990.

Straubinger, Erika. *Zwischen Unterdrückung und Befreiung: Zur Situation der Frauen in Gesellschaft und Geschichte Perus. Geschichtlicher Rückblick und Gegenwartsanalyse.* Frankfurt am Main: Peter Lang, 1992.

Strong, Simon. "Where the Shining Path Leads." *The New York Times Magazine,* May 24, 1992.

————. *Shining Path, the World's Deadliest Revolutionary Force.* New York: Harper Collins, 1992.

Tamez, Elsa. *Bible of the Oppressed.* Maryknoll, N.Y.: Orbis Books, 1982.

————. *Against Machismo: Interviews by Elsa Tamez.* New York: Meyer Stone/Crossroad, 1987.

Tamez, Elsa, ed. *Through Her Eyes: Women's Theology from Latin America.* Maryknoll, N.Y.: Orbis Books, 1989.

————. "Quetzalcóatl y el dios cristiano: Alianza y lucha de dioses." *Vida y Pensamiento* (San José, Costa Rica) 11, no. 1 (1991): 31–54.

Tauro, Alberto. *Clorinda Matto de Turner y la novela indigenista.* Lima: Universidad Nacional de San Marcos, 1976.

Taussig, Michael. *Shamanism, Colonialism, and the Wild Man: A Study in Terror and Healing.* Chicago: University of Chicago Press, 1987.

————. *The Nervous System.* New York: Routledge, 1992.

Thistlethwaite, Susan Brooks. *A Just Peace Church.* New York: United Church Press, 1986.

————. *Sex, Race, and God: Christian Feminism in Black and White.* New York: Crossroad, 1989.

Thistlethwaite, Susan Brooks, and Mary Potter Engel, eds. *Lift Every Voice: Constructing Christian Theologies from the Underside.* New York: Harper & Row, 1990.

Tinker, George. "Native Americans and the Land: 'The End of Living and the Beginning of Survival.'" In *Lift Every Voice: Constructing Christian Theologies from the Underside,* edited by Susan Brooks Thistlethwaite and Mary Potter Engel, 141–51. New York: Harper & Row, 1990.

Tinoco, Inés Coronado. See Coronado Tinoco, Inés.

Todorov, Tzvetan. *The Conquest of America: The Question of the Other.* New York: Harper & Row, 1984.

Valcárcel, Rosina. *Una mujer canta en medio del caos.* Lima: Colección Amarilis, 1991.

Vargas, Virginia. *El aporte de la rebeldía de las mujeres.* Lima: Ediciones Flora Tristán, 1989.

————. "The Women's Movement in Peru: Streams, Spaces, and Knots." Mimeograph, 1990.

————. *Como cambiar el mundo sin pedernos: El movimiento de mujeres en el Perú y América Latina.* Lima: Ediciones Flora Tristán, 1992.

Vicuña, Julia. "Las mujeres en Sendero." *VIVA* 16 (September 1989): 8f.

Voss-Goldstein, Christel, and Horst Goldstein. *Schwestern über Kontinente. Aufbruch der Frauen: Theologie der Befreiung in Lateinamerika und feministische Theologie hierzulande.* Düsseldorf: Patmos, 1991.

Wachtel, Nathan. *The Vision of the Vanquished: The Spanish Conquest of Peru through Indian Eyes, 1530–1570.* New York: Barnes & Noble, 1977.

Wallace, Paul A. W. *White Roots of Peace.* Philadelphia: University of Pennsylvania Press, 1946.

Wallis, Jim. "The Challenge of Nonviolence." *Sojourners* 22, no. 3 (April 1993): 4f.

Worcester, Donald E. *Bolivar.* Boston: Little, Brown, and Co., 1977.

World Council of Churches. "Peru One Year Later: Report of an International Ecumenical Delegation to Peru, September 30–October 7, 1991." Geneva, February 1992.

Yoder, John Howard. *When War Is Unjust: Being Honest in Just War Thinking.* Minneapolis: Augsburg, 1984.

Yoder, Perry B., and Willard M. Swartley, eds. *The Meaning of Peace: Biblical Studies.* Louisville: Westminster/John Knox, 1992.

Young, Grace Esther. "The Myth of Being 'Like a Daughter.'" *Latin American Perspectives* 54, vol. 14, no. 3 (Summer 1987): 365–80.

Yúdice, George. "Testimonio and Postmodernism." In *Latin American Perspectives* 18, no. 3 (Summer 1991): 15–31.

Yuyachkani. *Allpa Rayku: Una experiencia de teatro popular.* Lima: Perúgraph Editores, 1983.

————. *Un día en perfecta paz.* Lima: Rumi Maqui Editores, 1989.

Zapata, Susana. "Las rabonas." *Mujer y Sociedad* 6, no. 11 (July 1986): 30–31.

# INDEX

Abortion, 99, 100, 135
Abraham (patriarch), 148, 173
Acha, Elisabeth, 35, 50, 70
Acuña, Father Angel, 134
Adorno, Rolena, 199 n.6, 216 n.10
Aggressiveness, training in, 176
Agosín, Marjorie, 209 n.64
Agriculture, 48
Alcoff, Linda, 225 n.26
Alfaro, Rosa María, 56–57
Aliaga-Abanto, Oscar, 210 n.4, 223 n.3
Alperin, Mimi, 222 n.20
Alvarado, María Jesús, 124
Amaru (snake), 79
American Indians:
  carrying whites on their backs, 143
  estimated deaths since the conquest, 199 n.2
  identity, shaping of, 217 n.24
  image of, in Matto de Turner, 31–32
  image of, in Moreno de Cáceres, 25, 27–29
  kept illiterate, 13
  percentage of population in Peru, xvii, 54
  Quechua, 59, 149
  and religion, 8
  term, use of, 204 n.1
  women, representing conquered land, 216 n.20
  See also Andean culture and religion; Ethnic groups of Peru; Women, under colonialism
American literature, 10
Americas Watch, 7
Amnesty International, 187, 202 n.21, 214 n.5
Andean culture and religion, 20–21
  ancestors, cult of, 139, 143
  apocalypticism, 72, 85
  biblical world, relationship to, 121, 150, 174
  Christ, meaning of, 144
  confession in, 149
  cosmology, 149

divinity, image of, 149–50
fiestas and rituals, 81
inadequacy of term "religion" for, 8
masks, 81
modernization and Western traits in, 64–65, 121, 150, 206 n.25
music, instrumental, and songs, 58, 60–62, 81, 205 n.19, 205–6 n.21
myth of devouring foxes, 76
myth of Incarrí, 85
orality of, 150
persistence of pre-Inca cults, 150
prayer, 149
priestesses, 149
reciprocity and correspondence of opposites, 139–40
reenacted by Yuyachkani, 75, 207 n.49
religious verse, pre-Columbian, 118
sacredness of land and burial places, 63–64, 141, 215 n.5
Satan, image of, lacking, 149
spirit force (supay), 59
suppression of, 140
trinity, concept of, 150
women, bearing arms, 62
women, under colonialism, 138–44
women, traditional status of, 58
See also American Indians; Incas
Andreas, Carol, 65, 69, 73, 200 n.15
Andreas, Peter R., 211 n.11
Apocalypticism, 72–74, 83, 85, 207 n.44
Aquino, María Pilar, 224 n.14
Arguedas, José María, 67–69, 218 n.13
Argumedo, Juana Lidia, 56, 59–62, 205 nn.17, 19, 20
Arizpe, Lourdes, 225 n.24
Armed forces of Peru, 46–47, 53, 74
  advancement in, 87–88, 98
  antisubversive campaign of, 46, 90
  criticism of, forbidden, 161
  depicted in La boca del lobo, 86–90
  depicted on arpilleras, 92 (illus.), 94 (illus.)